I / GALLERY OF THE ARTS / 5 CONTINENTS

FRÉDÉRIC ELSIG

PAINTING IN FRANCE IN THE 15TH CENTURY

I / GALLERY OF THE ARTS

CONTINENTS

The author would like to warmly thank
Philippe Lorentz and Mauro Natale,
with whom he shares the same interest
in 15th-century artistic exchanges.

EDITORIAL COORDINATOR
Paola Gallerani

TRANSLATION
Susan Wise

EDITING
Andrew Ellis

ICONOGRAPHIC RESEARCH
Alessandra Fracassi

CONSULTANT ART DIRECTOR
Orna Frommer-Dawson

GRAPHIC DESIGN
John and Orna Designs, London

LAYOUT
Cromographic S.r.l., Milan

COLOUR SEPARATION
Galasele, Milan

PRINTED JULY 2004
by Leva Arti Grafiche, Sesto San Giovanni (MI)

PRINTED IN ITALY

CONTENTS

INTRODUCTION

Whereas studies of fifteenth-century Italian and Netherlandish painting have enjoyed a long tradition, French painting of the same historical period has never received the kind of authentic historiographical analysis that would have assured it intellectual legitimacy and lasting fame. Although French art of this period drew the attention of a few connoisseurs and men of letters like Jean Lemaire de Belges and Jean Pèlerin Viator, these writers (respectively in 1503/04 and 1521) briefly mentioned only a handful of the more renowned painters, notably Jean Fouquet, Colin d'Amiens, Jean Poyer, and Jean Hey. Rarefied by Protestant iconoclasm and by changes in taste imposed by the Counter-Reformation, French painting of fifteenth century progressively fell into oblivion with the exception of the works linked to monarchy, whose memory is preserved thanks to scholars, such as François-Roger de Gaignières (1644–1715). However, subsequent to the dispersal of art works caused by French Revolution, a new awareness of the importance of the national patrimony came into being, and, as part of a broader scholarly interest in the Middle Ages, research into the country's heritage gained momentum amidst a nationalistic mood that favoured historical scholarship.

The first studies of the "French primitives" in the 1850s aimed to glorify the genius of France, anachronistically applying their survey to the country's nineteenth-century political borders, however. The mission of these studies was therefore to demonstrate the wealth of the nation's patrimony by bringing to light new works and new documents relative to painters and their production. Largely pursued by archivists, this research did not go beyond the bounds of local erudition, and the results would be disclosed to the public for the first time in the World's Fair held in Paris in 1900, and then especially in the 'Exposition des Primitifs Français' organised by Henri Bouchot at the Louvre and the Bibliothèque Nationale in 1904.

Epitomising the typical nineteenth-century nationalist vision, the 1904 exhibition assembled a significant number of works which, having been discovered on "national"

territory, were indiscriminately classified as French painting. This raised the objections of several scholars, in particular Louis Dimier, who wished to limit the field of study to the territory of the French Crown as it was in the fifteenth century, and to painters of French birth. Consequently, he tended to point out the paucity of the production, whose few surviving examples were furthermore mostly the work of foreign artists.

Notwithstanding the controversy it prompted, the 1904 exhibition was a decisive turning point, and gave rise to a new generation of art historians. This novel approach, which challenged both Bouchot's nationalistic outlook and Dimier's more restrictive conception, was assumed by connoisseurs such as Georges Hulin de Loo and Paul Durrieu. Concentrating on stylistic analysis and confronting the works with related documentation, their procedure endeavoured to identify a common spirit in all the works linguistically connected with French civilisation. In the wake of the Bouchot's exhibition, between the two world wars the international art market saw a sudden new interest in the French Primitives, as testified by the Kleinberger Galleries exhibition in New York in 1927. Summarised in 1931 by Paul-André Lemoisne's book *La Peinture française à l'époque gothique*, in the late 1930s, the exhibition led to a whose series of studies (Germain Bazin, Jacques Dupont, etc.) stimulated by another Paris show entitled 'Chefs-d'œuvre de l'art français' (1937), which attempted to define the French spirit from Jean Pucelle to Paul Cézanne, and received the contribution of the future specialist in area of artistic production, the art historian Charles Sterling.

Impressed by Georges Hulin de Loo's method, Charles Sterling soon became one of the most distinguished connoisseurs, and wrote two important surveys that are still fundamental, the first of which was published in 1938, the second in 1941, under the pseudonym Charles Jacques (a second edition appeared a year later under his real name). Until his death in 1991, in a numerous articles and several books Sterling tirelessly refined the notion of French painting, which he positioned midway between the Netherlandish analytic vision and the Italian synthetic vision. Sterling's contribution is threefold: first he cast light on the specificity of regional productions, as Grete Ring would likewise do in *A Century of French Painting 1400–1500* (1949); Michel Laclotte in his 1966 compendium; and similarly John Plummer in the catalogue for the New York exhibition 'The Last Flowering' (1982). Subsequently, Sterling published countless hitherto unknown works that he associated with documented names, thereby recomposing the identities of several previously anonymous artistic personalities. Last, he demonstrated the versatility of the painters who worked on various types of support (such as walls, panels, manuscripts) and regularly supplied cartoons for tapestries or stained-glass windows.

Charles Sterling's research was continued and enriched in particular by Nicole Reynaud and François Avril, who worked together in mounting a remarkable exhibition at the Bibliothèque Nationale in 1993, entitled 'Les manuscrits à peintures en France, 1440–1520', and the book published on the occasion was a milestone insofar as it was the most complete survey to date. On the basis of stylistic analysis, the curators strove to define the regional variations of a same linguistic culture. However, in deference to the burgeoning notion of a European Community, they focused less on identifying a specifically French spirit, than on portraying France as a hub of international exchanges.

A century after the 1904 exhibition, just what is the outcome of these studies? While the first half of the twentieth century brought to light a number of works under the nationalist label "French School", the second half of the century formed our vision of the production at two levels. On the one hand it revealed the existence of collective styles, meaning traditions identifiable by region. On the other, it highlighted individual styles, thereby exposing distinct artistic personalities at work alongside the better-known painters like Jean Fouquet or Jean Bourdichon, namely Barthélemy d'Eyck, André d'Ypres, Antoine de Lonhy, Jean Poyer, and Jean Hey—all artists of considerable versatility. The tension between these two levels shows how important it is today to present a dynamic view of artistic developments that takes into account the artists' mobility, which depended upon their network of patrons, and on interaction between the various regional productions.

Given this overview of past research, the present study will devote special attention to the circulation of influences, painters, and works, and thereby attempt to draw a map of artistic development which, instead of coinciding with past or modern political boundaries, will highlight the main currents of cultural exchanges, and the necessarily overlapping frontiers. While this study should ideally take into account the whole of Europe, of which French territory is but a part, it will instead be limited to the lands of the French Crown (i.e., Paris, the Loire Valley, and Lyon) and to territories conquered during the last quarter of the fifteenth century (Picardy, Burgundy, Anjou, and Provence). It will, moreover, only mention the Duchy of Savoy, which deserves a specific study owing to its distinctly cosmopolitan culture.

Our study is divided in three periods. We shall first examine how the precious rhetorics of International Gothic were diffused in the age of King Charles VI and the English occupation (1380–1435). Then we shall analyse the new taste inspired by Netherlandish painting and diffused over the French soil between the Treaty of Arras (1435) and the death of Louis XI (1483). Last, we shall undertake to observe the

new trends arising under Charles VIII and Louis XII (1483–1515), that is, when Netherlandish painting became widespread and attention began to turn to Italy.

INTERNATIONAL GOTHIC AND THE FRENCH COURTS (1380–1435)

International Gothic, a concept that art history invented in the late nineteenth century, designates a style notably exemplified by Simone Martini at the pontifical court in Avignon (ca. 1336–44) and shared by several European courts between the late fourteenth and early fifteenth century that presents three essential characteristics: first preciousness of the materials imitating the effects of goldwork, a favourite technique at the time; then the flat conception of space that adopts the high horizon and teeming details of tapestry, another technique princely courts were fond of; last the fluidity of the draperies and sophisticated sinuosity of the soaring figures that belong to the same unrealistic world as courtly literature, still steeped in Guillaume de Lorris' *Romance of the Rose* (Guillaume de Machaut in particular).

This refined aesthetics was diffused by the patronage of King Charles V le Sage (Charles V the Wise, ruled 1364–80). He removed his residence from the old palace of the Cité to the Louvre which he remodelled, having Raymond du Temple build the "grand' vis" (spiral staircase) and equipping his large library. Fond of literature and luxury items, he commissioned or purchased a number of manuscripts, becoming the prototype of the collector. He also owned paintings on wood like the panel by Matteo Giovanetti (known from a copy by Gaignières) offered by the pope to his father Jean II le Bon (John II the Good), which he placed in the Sainte-Chapelle and that largely contributed to making Simone Martini's repertory known to the court painters. In fact he engaged several artists who, after winning a reputation in the Parisian marketplace, were given an advantageous position in his service, a title of *valet de chambre*, and a salary, while also working for other members of the court.

Among the leading painters, Jean Le Noir (documented from 1335 to 1380), who illuminated a breviary for the king (Paris, Bibliothèque Nationale, MS Lat. 1052), represents a local tradition derived from Jean Pucelle and only slightly affected by Italian models, which is characterised by the rhetorical excess of whirling volutes of the draperies. It contrasts with a more innovative Netherlandish manner featuring a tendency to simple, monumental layouts, as we see in Jean de Bruges (documented from 1368 to 1380). In 1371 Jean de Bruges painted a portrait of the king in the Bible offered by Jean de Vaudetar (The Hague, Rijksmuseum Meermanno-Westreenianum,

MS 10 B 23, fol. 2) and some time later provided Nicolas Bataille with cartoons for the *Apocalypse* tapestries of Angers, commissioned by the king's brother, Louis d'Anjou. Belonging to the next generation, Jean d'Orléans (documented from 1361 to 1392) achieved the synthesis of Pucelle's tradition and the Netherlandish manner. The altar frontal known as the *Narbonne Parement* (Paris, Musée du Louvre) is notably attributed to him: painted around 1375 with black ink on a silk (samite) band, it depicts the king and his wife Jeanne de Bourbon kneeling in front of scenes of the Passion of Christ.

Charles V le Sage (Charles V the Wise) had a crucial impact on the artistic patronage of the period that concerns us. First, he provided the group of princes with an orderly court model. Then he imposed his tastes and practices as a collector on his brothers, the dukes Louis d'Anjou, Jean de Berry and Philippe de Bourgogne, and on his son, Charles VI le Fou (Charles VI the Mad). Last, he was in part responsible for making Paris become an authentic focal point attracting northern sculptors, goldsmiths and painters.

The influence of Paris under the reign of Charles VI le Fou

At the time of his father's death, Charles VI (1380–1422) was only twelve. Five years later he married Isabeau of Bavaria. In 1392, horror-struck by the spectacle *Bal des Ardents*, during which dancers disguised as savages burned alive, he became chronically insane. Like his brother Louis d'Orléans (who maintained a literary retinue, including Eustache Deschamps and Christine de Pisan, in the castles of Pierrefonds and La Ferté-Milon), he nonetheless guaranteed continuity with his father's patronage, by enlisting the services of the same artists. He also had Raymond du Temple work in the chateau of Vincennes toward 1390. He enriched the library with over 200 books, confirming Gilles Malet as chief librarian, and by 1391 devoted himself to increasing the Treasury, much of which was unfortunately later melted down to pay for his army in 1417. Among the rare goldwork vestiges, the *Goldenes Rössl* (Altötting, Schatzkammer), perhaps by the queen's goldsmith Jean de Clerbourg (documented from 1393 to 1415), was offered, according to the custom, on the occasion of the 1404 New Year's gifts by Isabeau of Bavaria to her husband.

To judge from the scale of salaries and the royal goldsmith Jean du Vivier's position (documented from 1378 to 1401), goldwork was more in demand than other techniques and equally called upon painters. It was the great Parisian speciality according to Eustache Deschamps' verses: "De tous ouvrages d'armes, d'orfevrerie;

De tous les arts c'est la fleur, quoi qu'on die: [...] Rien ne se peut comparer à Paris" (Of all works of arms and of gold; Of all the arts it's the pick, say what they may: [...] Nothing matches Paris). This may explain in part the impression of penury of the pictorial production at the start of Charles VI's reign. Very few ascertained Parisian works survived from the 1380s, that is, the period when the courts of Bourges and Dijon were being formed, probably absorbing the capital's greatest energies. One of the most active painters, Jean d'Orléans, who began collaborating with the goldsmith Jean du Vivier in 1377, enjoyed a long career. In 1383 he coloured the statues adorning the Hôtel Saint-Pol in Paris, a royal residence, and supplied painted panels to Philippe le Hardi (Philip the Bold) on behalf of Jean de Berry. In 1391 he again appeared at the top of a list in the *Statutes* drawn up by painters. In subsequent years he painted an *Annunciation* for the Dauphin's room and restored wall paintings, notably a representation of St Christopher in the chateau of Vincennes.

One of the few extant wall paintings, the vault of the axial chapel of the Le Mans Cathedral, a building financed by the king, might give us an idea of Parisian painting toward the year 1385. Apparently owed to the patronage of Bishop Gontier de Baigneux, it features angel musicians whose fine quality in the delicate treatment of the modelling was revealed by recent restoration. Compared to the *Narbonne Parement*, the murals' language is softer, particularly in the quieter draperies, and directly anticipates an ensemble of four panels. Conceived as precious objects intended to change hands as gifts, they borrow their small size and delicately punched gilding from goldwork. Furthermore they develop the favourite theme of princely devotion: the Passion of Christ. Last, and most remarkable, all four of them come from the same workshop, that of the Master of the Small Pietà Roundel.

pls. 1–2 Held at the Louvre, the *Small Pietà Roundel*, whose reverse features the three nails surrounded by the crown of thorns, shows on a background of star motifs the dead Christ wrapped in a transparent shroud in his mother's arms, and flanked on one side by St John and Nicodemus, and on the other by Joseph of Arimathea and St Mary Magdalene. Its symmetrical composition and the motif on the reverse are repeated in a heavily retouched rectangular panel of lesser quality (Brussels, Musées Royaux des Beaux-Arts) that adds three angels and a Carthusian monk at prayer. A *Deposition* (Paris, Musée du Louvre) borrows the same dramatic setting but with an oblique

pl. 3 composition. It represents, on the same star motif background, the dead Christ wrapped in a transparent shroud and deposed in the sarcophagus by Nicodemus, Joseph of Arimathea, and a third elder along with the usual protagonists. But it adds a Holy Woman and, on the far left and slightly recessed, an elderly man holding an unguent jar and sometimes identified, without cogent reasons in the absence of heraldry, with Jean de Berry. Its diagonal structure recalls a fourth panel (Troyes,

Musée de Vauluisant), unfortunately very damaged, that shows the body of Christ held by the Virgin and St John in the presence of two angels in liturgical garb.

These four panels confirm the Master of the Small Pietà Roundel as one of the most outstanding figures of the period. Active between 1395 and circa 1405, this artist evinces very close ties with the painters active in Dijon, especially with Jean de Beaumetz. Yet he uses a less pathetic language, preferring the models of the Parisian illuminators to those of Sienese paintings, and presents several curious features: the systematic use of punching for the background motifs, and scattered nimbi (defined by stippling); the variety of motifs in gold dust applied on the clothing with the tip of the brush (in particular the stippled motifs); rounded figure types with parted lips, circles under the eyes and evenly wavy hair; soft modelling, yet dry outlines. So might we identify him with the leading court painter of the day, Colart de Laon (recorded from 1377 and deceased before 1417)?

Valet de chambre of Charles VI and his brother Louis d'Orléans since 1391, four years later Colart de Laon delivered "large paintings" to the duc de Bourgogne, Philippe le Hardi. In 1396 he was enlisted by Louis d'Orléans to execute paintings for the church of the Celestines in Paris and the next year adorned a reliquary of the queen Isabeau of Bavaria which confirms his practice of goldwork. He also made tapestry designs for the queen in 1400 and six years later an altarpiece for the *Parlement* (superior court) of Paris. His position within Parisian production and his constant contacts (as of 1377) with the court of Burgundy in Dijon make him an ideal candidate for identification with the Master of the Small Pietà Roundel. Or instead should we recognise him, as has been proposed recently, as the author of an altarpiece commissioned by Pierre de Wissant for the cathedral of Laon? Housed today in the museum of that city, the remaining double-faced panel of this altarpiece appears to belong to the generation of Malouel or the Limbourgs, and to date to around 1410. It belongs to the same period as a painter, more clearly residing in Paris, who is a third candidate for the identification with Colart de Laon: the author of the *Coronation of the Virgin* of Berlin (Gemäldegalerie).

On a punched gold ground and in front of a flower bed, this round panel presents the Virgin risen to Heaven in the company of two angels in liturgical garb, who is crowned by Christ seated under the dais near two angels peering from behind the curtain. Its composition and several details are repeated in the frontispiece of a *Golden Legend* (Paris, Bibliothèque Nationale, MS Fr. 242) illuminated around 1402 by an illuminator of whom we know several miniatures (in particular in a *Boccaccio* of the duc de Berry; Paris, Bibliothèque Nationale, MS Fr. 598) and who might be one and the same as the Master of the Coronation of the Virgin. He is

pl. 4

equally the author of a small panel, painted for royal circles and presently held in a Parisian collection (formerly Vitale Bloch collection), that shows a Madonna and Child between two angels. Active in the first decade of the fifteenth century, this artist may have been trained by the Master of the Small Pietà Roundel, from whom he differs by more elegant figures, a more suggestive manner (see the blurred definition of details such as the eyes), and a more diluted pictorial material applied in transparent glazes. Their connection is confirmed by a third personality by whom we know but one work, more modest (a *Madonna and Child under a baldachin between a donor, St Benedict and St Andrew* in a private collection) and who is midway between our two painters. We should mention that beside Colart de Laon other names as well are documented in royal circles, such as Henequin Gatel and Jean Guymont.

Whatever his identity may be, the Master of the Coronation of the Virgin, whose versatility should be underscored, in his soaring figures appears to be familiar with the brilliant formulas of the Boucicaut Master. The latter, active in the same period, owes his conventional name to a magnificent book illuminated for Jean le Meingre, marshal of Boucicaut and governor of Genoa from 1402 to 1409 (Paris, Musée Jacquemart-André, MS 2), a manuscript in which he sought new spatial and volumetric solutions. Close to the royal circle, toward 1409 he illuminated a *Dialogue* Pierre Salmon offered King Charles VI, portrayed in the frontispiece (Paris, Bibliothèque Nationale, MS Fr. 23279). With his main associate (temporarily called the Master of the Mazarine), he ran a flourishing workshop in Paris whose clients were as prestigious as they were varied: including Jean de Berry, Jean Sans Peur (John the Fearless), a member of the Milanese Visconti family and a member of the Trenta family of Lucca, Italy. It has rather convincingly been suggested identifying him with the Bruges artist Jacques Coene (mentioned in Aragonese documents in 1388, and as working on the cathedral in Milan in 1399), who appears to have been an expert in colours and one of the leading personalities of his time.

Jacques Coene's career attests to the influence of Paris, a hub drawing the greatest Netherlandish painters and which exported artists and art works to the south. This is corroborated by a large canvas apparently sent from Paris to Le Puy (a city attached to the French Crown since 1271), where it is conserved in the Musée Crozatier. On a ground featuring brocade motifs it represents the Virgin of Mercy as the person-ification of the Church, who protects the entire community in the folds of her wide mantle, upheld by two female saints (Mary's sisters?), and symbolically separating earthly space from that of heaven, occupied by six apostles. On the basis of the costumes worn by some laymen on the Virgin's left, the piece may date to the first decade of the fifteenth century. Despite its poor state of preservation owing to the

pl. 5

delicate technique used, its incisive style recalls such Parisian illuminators as Jacques Coene or the Master of the Cité des Dames. Its elegant linearity forms a strong contrast with the volumetric heaviness of the murals painted in 1405 nearby on the lands of the duc de Berry at Ennezat in Auvergne.

The Ennezat wall paintings show a *Last Judgement* attended by the apostles and the donors Étienne and Audine Morelle. To judge from the sophisticated drawing of several draperies, they reveal a familiarity with Bourges (the pseudo-Jacquemart) and Parisian circles, exspecially works such as the *Death of the Virgin* known by a drawing in the Louvre [fig. 1]. Yet their style, with leaden volumes and rather squat morphologies, is essentially conditioned by a Mediterranean manner conveying late fourteenth-century Tuscan models, in particular those of Taddeo di Bartolo. It also attests the influence of Avignon, which even at the time of the Great Schism (1378–1417) continued to produce works of quality, as can be seen in the Worcester *Virgin and Child with the Blessed Pierre de Luxembourg*, unfortunately heavily over-painted, and especially in the *Thouzon Altarpiece* (Paris, Musée du Louvre) painted toward 1410. The influence of Avignon that essentially spread to Languedoc and Auvergne also went up the Rhône river to Dauphiné and Bresse, where recently very handsome fragments of murals were discovered in the Saint-Oyen church in Meillonnas. Yet it remained far more modest than that of Paris relayed by the courts of Berry and Burgundy.

The courts of Berry and Burgundy

After the deaths of their brothers Charles V (1380) and Louis d'Anjou (1382), the dukes Jean de Berry and Philippe de Bourgogne took advantage of their nephew Charles VI's weakness to develop brilliant courts, on the model provided by the late king, that evolved concurrently in the 1380s. They both practised the same artistic policy consisting of recruiting artists from the north into the cosmopolitan circles of Paris, where they were used to acquiring precious items for their private collections or for New Year's gifts. Thus they kept up a relationship of exchanges and competition that produced wonderful masterpieces.

Duc de Berry et d'Auvergne since 1360, Jean de Valois played a very active role in government, taking over the regency in the early 1380s and residing more and more frequently in Paris after 1396. Yet he bestowed all his munificence on his duchy. He set up several residences such as the chateau of Mehun-sur-Yèvre and endowed his two capitals, Bourges and Riom, with a palace accompanied by a Sainte-Chapelle designed by Guy de Dammartin. Following in his older brother's footsteps, he

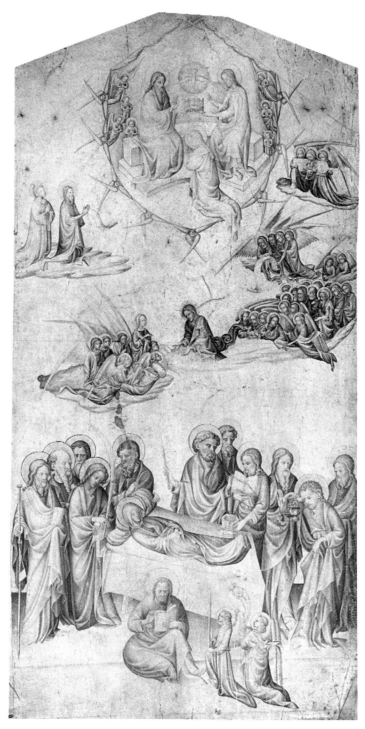

Fig. 1. Lombard artist active in Paris (?), *Death and Coronation of the Virgin*, ca. 1400.
Paris, Musée du Louvre, Département des Arts Graphiques, inv. 9832

became the greatest collector of his day, interested in all kinds of precious items (antique medals, cameos, and ivories) and even creating a zoo with exotic animals on his properties. He tirelessly acquired goldwork pieces like the chalice offered to Charles VI (London, British Museum), tapestries on courtly themes like the hangings of *The Nine Worthies* (New York, Metropolitan Museum of Art, Cloisters) and especially early or more recent manuscripts that enhanced his extraordinary library, whose inventory was drawn up by the treasurer Robinet d'Estampes.

Aside from second-hand purchases that prove his highly varied taste, he commissioned many works directly from the royal painters residing in Paris. Toward 1375 he entrusted the illustration of the *Petites Heures* (Paris, Bibliothèque Nationale, MS 18014) to the ageing Jean le Noir, who probably died before completing them. In 1369 and then in 1371 he purchased panels from Jean d'Orléans whom he enlisted toward 1380 to execute the *Très Belles Heures* (Paris, Bibliothèque Nationale, MS 3093). However, when he formed his court toward 1385 he directly engaged André Beauneveu (documented from 1359 to 1401/03), an artist of great versatility whose reputation had continued to spread since the 1360s in Flanders as well as in France.

Born in Hainaut, André Beauneveu belongs to the generation of Jean de Bruges and shares the latter's monumental conception of space and expressive treatment of draperies and hair. He was enlisted toward 1386 by Jean de Berry, for whom he immediately illuminated a *Psalter* (Paris, Bibliothèque Nationale, MS Fr. 13091) with lovely grisaille figures and to whom he would remain attached until his demise, around 1401/03. Toward 1390 in the chateau of Mehun-sur-Yèvre he made a painted and carved decor, commended by the chronicler Jean Froissart, that was appraised in 1393 by two artists in the duc de Bourgogne's service: the painter Jean de Beaumetz and the sculptor Claus Sluter. His contacts with the latter probably explain the aspiration to simplicity expressed in the stained-glass windows of the Sainte-Chapelle of Bourges, in all probability conceived after his cartoons and today partly conserved in the cathedral.

André Beauneveu's style is an apt expression of the first Netherlandish generation, spanning over the last quarter of the fourteenth century, characterised by a highly graphic manner, simplified spatial conventions, draperies with countless folds and rather flat modelling. Beginning in the 1390s a second Netherlandish generation gradually arose that seems to have thoroughly assimilated the Sienese models available in the French courts and that coincides with the "classical" phase of International Gothic. It features a brighter palette, a more complex, articulated composition, deeper space and more plastic volumes. Represented in Paris by the Master of the

Coronation of the Virgin [fig. 2] and Jacques Coene, it was expressed at the Berry court by Jacquemart de Hesdin.

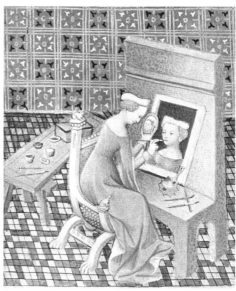

Fig. 2. Master of the Coronation of the Virgin, *Marcia paints her portrait*, 1403, Boccaccio, *Des Femmes nobles et renommées*. Paris, Bibliothèque Nationale, MS Fr. 12420, folio 101v.

Born in Artois, Jacquemart de Hesdin (recorded from 1384 to 1413) was engaged in 1384 by Jean de Berry who offered him a regular salary until at least 1409. In 1398 he was accused of stealing models and colours from another ducal painter, Jean de Hollande, working at the chateau of Poitiers at the time. In those same years he illuminated the Hours of the Virgin and of the Passion in a prayer-book mentioned in the 1402 inventory (Brussels, Bibliothèque Royale Albert Ier, MSS 11060, 11061). The Louvre has an admirable sheet cut out of the *Grandes Heures*, illuminated just before 1409. It figures *Christ carrying the Cross* in a composition directly inspired by the Orsini polyptych painted by Simone Martini, and owned at the time by the duc de Bourgogne at the Carthusian monastery of Champmol (today divided between Antwerp, Berlin, and Paris). It presents the same pathetic rhythm and intricate composition. Despite its poor state of conservation, the work displays great delicacy in the gentle heightening as well.

The brothers Pol, Jean and Herman de Limbourg belong to the same generation. Born in Nijmegen, they began their apprenticeship in goldwork in Paris in 1400 before their uncle Jean Malouel introduced them two years later to the duc de Bourgogne, for whom they illuminated a *Bible Moralisée* (Paris, Bibliothèque Nationale, MS Fr. 166) with an added grisaille frontispiece figuring a *St Jerome in his Study*. After their patron's death (1404) they entered the service of Jean de Berry who gave them a salary, various bonuses, and the title of *valet de chambre* (to Pol in 1413; to the two others in 1415). Between 1405 and 1408 they illuminated the *Belles Heures* (New York, The Metropolitan Museum of Art, Cloisters). Before dying of the plague in 1416, as did the duke himself, they spent the last years of their lives working on the *Très Riches Heures* (Chantilly, Musée Condé, MS 65), which they unfortunately did not complete. This superb manuscript, rightly considered the emblem of International Gothic, features an extraordinary calendar describing the activities

of the months in settings we occasionally recognise. The month of January shows the duc de Berry receiving New Year's gifts during a rich banquet held probably in one of the halls of the palace of Bourges, equipped with a large fireplace and adorned with tapestries on chivalric themes (the Trojan War). The month of April represents a betrothal in front of a castle identified as that of Dourdan. The month of May, in a wood near the Palais de la Cité, figures a charming youthful company composed of men in gorgeous costumes and women whose aesthetic canon is worthwhile mentioning: tall slim body, long neck, small round breasts, high waist and protruding belly.

pl. 6

The *Très Riches Heures* are evidence of the duke's fondness for luxury and ostentation. They display as well the quality achieved by the Limbourgs' art that reveals their familiarity with the colours of enamel work as well as the feeling for volume developed in painting on wood. This last technique was probably practised by the Limbourg brothers, as we see in the Washington *Portrait of a Woman in Profile*, comparable to several figures in the month of April. It obviously caught the eye of Jean de Berry, who in Paris acquired small panels in goldwork style for himself or his circle but whose patronage mostly focused on miniatures. On the other hand, in the court of Burgundy, the technique was highly developed upon Philippe le Hardi's instigation.

pl. 7

Made duke of Burgundy in 1363, six years later Philippe le Hardi married Margaret of Flanders, obtaining Flanders and Artois at the death of his father-in-law Louis de Male in 1384. He then decided to raise a sanctuary at the entrance to Dijon, the capital of his large duchy: the Champmol Charterhouse, dedicated to the Trinity and intended for the Burgundy dynasty. He engaged Drouet de Dammartin, an associate of Raymond du Temple and related to Guy de Dammartin, to design the edifice that he embellished by the donation of imported works or by directly commissioning sculptors and painters hired in Paris or in the northern regions of the duchy. At his death in 1404, his son Jean Sans Peur pursued the work until his own death.

Among the imported works, we should mention a portable polyptych (split between Antwerp and Baltimore) created by a Guelders painter on the accordion-style model of the Orsini polyptych. Philippe le Hardi also commissioned a sculptor from Termonde, Jacques de Baerze, for two large wooden altarpieces (Dijon, Musée des Beaux-Arts) that in 1392 he sent to Ypres, in Artois, to be gilded and coloured by Melchior Broederlam (documented from 1381 to 1401). The latter, ducal painter since 1383 and *valet de chambre* four years later, began work on the altarpieces in 1393, painted their reverses and delivered them to Dijon in 1399. Beside the triptych of the *Crucifixion* (the only one to conserve its paintings), he represented four Marian

scenes: the *Annunciation*, the *Visitation*, the *Presentation in the Temple*, and the *Flight into Egypt*. His style featuring full, well-defined forms with dense colours recalls several tapestries produced in Artois, such as the *Annunciation* of the Metropolitan Museum of New York or the *Concert* scenes of the Musée des Arts Décoratifs in Paris.

Besides importing works, the duke called several painters to his court. In 1373 he charged his equerry Jean Blondel to go to Milan to fetch the painter Jean d'Arbois, about whom we unfortunately know nothing. Two years later in Paris he engaged Jean de Beaumetz (documented from 1360 to 1396), born in Artois, who in 1376 succeeded Jean d'Arbois as court painter. At the Champmol Charterhouse Beaumetz directed an équipe of nineteen collaborators. In the early 1390s with his assistant Girard de la Chapelle he painted twenty-six Calvaries, one for each monk's cell, only pl. 8 two of which are extant: one in the Louvre; the other in the Cleveland museum. Identical in composition, the two panels depict a Carthusian monk at prayer in front of the very object of his meditation: *Christ on the Cross* accompanied by St John and the female saints. They derive from the idea formulated by Simone Martini in the Orsini polyptych, from which also comes their acute sense of pathos. Their sophisticated rhetorics still belonged nonetheless to the first Netherlandish generation and must certainly have been deemed rather old-fashioned by the duke, who had demonstrated his interest in the new taste, by importing works by Melchior Broederlam. This can be seen in a very fine drawing [fig. 3] with three studies of the *Virgin and Child* in various poses (Basle, Kupferstichkabinett), and also in a curious pl. 9 panel with the *Madonna and Child* in the Frick collection in New York, by an associate of Broederlam, who might well be the painter known as the Master of the Breviary of Jean Sans Peur, early in his career (compare with the historiated initial, in London, British Library, Add. 35311, fol. 8).

When Jean de Beaumetz died in 1396 he was replaced by a painter belonging to Melchior Broederlam's generation: Jean Malouel (documented from 1382 to 1415). Born in Nijmegen, in the Champmol yard the latter absorbed not only the Sienese repertory, but above all the forceful monumentality of the Haarlem sculptor Claus Sluter (documented from 1379 to 1406), several of whose works he was hired to colour and gild, including the large cloister cross (the base, known as the "Well of Moses" has survived). He may also be responsible for the *Virgin and Child* (before 1400), formerly in the Beistegui collection and now in the Louvre, which despite its awkward execution possesses several of his characteristic traits. Several years later (before 1404) he painted the *Large Pietà Roundel* (Paris, Musée du Louvre). This pl. 10 work, bearing the coat of arms of Philippe le Hardi on the back, presents the Carthusians' devotional object, the Trinity, as the Pity of Our Lord: the dead Christ is upheld by the Father and angels in liturgical garb in the presence of the Virgin

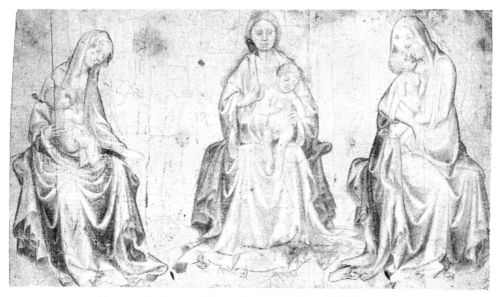

Fig. 3. Jean de Beaumetz, *Three studies for the Madonna and Child*, ca. 1395.
Basle, Öffentliche Kunstsammlung, Kupferstichkabinett, inv. U.XVI.I.

and St John. Thus it possesses a eucharistic value that its round form enhances by recalling the Host. Its figure types with thin noses and its modelling with deep shadows are carried further in the *Virgin and Child with Butterflies*, painted on canvas at the time of Jean Sans Peur, ca. 1410–15 (on loan to the Gemäldegalerie, Berlin). In this canvas, probably created independently, the Virgin, depicted half-length and attended by her angelic court to underscore the spiritual nature, appears both as mystical spouse and compassionate mother of Christ naked under His red coat who is aware of His future Passion and Resurrection emblematically represented by the butterflies.

pl. 11

In the three works attributed to him, Jean Malouel displays considerable sensibility in responding to the iconographic requirements of his patrons. His enamelled palette and plasticity borrowed from goldwork closely relate him to the art of his nephews, the Limbourg brothers. Upon his death in 1415 he was replaced by Henri Bellechose, born in Breda, who continued his predecessor's manner in his only known work: the altarpiece painted in 1416 for the Champmol Charterhouse and today in the Louvre. The large-format panel depicts the Trinity as the Throne of Grace (the Father holds the crucified Son) between St Denis' last communion given by Christ himself and the decapitation of the holy bishop with that of his companions Rusticus and Eleutherius. While retaining ties with Parisian production (the Master of the Small Pietà Roundel), Bellechose borrows a few elements from Jean Malouel, notably the

pl. 12

type of punching on the nimbi and the gold ground; the angular morphology of the faces especially those of the angels; the sharp outlines. But he goes even further in seeking monumentality by accentuating the shadows of the modelling (see the executioners' faces) and especially by painting on a large unified surface, a formula that would later be widely practised.

The English occupation and the "Mannerist" phase of International Gothic

Owing to events this triangular dynamic between Paris, Bourges and Dijon unfortunately broke up after a few years. On the one hand the sudden disappearance of artists like Malouel and the Limbourgs as well as sovereigns like Jean de Berry (1416), Jean Sans Peur (murdered in 1419 by the Armagnacs on the bridge of Montereau) and Charles VI (1422) left a huge vacuum. On the other hand, the Hundred Years' War continued with a new dramatic event: in 1415 the English won the victory of Agincourt and, in accordance with the Treaty of Troyes signed in 1420 by Queen Isabeau of Bavaria, occupied Paris from 1423 until 1436, while the Dauphin, the future Charles VII, sought shelter in Bourges.

Political events substantially altered the geography of the arts. By 1415–20 the collapse of Parisian production and its triangulation with Bourges and Dijon strengthened Avignon, which henceforth succumbed to the Franco-Netherlandish repertory. Among the most representative painters, Jacques Iverny (documented from 1410 to 1435) took up the Dijon innovations and combined them with his Mediterranean background. In the early 1420s, probably for a church in Avignon, he made an altarpiece (Turin, Galleria Sabauda) signed "Jacques Iverny" that depicts the Madonna and Child with two angels between St Stephen and St Lucy, as well as a dead Christ between St Peter and St Paul in the predella, according to a compartimented structure deriving from Tuscan models. Several years later he painted an *Annunciation with St Stephen presenting the patrons* (Dublin, National Gallery of Ireland) whose unified surface recalls the altarpiece by Henri Bellechose.

pl. 13

Avignon's composite culture was diffused over the same territory as in the preceding decades. It appeared especially in the duchy of Savoy and Dauphiné, where the Avignon painter Robin Favier worked. In 1426 he was in Saint-Antoine-en-Viennois where he illuminated two *Lives of St Antony*, one for the mother house of the order of the Antonites (Valletta, Public Library), the other for the abbey of Sant'Antonio at Ranverso (Florence, Biblioteca Laurenziana, Med. Pal. 143). He might also be the author of the wall paintings of the abbey of Saint-Antoine-en-Viennois and of those (unfortunately almost erased), on the lintel of the north portal of Saint-André in

Grenoble, where he is recorded at the same time. His style is characterised by the exacerbated use of the Franco-Netherlandish repertory apparent in the profusion of draperies. He tends to an excess, widespread during the English occupation, that can be called "mannerist" and be seen in particular in the murals, of lesser quality but in better condition, of Saint-Bonnet-le-Château in the county of Forez (joined to the Bourbonnais in 1372).

The wall paintings of Saint-Bonnet-le-Château, bearing the arms and mottoes of the Bourbon family, illustrate a cycle from the life of Christ on the walls and angel musicians on the vault. They have been attributed without decisive proof to an Avignon painter, identified with a certain Ludovicus Vobis (documented locally from 1416 to 1426). Without barring this possibility, we should point out their indebtedness to early fifteenth-century miniatures, in particular to an itinerant painter known as the Master of the Initials of Brussels, a Bolognese active in Paris ca. 1395–1400 who returned to Bologna before 1408 and was still recorded in 1416. What are we to think? Might the Saint-Bonnet-le-Château murals be owed to a later stage of the Master of the Initials of Brussels or to a pupil of the illuminator, trained in Paris, who had fled the English? Whatever may be the case, like the wings of the shrine of Saint-Jean-de-Maurienne, they do appear to belong to the "mannerist" phase of International Gothic that coincides with the scattering of the Parisian artists by 1415–20 and whose greatest divulger is the Rohan Master.

The Rohan Master, whose singular expressiveness can be compared to the anxiously nostalgic tone of the poet Charles d'Orléans (captured in Agincourt in 1415), owes his name to his masterpiece, the *Grandes Heures de Rohan* (Paris, Bibliothèque Nationale, MS Lat. 9471), that features entirely unusual compositions, deforming the repertory of the hypothetical Jacques Coene. Active in Troyes and then Angers between ca. 1415–35, he belongs to the circle of the author of the double-faced panel of Laon (Colart de Laon?) and fully expresses the exacerbated style diffused around Paris at the time.

pl. 14

In Paris, John of Lancaster, duke of Bedford, assumed the regency for his nephew Henry VI of England from 1422 to his death in 1435. He had to face the resistance of several French factions and in 1431 sentenced Joan of Arc whom the Burgundians had delivered into his hands. He had a court copied on the Burgundian one that included men of letters, goldsmiths like Jean Vasse (active in Rouen) and musicians like John Dunstable. He also practised artistic patronage, having monuments raised in Rouen (the manorhouse *Joyeux Repos*, and his tomb in the cathedral, now destroyed) and giving work to the few artists still in Paris, including the Master of the Duke of Bedford.

The Master of the Duke of Bedford, also trained in contact with the hypothetical Jacques Coene, illuminated at least three manuscripts for John of Lancaster: a *Book of Hours* (London, British Library, Add. 18850), a breviary (Paris, Bibliothèque Nationale, MS Lat. 17294) and a benedictory missal (lost). Active between ca. 1410–35, the Master of the Duke of Bedford ran a large and busy *atelier* that turned out manuscripts in large numbers for a highly varied clientele. His style, as we see in particular in the *Tower of Babel* from the London *Book of Hours*, is characterised by expressive figures and an accumulation of details arranged without spatial logic. Like the Rohan Master, he displays this "mannerism" that carries to extremes the repertory of International Gothic in order to resist, yet but for a short time, the new taste imposed by the duc de Bourgogne: the *Ars Nova*.

pl. 15

THE DIFFUSION OF THE ARS NOVA (1435–83)

Under the occupation the duc de Bourgogne, Philippe le Bon (Philip the Good, ruled 1419–67), successor of his father Jean Sans Peur and ally of the English as of 1420, took advantage of his rivals' weakness to become the most powerful man in Europe. He formed a brilliant court that he removed from Dijon to Brussels, thus making Flanders a leading cultural centre while Parisian production was declining. He replaced the courtly ideal of Charles V, enchanted by the dreamworld of the *Romance of the Rose*, by a more pragmatic conception of the present world, reflected in the abundance of *Chronicles* by Jean Wauquelin and Georges Chastellain. He surrounded himself with men of letters, goldsmiths (who retained their primacy among craftsmen), and particularly musicians like Gilles Binchois, who ontinued a musical revival—the *Ars Nova*. Erwin Panofsky successfully applied this formula to the pictorial revolution carried out in the 1420s by Robert Campin (in Tournai), Jan van Eyck (in Bruges) and Rogier van der Weyden (in Brussels) that broke with the precious aesthetics of International Gothic to establish a more immediate, more illusionist perception of the tangible world.

The *Ars Nova* spread rapidly over Europe in the 1430s concurrently with the prestige of the Burgundian court that imposed its tastes and values to all the other courts, as testified by the career of the musician Guillaume Dufay, recorded at the court of Savoy and Ferrara. It was essentially diffused through two channels. First, diplomatic connections in the important political-religious assemblies like the Council of Basle and matrimonial ties insured a swift circulation in princely circles and explain the precocious interest of the King Alfonso of Aragon who as early as 1431 sent his painter Lluis Dalmau to Bruges and by mid-century had become the greatest collector of Netherlandish painting. Then economic connections linking Bruges to

the main Mediterranean ports allowed tradesmen and financiers to imitate the princes' tastes and actually create an art market.

In 1435 the Treaty of Arras that sealed the close bonds between France and Burgundy launched the process to reconquer first Paris (1436), then the Loire (the Truce of Tours in 1444) and last Normandy (1453), officially putting an end to the Hundred Years' War. It allowed the introduction in France of the *Ars Nova* that spread gradually, with some slight resistance, during the reigns of Charles VII (d. 1461) and his son Louis XI (ruled 1461–83). They adopted the new courtly paradigm imposed by the duc de Bourgogne, as we gather from the presence of a musician like Jean Ockeghem in France. Invigorated by their victory they still claimed a sense of the French "nation" displayed in the vigorous revival of the literary themes of the era of Philippe le Beau (Philip the Fair), like the legends of the Trojan origins or the "garden of France". To underscore the revival of the court of France, they somewhat abandoned Paris to give more importance to the Loire (from Bourges to Tours) where they built new residences, in particular in Chinon and Langeais. So for this period the Loire Valley is where we should seek the identity of "French painting" that selectively assimilated the *Ars Nova* through economic channels via Paris and diplomatic channels that from Burgundy spread through Provence and Anjou under the "bon roi" René.

Economic channels

In the late Middle Ages the city of Tournai, an enclave of the French crown in Flanders, became very prosperous, establishing a privileged relationship with Paris that benefited from an economic recovery in the 1440s. Via the neighbouring cities of Artois and Picardy, these ties played an essential role in the trade of tapestries, and facilitated the circulation of the *Ars Nova*. Robert Campin, who perfected a robust, sculptural style contrasting with International Gothic's slighter, two-dimensional formulas, ran a flourishing workshop in Tournai, where between 1427 and 1432 painters like Rogier van der Weyden and Jacques Daret collaborated. In 1434 the latter executed a Marian altarpiece in the Notre-Dame church of Arras (now divided between Berlin, Paris, and Madrid), which, on the occasion of the treaty the following year, made a great impression on the assembled prelates, including Nicola Albergati. As court painter of the duc de Bourgogne, Daret was in Arras from 1446 to 1457, certainly playing a role in the spreading and steady assimilation of *Ars Nova* in the region.

In Picardy, a land made Burgundian by the Treaty of Arras, the sudden development of Amiens offered favourable terrain for painters, such as the illuminator known as the Master of the Collins Hours (after a Philadelphia manuscript), to whom some

pl. 16

scholars have tentatively attributed the Louvre *Ministry of the Virgin*. Painted in 1438 for Amiens Cathedral, the panel affords a most unusual iconography. Set within a Gothic-style church in front of an altar adorned with a carved altarpiece, the work depicts the Virgin dressed as a high-priest of the Old Law, passing on the relay, through the incarnation, to Christ, who is dressed as a pope and accompanied by two angels bearing his pontifical attributes, in the company of nine other angels and the work's donor, the merchant Jean du Bos. Steeped in the repertory of the presumed Jacques Coene (especially for the architectural setting), the work seems to struggle to apply the Tournai models, hardening the rhetorics of International Gothic. Yet it takes a step toward a deeper assimilation that would be gradually achieved in the 1440s, leading to different interpretations: sharp in the Master of 1451, so-named after the Metropolitan Museum of New York wings, and softer in Simon Marmion.

Hailed as "prince of illumination" by Jean Lemaire de Belges, Simon Marmion is recorded as being in Amiens in 1449, where he was trained by his father Jean. Under the pressure of harsh competition in Amiens in the mid-1450s, Simon moved to Valenciennes, where he resided until his death in 1489. Between 1455 and 1459 (that is, about ten years before winning his mastership in Tournai), working with a goldsmith, he painted a large altarpiece commissioned by Guillaume Fillastre for the abbey of Saint-Bertin in Saint-Omer (now divided between Berlin and London), which marks the point of departure for the reconstruction of the artist's oeuvre. In particular, we can attribute to him a *Mass of St Gregory* (Burgos Cathedral; Toronto, Art Gallery of Ontario), and a number of miniatures including the frontispiece of a volume of the works of Valerius Maximus (Winterthur, Fondation Reinhart). Marmion's style offers a more delicate interpretation of the Tournai models, showing the world through a velvety veil that softens the harsher contrasts, and belongs to a current that reached Paris.

When Paris was reconquered in 1436, several painters employed by John of Lancaster emigrated with the English to Rouen in Normandy. The pictorial production was then ruled by the Master of the Duke of Bedford's followers and especially his principal associate, called the Dunois Master. The latter, active until the 1460s, illuminated a *Book of Hours* (London, British Library, Yates Thompson, MS 3) for Jean de Dunois and was particularly prominent since he worked for the most important royal officials, in particular the treasurer Étienne Chevalier, Simon de Varie (an associate of Jacques Cœur) and the chancellor Guillaume Jouvenel des Ursins. Like the Master of the Collins Hours at Amiens, he belongs to a transitional style, superficially grafting motifs borrowed from the *Ars Nova* onto his stiff interpretation of International Gothic. In several miniatures and especially the representation of *Sloth* in the *Dunois Hours*, he punctually quoted the hazy landscape of the *Chancellor Rolin*

Virgin (Paris, Musée du Louvre) painted by Jan van Eyck toward 1434 and which he himself probably brought to the Treaty of Arras the following year. In a panel commissioned by the canons of Notre-Dame (Paris, École des Beaux-Arts), he depicted the Trinity after a model by Robert Campin. He might equally be the author of two other panels, unfortunately heavily overpainted: ca. 1435–40, a *Last Judgement* of the Musée des Arts Décoratifs in Paris; ca. 1445–49, the scarcely individualised portrait of the Jouvenel des Ursins family (Paris, Musée National du Moyen-Age; on loan from the Louvre). His nostalgic tone would thenceforth be pursued by the Master of Jean Rolin, and later still by Maître François in the serial production of manuscripts for a varied clientele.

pl. 17

On the other hand, the rapid spread of the Tournai innovations through Paris was fuelled by the arrival of André d'Ypres, a major painter who adjusted perfectly to the economic channels. Documented as active in Amiens between 1425/26 and 1444, André d'Ypres became free-master in Tournai in 1428, when Rogier van der Weyden was working in Robert Campin's *atelier*. Probably to get away from the saturated Amiens market, around 1445 he installed himself in Paris, a more open city that encouraged the presence of foreigners, who had been made exempt of taxes in 1443. However, he did not stay long, as he went to Rome for the 1450 jubilee, perhaps with Rogier van der Weyden, and died in Mons on the way back. However he had time to make several miniatures, in particular the handsome frontispiece of the *Livre de bonnes mœurs* by Jacques Legrand (Brussels, Bibliothèque Royale, MS 11063, fol. 3), cartoons for stained-glass windows for the nave of Saint-Séverin, and altarpieces such as the *Passion* triptych commissioned by Dreux Budé (divided between Los Angeles, Montpellier, and Bremen). Toward 1449 he also undertook the famous *Parlement Altarpiece*. This work, held in the Louvre, was meant to replace the old altarpiece painted by Colart de Laon in 1406. In front of a perfectly recognisable Parisian landscape, it depicts the Calvary between the saints Louis, John the Baptist, Denis, and Charlemagne. Its manner is entirely inspired by Rogier van der Weyden, characterised by the expressive rhythm of the figures that appear to be chiselled in front of a very deep space. It may have been completed in the early 1450s by André d'Ypres' son, Colin d'Amiens, who took over his father's workshop and entire repertory.

pl. 18

Active between 1450 and ca. 1495, Colin d'Amiens was celebrated by historiography as one of the most outstanding painters, especially by Jean Pèlerin Viator, who mentioned him between Andrea Mantegna and Perugino. In 1461 he participated in the works for the obsequies of Charles VII at Notre-Dame and Saint-Denis. Three years later he adorned banners for Louis XI, providing the model for his statue for the tomb of Notre-Dame de Cléry in 1481. In 1495 he executed a cartoon for a carved *Deposition*, still conserved in the Malesherbes chateau chapel, whose stylistic

Fig. 4. Colin d'Amiens, *Cartoon for the wall-hanging of the Trojan War* (10th section), ca. 1465. Paris, Musée du Louvre, Département des Arts Graphiques, inv. R.F. 2146.

components enable us to attribute to him a large group of works. As versatile as his father, he created cartoons for the stained-glass windows of the Brinon family in the choir of the Saint-Séverin church and for famous tapestries (*Trojan War* [fig. 4] and *Destruction of Jerusalem*). He illuminated countless manuscripts, in particular a Book of Hours for Olivier de Coëtivy and Marie de Valois, the natural daughter of Charles VII, and his mistress Agnès Sorel (Vienna, Österreichische National-bibliothek, Cod. 1929). His only extant altarpiece is the *Resurrection of Lazarus* in the Louvre. Cut into two parts in the late nineteenth century, it was recomposed only recently. Probably painted at the end of the 1450s for patrons unknown, it displays a more velvety manner than that of André d'Ypres, recalling the art of Simon Marmion—Colin d'Amiens' exact contemporary.

pl. 19

The *Ars Nova* also spread outside this economic sphere, reaching the territories of the French Crown through diplomatic channels, travelling from the court of Philippe le Bon in Brussels along unexpected paths from Provence to Anjou, due to the configuration of the land ruled by René d'Anjou.

Diplomatic channels

As soon as Philippe le Bon removed the capital of the duchy of Burgundy to Brussels, the pictorial production of the Dijon region declined. Of course it possessed the

great models of the *Ars Nova* imported by the court, as testified by such works as the Washington *Annunciation*, the left wing of a triptych painted toward 1430 by Jan van Eyck and sent by the duke to the Champmol Charterhouse; or the two masterpieces commissioned by chancellor Nicolas Rolin: the *Virgin and Child* by Jan van Eyck (ca. 1434) painted for the private chapel of Notre-Dame-du-Châtel in Autun; and not least the impressive *Last Judgement* by Rogier van der Weyden (dating to just before 1450), conserved in the Hôtel-Dieu in Beaune. However, the painters living in the area only assimilated these illustrious models superficially, offering a rather stiff interpretation of them similar to that of the Master of 1451 in Picardy, owing to certain reticence toward the new tastes, or to the local patronage's attachment to the old Burgundian capital's ostentation.

First we should mention the works, apparently created for the Champmol Charterhouse, which in the 1440s froze International Gothic in petrified forms and strident colours, as exemplified by the small *Calvary with the Carthusian Monk* (Dijon, Musée des Beaux-Arts), whose Virgin resembles an alabaster figure by Claus de Werve, or the large *Calvary with St George Martyr* (Dijon, Musée des Beaux-Arts; on loan from the Louvre) painted with a certain coarseness and that clearly derives from Bellechose's altarpiece. Then several works tended to assimilate the new canons, simplifying them while maintaining a bright palette. Such is the case of the *Presentation in the Temple* (Dijon, Musée des Beaux-Arts). Painted during the 1440s, the panel depicts a three-dimensional view of a Gothic church with the actors of the scene and the donors identified on fragile evidence with Hennequin de Frettin and Jeanne de Presles. Rightly compared to the murals of the Notre-Dame church in Dijon, it has been attributed to a painter of Artois, Jean de Maisoncelles, documented in Dijon from 1436 to 1479. His Tournai-manner, parallel to Jacques Daret's, is close to that of two portraits in Dijon, whose attribution is still uncertain.

pl. 20

The Dijon portraits probably formed a diptych, and show a man and a woman in prayer in front of statues of the Madonna and Child and a saint; the two figures were mistakenly identified with Hugues de Rabutin and his wife Jeanne de Montagu, on the sole basis of the work's provenance from the chateau of Epiry in Saint-Emiland (formerly Saint-Jean-de-Luze). The style of the costumes suggests a date of around 1470, or slightly earlier, and they clearly acknowledge a northern background close to that of the hypothetical Jean de Maisoncelles, but the sharp outlines seem more related to local taste, and therefore implies the involvement of another artist, perhaps this Guillaume Spicre who, though probably born in the diocese of Tournai, is documented from 1454 to 1477 as being in Dijon, where he replaced Thierry Esperlan de Delft as painter and glass-maker in the ducal retinue. His name does not appear in the Dijon 1474 tax register, though he may have simply left the city, and in fact,

pls. 22–23

a document of March 1473 (mentioning a "Magister Spicre") probably indicates that he was commissioned for the wings of the high altar of Lausanne Cathedral in the duchy of Savoy. This altarpiece, whose central panel was carved by the goldsmith Charles Humbelot, was seized by the Bernese in 1537 and later perished. However at the chateau of Saint-Maire in Lausanne some fragmentary murals have survived, commissioned toward 1476/7 by Bishop Benoît de Montferrand; these vividly contrast with the Savoy production and, despite their poor condition, offer an intriguing connection with the Dijon portraits, witness the same structure of the faces and the impassive eyes, whose corners are emphasised by a black line. On this evidence it is tempting to attribute the murals and the Dijon diptych to Guillaume Spicre.

Another argument is provided by the analogies with a complete set that has recently assigned to Guillaume's son, Pierre Spicre. The latter, who worked in his father's shadow until the mid-1470s, did not open an independent workshop until 1477, shortly before his own death. Yet he had his own career for a few years, since in 1474 he was given the patrons' important commission for the hangings of the Notre-Dame de Beaune collegiate church. Ordered by Cardinal Jean Rolin, these hangings would not be woven until 1500/01, but they certainly reflect their designer's style. They narrate the various episodes of the Virgin's life, in accordance with Campin's repertory. They provide evidence for attributing to Pierre Spicre the execution of wall paintings in the Saint-Cassien church of Savigny-les-Beaune, the illuminations of a *Rational des divins offices* (Beaune, Bibliothèque Municipale, MS 21), those of

pl. 21

a *Recueil de l'hôpital du Saint-Esprit de Dijon* (Dijon, Archives de l'hôpital général, A. H. 4) and a *Mass of St Gregory* conserved in the Louvre. This panel, which also comes from the Champmol Charterhouse, shows St Gregory inside a three-dimensional church, accompanied by two clerics and an angel bearing the pontifical tiara, raising the Host in front of the apparition of the dead Christ upheld by an angel. Conceived toward 1460 after a Tournai prototype though replacing the traditional profile with a frontal view, the panel is characterised by a more radical, more fully assimilated simplification of the volumes than in the Dijon portraits.

If we accept this dual assumption, the murals of Notre-Dame in Dijon (with the *Crucifixion*) and those of the Saint-Léger chapel in the Notre-Dame de Beaune collegiate church—often associated with the Spicres—must instead be assigned to other painters whose identity is yet to be ascertained. The first mural (a *Crucifixion*) has a northern tone, furthermore, with hints of Rogier van der Weyden, as in the fragments of the Saint-Vincent chapel in Autun Cathedral (commissioned by Jean Rolin ca. 1460–70) and the Lamoureux chapel in the cathedral of Châlon-sur-Saône (ca. 1471–75). The second mural, commissioned by Cardinal Jean Rolin just before the

hangings (ca. 1470), represent notably the *Stoning of St Stephen* and the *Raising of Lazarus*. Their complex background, with its sculptural character rooted in Sluter's tradition and its slightly Italianate setting, belongs to a trend initiated mid-century by the enigmatic illuminator of the *Débat du chrétien et du Sarrasin* (Paris, Bibliothèque Nationale, MS Fr. 948), commissioned toward 1447 by its author, Jean Germain, bishop of Châlon-sur-Saône (1436–61). Might it be the same painter, still under the influence of International Gothic, who would have developed in a little over twenty years? Without an intermediary link it is very difficult to reply.

Whereas the economic channels bore the Tournai style to Paris, the style fostered in Burgundy through diplomatic channels was far more composite, and betrays the influence of Jan van Eyck, in addition to that of Robert Campin and Rogier van der Weyden. Here the style became more luminous and simple, adjusting to the local clientele's taste. From Burgundy the new ideas quickly spread to Provence through the patronage of René d'Anjou (son of Louis II and Yolande of Aragon), who married successively Isabelle of Aragon (1420) and Jeanne de Laval (1453). He thus took possession of the duchies of Bar (1430), Lorraine (1431), and Anjou together with the county of Provence (1434). While officially a detainee of Philippe le Bon in the early 1430s, René was so charmed by the Burgundian court that he soon made it his model. In January 1433 he travelled to Flanders, where he probably met Jan van Eyck, and may have commissioned him for the outstanding *Annunciation* of the Museo Thyssen-Bornemisza in Madrid. In all probability on this occasion in the Bruges painter's *atelier* he enlisted the services of the one who would become his official painter, Barthélemy d'Eyck, recorded from 1447 to 1470, first as *valet de chambre*, then in 1457 with the supreme title of *valet tranchant*.

Barthélemy d'Eyck, whose artistic personality has only recently been reconstituted, was celebrated as one of the leading painters by historiography and especially by Jean Pèlerin Viator. Perhaps related to Jan van Eyck and born as he was in the diocese of Liège, he may have trained in Bruges in the early 1430s in Jan van Eyck's workshop along with painters such as Lluis Alimbrot (active later in Valencia) and a few of the illuminators working on the *Turin-Milan Hours*. If he was indeed recruited by René early in 1433, he probably accompanied him on his various travels, in particular in April 1434 to the Council of Basle where he had the opportunity to see the *Altarpiece of the Mirror of Human Salvation* that Konrad Witz was executing: the relationship between the two painters is so close they were dubbed "the twins". He thus acquired monumental canons derived from Robert Campin that he blended with his own apprenticeship with Jan van Eyck and that was expressed toward 1435 in the impressive *Holy Family* of Le Puy Cathedral. Painted on canvas, it was probably sent to Le Puy from Dijon where René was still a captive. It might derive from a lost

composition by Konrad Witz, of whom we have other less forceful echoes. It shows frontally St Joseph seated on a bench in front of a fireplace peeling an apple for the Child held by the Virgin who is glancing at a book presented by an angel. Its iconography, rehabilitating the figure of St Joseph, belongs to an early fifteenth-century theological trend from the Sorbonne (Jean Gerson, Pierre d'Ailly) and its presence in Le Puy might be explained by the convent of Clarisses founded in 1432 by the future St Colette who was particularly devoted to the saint.

Between 1438 and 1442 Barthélemy d'Eyck with his father-in-law the embroiderer Pierre du Billant probably belonged to the suite of René who, in order to validate his hereditary rights, settled in Naples until Alfonso of Aragon forced him to leave. There the artist executed the figures of the *Hommes illustres* in ink and water-colour in a manuscript intended to legitimate the Anjou dynasty, a *Universal Chronicle* (dubbed *Cockerell Chronicle*), of which the nine known sheets are dispersed today (in particular in Amsterdam and New York), and which derives from an Italian tradition present in the wall paintings that Masolino painted in 1432 in the Orsini Palace in Rome (destroyed). Upon his return from Naples, Barthélemy d'Eyck travelled back and forth between Anjou and Provence. In the residences of Angers and Tarascon he had a room inside René's private apartments, expressly furnished so that he could continue with his illumination works. Here he illustrated a number of manuscripts, including the *René Book of Hours*, ca. 1442–43 (London, British Library, Egerton
pl. 25 1070), Boccaccio's *Teseida*, ca. 1460 (Vienna, Österreichische Nationalbibliothek, Cod. 2617) and above all the *Cœur d'amour épris*, ca. 1460 (Vienna, Österreichische Nationalbibliothek, Cod. 2597) on an allegorical poem composed by René himself. Toward 1443/45, in the Saint-Sauveur cathedral in Aix-en-Provence, where the court resided more and more frequently, Barthélemy d'Eyck painted a triptych that was a kind of manifesto of the *Ars Nova* in Provence, where production at the time was represented by painters of the generation of the Dunois Master, that is, the "petrified" phase of International Gothic, such as the author of the Rolin family *Calvary* (Aix-en-Provence, Musée Arbaud).

The triptych by Barthélemy d'Eyck, painted for the chapel of the draper Pierre Corpici, depicts the *Annunciation* in the central panel (today kept in the Madeleine church). In an aisle of a church the archangel Gabriel appears to the Virgin kneeling in front of a lectern and a vase of flowers, who receives the Word (in the form of the infant Jesus bearing His Cross) from the Father's mouth, in the company of two angels in the upper left corner. The wing-panels (divided between Brussels and Rotterdam) display *Noli me tangere* on the outside and inside the prophets Isaiah
pl. 24 and Jeremiah presented in niches like living sculptures and whose poses seem to parody Jan van Eyck's *Annunciation* owned by René d'Anjou, perhaps portrayed as

Jeremiah. In any case the triptych's marked plasticity testifies to the author's composite background, with a debt to Jan van Eyck for the accurate definition of textures, notably in the flesh tints or the objects placed above the prophets, and to Campin (or Witz) for the sculptural monumentality of the overall setting. The altarpiece was soon to influence local painters.

The Saint-Mitre chapel in Saint-Sauveur Cathedral still preserves stained-glass windows executed at the request of Archbishop Nicolaï by the painter Guillaume Dombet, born at Cuisery in Burgundy and recorded in Aix-en-Provence from 1414 to 1458. The windows feature the saints Blaise, Mitre, and Nicholas in Gothic-style niches. They have been rightly compared to the *Tarascon Pietà* (Paris, Musée National du Moyen-Age), probably painted in the 1450s in Guillaume Dombet's workshop, which apparently belonged to René d'Anjou's collections in the chateau of Tarascon. On a gold ground with plant motifs it shows the dead Christ in His mother's arms, accompanied by St John delicately removing the crown of thorns, by St Mary Magdalene cleansing the wounds, and by the two other holy women. Frozen in the "petrified" phase of International Gothic it nonetheless betrays some familiarity with the canons of the *Ars Nova*, especially those of Robert Campin in the broken, crumpled folds of the mantles. We can also make out a contact with Barthélemy d'Eyck, whose lesson is profoundly assimilated almost at the same time by the author of the *Boulbon Altarpiece*.

The *Boulbon Altarpiece* (Paris, Louvre) probably comes from the church of Saint-Agricol in Avignon. Its iconography is unusual: Christ appears standing in a sarcophagus inside a chamber, with a townscape visible through an open door. On His right stands St Agricol presenting the donor; on His left is the face of the Father who, glimpsed through a window, is linked to the Son by the Dove of the Holy Ghost, forming an image of the Trinity. The instruments of the Passion are arrayed on Christ's left. Although the panel's poor state of conservation hinders stylistic analysis, the quality of the craftsmanship is evident. Monumental in layout, the handling is markedly indebted to Barthélemy d'Eyck. However the simplified volumes and pure light also suggest the influence of another painter active at the time, Enguerrand Quarton (or Charonton).

pl. 26

Born at Laon in Picardy, Quarton is attested in Aix-en-Provence by 1444 in the company of Barthélemy d'Eyck, with whom he illuminated almost at the same time a *Book of Hours* (New York, Pierpont Morgan Library, MS 358). He is documented until 1466 in Arles and Avignon, where he ran a workshop and executed murals in the Rolin chapel of the church of the Celestines (today known by a nineteenth-century survey). Just before 1450 he added a miniature to the *Boucicaut Hours* (Paris, Musée

Jacquemart-André, MS 2, fol. 241) and executed the *Requin Altarpiece* (Avignon, Musée du Petit-Palais) depicting the Virgin between the donors presented by St James and a bishop saint (Siffrein?) in front of a green brocade ground. In 1452 in collaboration with Pierre Villate he painted the *Virgin of Mercy* (Chantilly, Musée Condé) commissioned by Jean Cadard for the Saint-Pierre de Luxembourg chapel in the convent of the Celestines in Avignon. The following year he was commissioned for the famous *Coronation of the Virgin* (Villeneuve-les-Avignon, Musée de l'Hospice). The contract drawn up with Jean de Montagnac (canon of Saint-Agricol, and chaplain of the Villeneuve charterhouse) contains a number of details concerning the iconography: the Virgin crowned by the Holy Trinity, the Carthusian monks' favourite theme. For the same building several years later he created one of the masterworks of fifteenth-century painting: the *Pietà* of Villeneuve-lès-Avignon (Paris,

pl. 27

Musée du Louvre). The panel, which unfortunately suffered great damage, depicts the dead Christ in His mother's arms between St Mary Magdalene and St John, who is delicately removing the crown of thorns (a gesture accurately repeated in the *Tarascon Pietà*), in front of a schematised landscape in the presence of the donor at prayer. Its austere layout directly anticipates works of lesser quality that might date to the 1460s,

pl. 28

in a phase concurrent to that of the Jean des Martins prayer-book, illuminated toward 1466 (Paris, Bibliothèque Nationale, N. a. Lat. 2661), like the Trinity triptych in the Saint-Siffrein cathedral of Carpentras or the diptych of the *Virgin and St John the Baptist* (divided between Altenburg and the Vatican).

Enguerrand Quarton's style, blending Netherlandish analytical description with Italian synthetic volumetry (especially that of Fra Angelico and Piero della Francesca), is characterised by simplified volumes standing out distinctly in a clear warm light, and by austere spaces producing an impression of silence and bareness. It directly influenced Pierre Villate, born in the diocese of Limoges and documented as a painter and illuminator in Avignon between 1451 and 1495. As we have seen, in 1452 he was associated with Quarton, with whom he appears to have collaborated in particular in a *Book of Hours* conserved in Namur (Grand Séminaire, MS 83). He might indeed be the author of a small set of miniatures like the *Virgin and Child* in a Book of Hours conserved in New York (Pierpont Morgan Library, MS 1107, fol. 145) that allows us to

pl. 29

attribute to him a panel of the Musée Grobet-Labadié in Marseille as well. This panel, with its unusual horizontal format, appears to be the predella of an altarpiece whose other panels are lost. In two separate areas it depicts on the one hand the kneeling donors dressed in the fashion of the 1460s and on the other St Bernardino of Siena to whom an angel appears holding Christ's monogram. It shares a number of points with the illuminations: more or less three-dimensional rooms offering glimpses of summary landscapes; slightly coarse figure types; a simplified, abrupt interpretation of Enguerrand Quarton's models.

Enguerrand Quarton's composite background, featuring an original, strict conception of light, belongs to a mid-fifteenth-century Mediterranean manner that has an exceptional unity and can be found in several painters: in particular in Valencia with the Master of Bonastre (Jacomart?); in Barcelona with Jaume Huguet; in Genoa with Donato de Bardi; in Naples with Colantonio; in Messina with Antonello, who may well have been in Provence around 1460 or slightly earlier. We find it as well in Languedoc, a royal land, as attested by the *Crucifixion of the Parlement of Toulouse* (today in the Musée des Augustins). The panel, unfortunately in very poor condition, shows Christ on the Cross between the Virgin and St John accompanied by King Charles VII and the Dauphin at prayer in front of a landscape thronged with soldiers. Painted toward 1460, its angular forms with sharp outlines evince obvious connections with Catalan circles. The ties between Languedoc and Catalonia are perfectly illustrated by Antoine de Lonhy. His recently rediscovered artistic personality appears typical of the versatile travelling painter. Probably born in the region of Châlon-sur-Saône he trained in Burgundy in a circle that was still under the influence of International Gothic yet inspired by the great models of the *Ars Nova*. In 1446 he entered the service of Nicolas Rolin for whom he made cartoons for stained-glass windows executed at the chateau of Authumes by a certain Euvrard Rubert (lost). In 1449 he illuminated a *Mappemonde spirituelle* (Lyon, Bibliothèque Municipale, P.A. 32) whose frontispiece shows the author, bishop Jean Germain, offering his work to the duc de Bourgogne. He may have been recommended soon after by the bishop of Châlon-sur-Saone to the bishop of Toulouse, Bernard de Rosier, appointed in 1452.

In any event presumably Antoine de Lonhy was active in Toulouse in the early 1450s and belonged to a larger emigration of Burgundian painters toward a more open market in southern France. Toward 1455–60 he illuminated a *Recueil de sermons de Saint Vincent Ferrier* (Toulouse, Bibliothèque Municipale, MS 345) and in 1460 the *Semita recta ad montem salutis*, a text which the humanist Lorenzo Traversagni dedicated to the archbishop (Paris, Bibliothèque Nationale, MS Lat. 3231). He also illuminated a missal, of which survive a *Crucifixion* (Prague, Narodni Galerie) and a *Majestas Domini* (Los Angeles, Getty Museum) steeped in Catalan culture. Indeed during his stay in Languedoc he kept up constant ties with Barcelona where he is recorded from 1460 to 1462 in connection with the embroiderer Antonio Sadurni and where he left two very fine works: the altarpiece of the Augustines of Domus Dei at Miralles (split between Barcelona and Peralada); the rose window of Santa Maria del Mar with its gorgeous *Coronation of the Virgin by the Trinity*. His essentially Burgundian style reveals close ties with Jaume Huguet's manner. In a Barcelona document of 1462 the painter is quoted as resident of Avigliana in the diocese of Turin. Perhaps summoned by Guillaume d'Estouteville (bishop of Saint-Jean-de-

pl. 30

Maurienne), Lonhy then moved to the duchy of Savoy where he worked until ca. 1480, episodically for the duchess Yolande de France (notably in 1477).

Shortly after Antoine de Lonhy's departure, another northern painter settled in Languedoc, Nicolas Froment, who probably received his training in Picardy, where in 1461 he executed the triptych of the *Raising of Lazarus* (Florence, Uffizi) that the pontifical legate Francesco Coppini offered Cosimo I de' Medici. There Froment also painted a *Transfiguration* for which there is a preparatory drawing (Berlin, Kupferstichkabinett) featuring an expressive graphism and caricatural types [fig. 5]. In his search for commissions, he joined the many Picardy painters migrating toward Burgundy and the south of France. He thus settled at Uzès in Languedoc in or right before 1465, then in Avignon where he worked from 1468 until his death in 1482–83. He soon entered the service of René d'Anjou, painting his portrait in the Matheron diptych, and for whom he executed the splendid *Moses and the Burning Bush*. The

pl. 31

triptych, painted toward 1475–76 for the Grands-Carmes church in Aix-en-Provence and held today in Saint-Sauveur Cathedral, depicts on the outside a grisaille *Annunciation* in marble niches paraphrasing René's diptych by Jan van Eyck. On the inside it shows the kneeling donors accompanied by their patron saints in front of a symbolic representation of Mary's virginity: inside a border adorned with prophets and a unicorn hunt, the Virgin appears to Moses in a bush that burns without being consumed and presents the Child holding the spotless mirror (the *speculum sine macula*), one of the Marian emblems.

Between the Florence triptych and the Aix-en-Provence one, Nicolas Froment's style gained in softness yet on the whole it was scarcely receptive to the Mediterranean manner. It retained its Picard roots: dynamic layout, sharp drawing, smooth modelling as in goldwork. It reappears, despite the overpainting in the foreground, in the *Martyrdom of St Mitre* (Aix-en-Provence, Saint-Sauveur Cathedral) that, with its Renaissance architectures, apparently derives from the *Christ bearing the Cross* carved by Francesco Laurana at the Celestines of Avignon (1478). It also influenced the painters who certainly attended Froment's workshop, such as the artist of the *Pérussis Altarpiece* (ca. 1480; New York, The Metropolitan Museum of Art).

By his artistic choices, René d'Anjou expressed great interest in northern painting and contributed to diffuse it through the Mediterranean area. But he was equally interested in the innovations from Padua that he was acquainted with through several manuscripts donated by the Venetian Jacopo Antonio Marcello to him or to his close circle: in particular a *Strabo* (Albi, Bibliothèque Rochegude, MS 4), dated 1459, that contains two miniatures by the young Giovanni Bellini, and a *Passion of St Maurice*

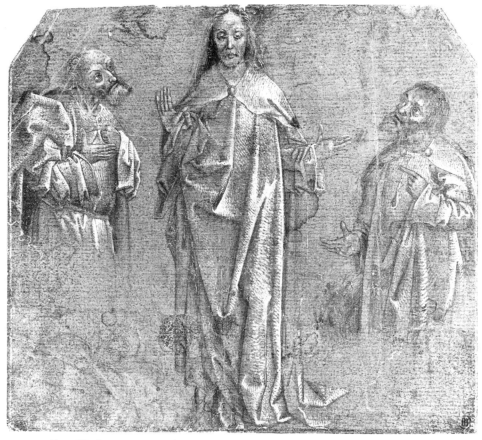

Fig. 5. Nicolas Froment, *Transfiguration*, ca. 1462–64. Berlin, Kupferstichkabinett, inv. KdZ 1974.

(Paris, Bibliothèque de l'Arsenal, MS 940) offered to Jean Cossa that contains four miniatures usually attributed to Andrea Mantegna. Owing to the configuration of his territories and the mobility of the court, René d'Anjou imported this new taste to western France and more precisely to Anjou, giving a vital boost to the painting produced in the royal domain.

Selective assimilation in the royal domain

After his exile in Bourges, King Charles VII gradually drove the English from the royal domain that was centred in the Loire Valley after the Truce of Tours in 1444. Wishing to symbolically underscore the revival of the "French nation" and political ties with the powerful duchy of Burgundy, he was certainly receptive to the *Ars Nova* circulating through Parisian as well as Angevin channels and assimilated selectively in

order to create its own identity. His wife Marie d'Anjou, René's sister, undoubtedly played a crucial role, as attested by the execution in 1444 of embroideries by Pierre du Billant (Lyon, Musée Historique des Tissus; Paris, Musée National du Moyen-Age), commissioned by René himself for the church of St Martin at Tours and conceived after cartoons by Barthélemy d'Eyck.

In 1445 Charles VII's official painter was a certain Conrad de Vulcop (documented until 1459) whose brother Henri worked for Marie d'Anjou. Born in the diocese of Utrecht, was he already part of the new wave of the *Ars Nova*, as is usually assumed, or did he still belong to the preceding generation? If we consider the second assumption, it is tempting to identify him with the Dunois Master, that is, the painter who worked for the highest court officials during the 1440s and whose style, still bound to traditional rhetorics yet open to the new canons, can be compared to the manner of the Master of Catherine of Cleves, a painter from Utrecht. If we accept this tentative hypothesis, it is worthwhile mentioning the artistic proximity of the Dunois Master with the principal illuminator of the *Mare historiarum* (Paris, Bibliothèque Nationale, MS Lat. 4915), who worked for the same patron: Guillaume des Ursins, chancellor of France from 1447 to 1472. Active in Angers toward the mid-fifteenth century, the Jouvenel Master might then coincide with Conrad's younger brother, Henri de Vulcop, recorded in Paris in 1451, and at Chinon in the service of Marie d'Anjou in 1454–55.

Such an assumption remains quite fragile while awaiting new elements to confirm it. Nonetheless it offers the advantage of highlighting the importance of the Angevin milieu in formulating the new taste adopted by the court of France and defined by its clarity of composition. In the key manuscript of the *Mare Historiarum*, there was a younger artist with the same background working alongside the Jouvenel Master. Known as the Master of the Geneva Boccaccio, he worked ca. 1450–1475 mainly at Angers in René's employ. He gradually assimilated Barthélemy d'Eyck's models and those of the Paduan manuscripts of the Angevin library, as we can see in a *Book of Hours* of the Bibliothèque Nationale in Paris. So might he then coincide with the mysterious Coppin Delf? The latter, celebrated subsequently by Jean Pèlerin Viator as one of the most outstanding painters, appears to come from the northern Low Countries (Delft?), which would facilitate an eventual collaboration with his compatriot Henri de Vulcop. He is documented from 1456 to 1488, mostly at René's court, then at that of the kings of France.

pl. 32

Another painter gravitating in Angevin circles is difficult to situate. Active in the 1440s, the Master of Bartholomaeus Anglicus is named after a singular manuscript of the *Livre des propriétés des choses* (Paris, Bibliothèque Nationale, MS Fr. 135),

pl. 34

an encyclopaedia of all the world sciences written in the thirteenth century by the Franciscan Bartholomaeus Anglicus and translated in French by Jean Corbichon under Charles V. He also seems to have designed cartoons for stained-glass windows figuring the dukes of Anjou in Le Mans Cathedral where we recognise the same sharp geometrised volumes. We also find this manner in Le Mans on a more modest scale in four panels of an altarpiece painted for the Benedictine abbey of Vivoin. These wings show the *Virgin and Child with St Benedict*, the *Martyrdom of St Hippolytus*, the *Adoration of the Magi* and the *Lamentation* (Le Mans, Musée de l'Hôtel de Tessé). They feature a volumetric simplification recalling illuminators such as the Master of Adelaide of Savoy who trained in Angevin circles then settled in Poitiers and worked until the 1470s. In this connection we should recall the parallel career of the painter Jean Gillemer, active in Poitiers and arrested for spying in 1471 in Le Mans.

The geometric style of the Master of Bartholomaeus Anglicus was pursued with more subtlety in the works attributed to Jacob de Litemont. He is recorded in 1451 as the official painter of Charles VII who certainly considered him more innovative than Conrad de Vulcop. He would be active at the court of France until 1474. A short while before entering the service of the court he presumably created two ensembles commissioned at Bourges by Jacques Cœur, the king's treasurer from 1447 until his arrest in 1451. The first, the mural (unfortunately heavily overpainted) in the mansion, showing angels, features drastic foreshortening reminiscent of the Master of Bartholomaeus Anglicus. The second, the large stained-glass window in the private chapel of the cathedral, depicts the *Annunciation between St James and St Catherine* inside a three-dimensional architecture. Its monumental layout and sculptural draperies admit contact with Jan van Eyck's models proving its creator's northern background. With its synthetic volumes it might also, but more superficially, reflect the Italianate taste of Jacques Cœur, who owned in particular an *Annunciation* by a painter from the Marches, probably the Master of the Barberini Panels (Munich, Staatsgemäldesammlungen).

pl. 35

After Jacques Cœur's arrest, that form of patronage was pursued in Bourges by Charles of France, Louis XI's younger brother, who until his death in 1472 maintained a court for the most part composed of his mother Marie d'Anjou's retinue, including a certain Jean de Laval, documented between 1463 and 1468. This artist might be one and the same as Jean Gillemer, who during his trial admitted travelling to Paris, Brussels, and even Milan. At any event, the obscure artist is identified with a highly complex figure known as the Master of Charles of France, who was perhaps trained in Paris or in Picardy in circles close to the painter of the Washington *Virgin enceinte*, but who elegantly combined the canons of the *Ars Nova* with several Italian motifs. He might thus be responsible for the delightful New York

pl. 33

Annunciation, dated to 1465, from the *Hours of Charles of France* (Paris, Bibliothèque Mazarine, MS 473).

In the court of Bourges there was also Henri de Vulcop. Documented in 1463–64 in the service of Charles of France, then in 1472 as an independent artist, he died in Bourges before 1479. Given these dates, he may have been responsible for the recently rediscovered Breuil chapel murals in the cathedral, which probably date to the early 1470s. On one side they represent a *Crucifixion* in an extensive landscape, on the other pl. 37 a *Noli me tangere* attended by the canons Jean and Martin du Breuil at prayer in the foreground in front of a curtain. Unfortunately, their poor condition makes any stylistic judgement problematic. Yet one notices a certain "northern" plasticity in the massing of volumes, an Italianate organisation of the setting indebted to Piero della Francesca, and the clarity of their layout that definitely belongs to the aesthetics produced in the Loire Valley. From that point of view, the setting sums up the experiments undertaken since the 1440s. So might it reflect the evolution (enriched by contributions by fellow artists, perhaps Jacob de Litemont, among others) of a painter like the Jouvenel Master, of whom we recognise several compositional models and figure types and the ivory-white faces? In any event, it comes from a background identical to that of Jean Fouquet, the most emblematic painter of the period.

Born in Tours toward 1420, Jean Fouquet was probably trained in Angevin circles caught in the "petrified" phase of International Gothic, though already aware of Netherlandish innovations. He must have been acquainted with the Jouvenel Master (Henri de Vulcop?), with whom for a long time he was mistakenly identified, and who may have recommended him to King Charles VII. As a matter of fact, shortly after the Truce of Tours in 1444 he was sent on a diplomatic mission to Rome, probably to carry a portrait of the *très victorieux* king of France to the Holy See, and to paint one of Pope Eugenius IV (since lost, but known through copies). He apparently enjoyed a great reputation as a portraitist and as a painter able to faithfully reproduce the tangible world, like the Netherlandish painters, with whom he is equated. So he may have painted the portrait of Gonella, the Ferrara court fool, which still features the sharp graphism of the Dunois Master's generation but is already receptive to Jan van Eyck's models (Vienna, Kunsthistorisches Museum). In Italy Fouquet met Filarete and Fra Angelico, whose deep influence on him is noticeable as soon as he returned to France, just before 1450, in a *Book of Hours* pl. 36 illuminated in collaboration with the Jouvenel Master, that is, the presumed Henri de Vulcop (Paris, Bibliothèque Nationale, N. a. Lat. 3211).

According to a recent hypothesis, on his return Jean Fouquet might also have collaborated on Jacques Cœur's stained-glass window at Bourges, thus contributing

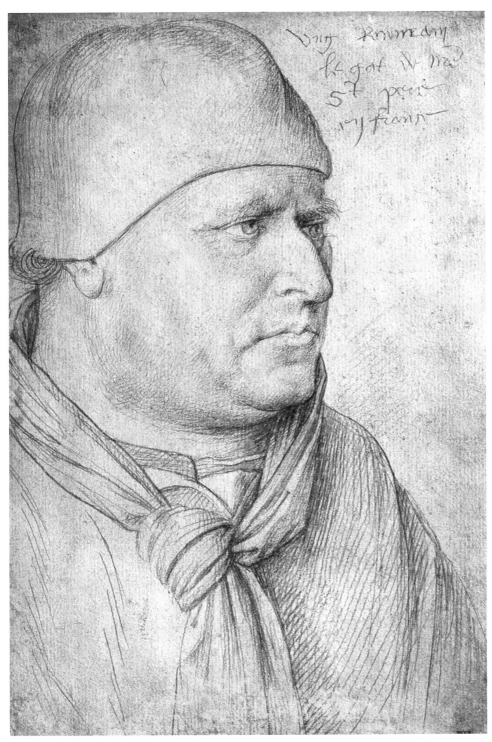

Fig. 6. Jean Fouquet, *Portrait of a legate*, ca. 1450–60. New York, The Metropolitan Museum of Art, inv. 49.38.

to develop the Italianate taste in royal circles. Though without a title (held by his elder Jacob de Litemont as of 1451), he was highly appreciated in the court and Charles VII, whose portrait he painted (originally from Sainte-Chapelle in Bourges, now in the Louvre). He depicted the king wearing a blue hat, his hands joined on a cushion, framed by curtains after a model borrowed from Fra Angelico. His incisive graphism featuring a black line and reflecting the painter's apprenticeship in the circle of the presumed Henri de Vulcop, indicates volumes by delicate heightening that produces a satiny texture.

pls. 38–39 The diptych commissioned by Étienne Chevalier, who succeeded Jacques Cœur as the king's treasurer, belongs to almost the same period. It features on the left the kneeling donor presented by St Stephen in a Renaissance architecture enhanced by Italian marbles (Berlin, Gemäldegalerie), and on the right the Virgin and Child surrounded by angels recalling Luca della Robbia's enamelled terracottas. Made for the church of Notre-Dame in Melun, the diptych originally had a frame containing two enamelled copper medallions: a scene from the *Life of St Stephen* (formerly in Berlin) and the painter's famous self-portrait (Paris, Musée du Louvre). For the same patron, toward 1455 Jean Fouquet illuminated a splendid *Book of Hours* (divided between the Musée Condé in Chantilly and other collections), in which he displayed his science of scenography, associating the principal scenes with anecdotal episodes in appropriate settings. So he offered a parallel to the *Passion Mystery* written by Arnoul Gréban and performed in Paris in the mid-fifteenth century, which belonged to a similar aspiration to cultural identity.

Settled at Tours, Jean Fouquet displayed great versatility in serving his city and the royal court. In 1461 he participated in the preparations for Charles VII's obsequies, and in the celebrations for his successor Louis XI's entry to Tours. Fouquet illuminated several manuscripts notably a *Book of Hours* (ca. 1455) for Simon de Varie, an officer of Charles VII (Los Angeles, Getty Museum, MS 7; The Hague, Koninklijke Bibliotheek, MS 74 G 37–37a), and toward 1469/70 the *Statuts de l'Ordre de Saint-Michel* (Paris, Bibliothèque Nationale, MS Fr. 19819). He provided cartoons for stained-glass windows, as evidenced ca. 1460 by the roundel of Laurens Girard, the king's secretary and notary (Paris, Musée National du Moyen-Age). But Fouquet was mostly in demand for his skills in portraiture. Among his first works is a likeness of a pontifical legate, which is known by an excellent drawing of the 1450s in New York (The Metropolitan Museum of Art, 49.38 [fig. 6]); that of the Chancellor Guillaume

pl. 40 Jouvenel des Ursins (Paris, Musée du Louvre) painted in the early 1460s and whose preparatory chalk drawing [fig. 7] is conserved in the Kupferstichkabinett (KdZ 4367) in Berlin; and last that of a man wearing a hat (Saint Petersburg, Hermitage, inv. 3895), who has been tentatively identified as Louis XI [fig. 8]. Fouquet is also known for his

altarpieces, notably an *Assumption* commissioned toward 1465 by the archbishop of Tours, Jean Bernard, for the church of Candes. Only one altarpiece has survived, however: discovered in 1931 in the little church of Nouans-les-Fontaines, it depicts the dead Christ in a confined setting mourned by ten figures at the foot of the Cross, in the company of an unidentified canon and St James. Painted toward 1460, probably for a church in Tours, the *Pietà's* brilliant scenography qualifies it as a masterpiece of the period.

Despite the widespread recognition of his skills and his immense success at court, Jean Fouquet had to wait until Jacob de Litemont's death to become Louis XI's official painter in 1475, but he himself died a short while after, toward 1478, leaving two sons, François and Louis, who do not appear to have long survived him. One of them might be an illuminator that was recently identified by isolating several works previously attributed to Fouquet. The Master of the Munich Boccaccio draws his name from a magnificent manuscript copied in 1458 for Laurens Girard, containing the French translation of a text by Boccaccio: *Des cas des nobles hommes et femmes* (Munich, Bayerische Staatsbibliothek, Cod. Gall. 6). Active from ca. 1460–80, this artist was particularly busy. Toward 1470 he illuminated the *Antiquités*

Fig. 7. Jean Fouquet, *Portrait of Guillaume Jouvenel des Ursins*, ca. 1460–65. Berlin, Kupferstichkabinett, KdZ 4367.

pl. 41

Judaïques (Paris, Bibliothèque Nationale, MS Fr. 247) whose ex libris, dated 1488, attributes nine sheets (from the point of view of invention rather than execution) to "la main du bon peintre et enlumineur du Roy Loys XIe, Jehan Fouquet natif de Tours" (the hand of the fine painter and illuminator of the King Louis XI, Jehan Fouquet born in Tours). Its manner interprets the workshop's usual scenographic schemes in a hazier light, a shift that was undoubtedly influenced by a great contemporary active in Paris, namely, Colin d'Amiens.

The artistic background of the Loire Valley, of which Fouquet's workshop was the most accomplished expression, developed in terms of a selective assimilation

Fig. 8. Jean Fouquet, *Portrait of a man with a hat*
(Louis XI?), ca. 1470. Saint Petersburg,
The Hermitage Museum, Drawing Gallery, inv. 3895.

blending contributions from the north with those from the south. Like poets such as François Villon, the valley's artists forged the new cultural identity of the "French nation", which was spreading not just through innovation, but also through a fondness for vernacular and localised, "dialect" forms of International Gothic, that tempered its rhetoric and strove toward an ideal of simplicity, aiming for greater expressive efficiency and scenographic clarity. In Paris the new manner was received and diffused in the serial, lower-quality production of illuminators such as Maître François. Surprisingly, however, it did not spread to the territories that Louis XI would annex to the royal domain upon the death in 1477 of Charles le Téméraire (Charles the Bold), and of René d'Anjou in 1480, namely, Picardy, Burgundy and Provence. Instead, at the time of Charles VIII and Louis XII (1483–1515), the regional forms of artistic expression adhered to the mainstream established during the previous generation, though occasionally wavering between attachment to established tradition and attraction for innovations, Netherlandish as well as Italian.

BETWEEN REGIONAL TRADITIONS AND REVIVAL (1483–1515)

At the death of Louis XI, his successor Charles VIII was only thirteen years old, and so, until the boy came of age, the regency of the vast territory he inherited was assumed by his older sister Anne of France, wife of Pierre II de Bourbon. In 1491 Charles married Anne of Brittany, ending a long conflict with the duchy of Brittany. After yielding Artois and Franche-Comté to the Habsburgs by the Treaty of Senlis (1493), he enforced his claims to the kingdom of Naples, which he had seized in a lightning campaign (1494–95). Among the twenty-two craftsmen that he brought back from Italy were the engineer Fra Giovanni Giocondo, and the sculptor Guido Mazzoni, whom he set to work on the royal residences, starting with the chateau of Amboise. Charles VIII met his death in 1498 in an banal accident (hitting his head on a door lintel), and left no heir. He was succeeded by Louis XII of the Orléans branch

who married his cousin's widow. The grandson of Valentine Visconti, he pursued the campaigns in Italy as of 1499, in particular with the annexation of the Milanese (1499–1512). He continued to embellish the Loire castles, again utilising the team of Italian craftsmen at his grandfather's residence in Blois, which he enhanced with a main building and a magnificent garden.

Firmly ensconced in the Loire Valley, the French court preserved its identity while evolving at the same pace as its European counterparts. After Charles le Téméraire's death, the court gradually set aside the Burgundian frame of reference to adopt a more sophisticated rhetoric based on the Habsburg model. The change was linked to a particular event that occurred toward 1500, namely, the invention of the "court intellectual", who appeased the princes' fondness for witticisms, puns, and other intellectual divertissements. So it engendered a coterie of men of letters, such as the great rhetoricians (Jean Molinet, Jean Meschinot, Pierre Gringore, Jean Marot, Jean Lemaire de Belges), who in turn were the instruments of royal propaganda and the mirror of court pomp, cultivating a set of court manners and affectations. The penchant for rhetorical excess was shared by the painters, who grew aware of the previous generation's achievements. This led to a dynamic between a fondness for renovated regional idiosyncrasies, and an attraction for new outside trends arriving from Italy and Flanders, where the *Ars Nova* in turn became international by its very standardisation, generating new experiments (in particular with Hugo van der Goes). These trends continued to circulate in the Loire Valley, where they were assimilated more and more selectively owing to the henceforth consolidated tradition. They travelled along the same cultural arteries created in the previous generation, arteries whose steady flow was guaranteed by the two main cultural hubs of Paris and Lyon.

The Lyon crossroads

The city of Lyon, where religious iconoclasm had considerably reduced artistic production (though we should mention the presence in the mid-fifteenth century of such illuminators as the Master of the Vienna Romance of the Rose, who in our opinion can plausibly be identified with the Jehan Hortart, known as Jean d'Écosse, author in 1463 of a *Livre du Roi Modus* conserved in New York), now began to make a sharp economic recovery under Louis XI, who in 1463 showed a preference for Lyon's market over the declining Geneva one. It became a printing centre in the 1470s and a cosmopolitan cross-roads where the economic and diplomatic channels converged. It was visited by tradesmen, leading banking institutions and the court, for which it was the ideal outpost at the time of the expeditions to Italy. Furthermore,

the Bourbon family, with its ducal government based in Moulins, was solidly entrenched in Lyon.

Charles de Bourbon (1434–88) became archbishop of Lyon in 1444. In the cathedral he undertook to build the family chapel which, completed at the end of the fifteenth century, became an emblem for the flourishing new virtuoso architecture of "Flamboyant Gothic". Like all the prelates wishing to display their magnificence, he frequently called in artists to work for him. In Paris especially he commissioned numerous manuscripts including a *Life of St Louis* (Paris, Bibliothèque Nationale, MS Fr. 2829), and probably had tapestries made in Tournai, including the *Coronation of the Virgin by the Trinity* (Sens, Musée de la Cathédrale Saint-Étienne), which recalls the sharp design of a stained-glass window (with the *Crucifixion*) that he commissioned for Moulins Cathedral (possibly the work of the mysterious Jean Prévost of Lyon?), whereas the *Adoration of the Magi*, also in Sens, might have been conceived by a Brussels painter known as the Master of Sainte-Gudule. At any event, Charles de Bourbon was apparently in contact with Flanders, like his brother Duc Jean II (1426–88), who commissioned a diptych (Chantilly, Musée Condé) from a pupil of Rogier van der Weyden, for his wife Jeanne of France. Furthermore, he engaged in his service another outstanding painter of Netherlandish extraction, Jean Hey.

Jean Hey probably trained at Ghent in the early 1480s under Hugo van der Goes, from whom he borrowed most of his technique, consisting of accurate draughtsmanship, a composition with daring perspectives, cold light, and a dazzling palette. The first record we have shows him in the service of Charles de Bourbon in 1482, when he renounced his honorary charge of *Procurateur des pauvres* to exercise his craft as a painter, while receiving a salary. But had he been directly hired in Flanders or, as is usually assumed, had he stopped over in Burgundy at the court of Cardinal Jean Rolin? The chronology of the works favours the first hypothesis, assuming it begins with the *Portrait of Charles of Bourbon* (Munich, Alte Pinakothek).

pl. 42 The portrait that forms the right wing of a devotional diptych depicts Charles as a cardinal and so might date to the years immediately subsequent to his appointment, between 1476 and 1480. Jean Hey still had strong ties with Ghent circles, yet his tense graphism gradually relaxed as he adjusted to the French clientele's tastes, as denoted in the *Nativity* (Autun, Musée Rolin). Probably painted for the Notre-Dame chapel of Autun Cathedral, the panel was commissioned toward 1480 by Cardinal Jean Rolin to whom the painter was perhaps recommended by Charles himself. It depicts the donor kneeling in front of Christ flanked by St Joseph and the Virgin whose refined features recall a drawing of a *Woman* in profile (Paris, Musée du Louvre), previously attributed to Perugino [fig. 9]. Its composition clearly relates it to the works of Hugo

van der Goes, and especially to the *Monforte Altarpiece* (Berlin, Gemäldegalerie), which Jean Hey might have seen in the workshop during his apprenticeship. It displays a certain overall softer manner that is accentuated in later works.

We might date to the 1480s a work such as the Glasgow panel (Art Gallery and Museum), which appears to be the right wing of a devotional diptych modelled upon a type that Fouquet had made popular in France. It depicts an ecclesiastic in a verdant landscape, presented by a warrior saint bearing on his armour the lily of France, and who has not yet been identified (he may be another ecclesiastical dignitary from Charles de Bourbon's circle). Its clear layout, blurred modelling, and softer treatment of textures (notice the wonderful rendering of the saint's hands, achieved by contiguous different tones of white) closely connect it with two fragments that formerly belonged to a single ensemble, devoted to a theme that had become immensely popular since Sixtus IV's day, namely, the Immaculate Conception. The London panel (National Gallery) presents Anne and Joachim embracing in front of the Golden Gate adorned with classical motifs, and Charlemagne bearing the lilies of France. The Chicago panel (Art Institute), probably lacking a figure of a saint on the left, balancing that of Charlemagne, depicts an *Annunciation* in a Renaissance interior pl. 43 adorned with a porphyry column, grooved pillars, and other classical motifs. The altarpiece must have been completed in the central section (now lost) with a *Madonna and Child* surrounded by angels. Who commissioned the work remains a mystery, but in view of the importance given to St Anne, it might have been Anne of France, which would suggest a date after the very late 1480s.

Upon the death of Charles de Bourbon (1488), Jean Hey entered the service of Pierre II de Bourbon, who had assumed the regency of the kingdom with his wife Anne of France in 1483 until Charles VIII came of age, and became duke in 1488, thus succeeding Jean II. While residing in Moulins, Jean Hey supplied the cartoons for the *Popillon Stained-glass Window* in the city's cathedral, and was in great demand by the numerous important figures attending the Bourbon court. In 1490 he did the portrait of little Margaret of Austria (New York, The Metropolitan Museum of Art) who, engaged to the future Charles VIII, was journeying through Moulins. Toward 1492–93 he painted a triptych of which fragments of the wings have survived (Paris, Musée du Louvre). In a unified landscape they show Pierre II de Bourbon presented by St Peter on the left, Anne of France, and her daughter Suzanne (born in 1491), accompanied by St John the Evangelist on the right. For Jean Cueillette, treasurer of the Bourbons, in 1494 Jean Hey painted a *Man of Sorrows* (Brussels, Musées Royaux pl. 44 des Beaux-Arts) that bears the signature "johannes hey teutonicus", the work that provided the key for identifying the painter. In December 1494 he also executed the portrait of little Charles-Orlant (Paris, Musée du Louvre), the son of Charles VIII and

Anne of France, who died in infancy. Almost at the same time Hey produced the frontispiece of a manuscript that Pierre II de Bourbon donated to the king of France, the *Statuts de l'ordre de Saint-Michel* (Paris, Bibliothèque Nationale, MS Fr. 14363), notable for its Italianate decoration similar to the Chicago *Annunciation*, and a diptych (on the model of the Melun panel). of which there remains only the left wing with a St Mary Magdalene presenting Madeleine de Bourgogne, wife of the Bourbon's chamberlain Bompar de Laage (Paris, Musée du Louvre). This last panel in some way heralds the painter's last period, in which he adopted a monumental approach and greater plasticity, culminating in the famous *Moulins Triptych* (Moulins Cathedral).

pl. 45

The triptych was painted for the castle that Pierre II de Bourbon began to build in Moulins in 1488, and specifically for the chapel that was still under way in 1500/01 and only completed in October 1503. On the back the triptych carries a grisaille *Annunciation*, while on the front it features an *Enthroned Virgin and Child*, the former crowned and surrounded by angels, her feet resting on a crescent moon, after a model that associates the Immaculate Conception with the Woman of the Apocalypse (chapter XII). On the side panels, the donors at prayer attend the Virgin's apparition behind curtains placed between the earthly and the heavenly spheres: on the left, Pierre de Bourbon is presented by St Peter in papal garb; on the right stand Anne of France and little Suzanne with St Anne. Given the dates of the chapel's construction, together with the style of the costumes and Suzanne's presumed age in the portrait (around ten years old), the triptych should date to around 1500, or slightly later. So it would be the last work of Jean Hey who, a short while after the death of his patron Pierre II de Bourbon, was mentioned in a verse by Jean Lemaire de Belges (early 1504) as one of the most outstanding painters of the day: "And you, Jehan Hay, is your noble hand out of work?", as if querying whether Hey had found a new patron elsewhere. It appears that the painter died shortly after.

Jean Hey's influence in the region must have been considerable, as attested by a few works of very uneven quality. First the large *Pietà* of the church of Autry-Issards depicting the members of the Dreuille family in a horizontal format can be compared to a small *Pietà* (Paris, Musée du Louvre), a *Virgin and Child* (Otterlo, Kröller-Müller Collection) and the *Petitdé stained-glass window* in Moulins Cathedral that all feature a similar tendency to petrify Netherlandish models. It is close to the *Tour d'Auvergne Triptych* (Raleigh, North Carolina Museum of Art), painted toward 1495 probably at Vic-le-Vicomte. Despite its grim subject matter, this panel (of which a sixteenth-century copy recently appeared on the market) seems to be connected with Moulins, and in particular with the *Dukes' Stained-Glass Window* in the cathedral, from which it borrows its geometric volumes. Last, the so-called *Comeau Hours* (Paris, Bibliothèque Nationale, N. a. Lat. 3197), illuminated toward 1500, reveal

pl. 46

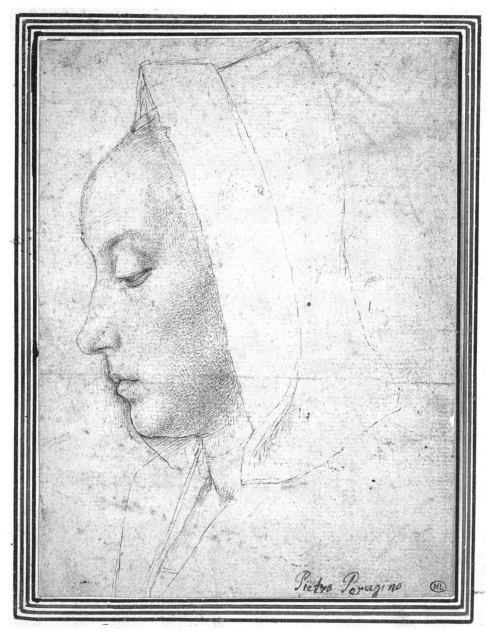

Fig. 9. Jean Hey, *Portrait of a woman in profile,* ca. 1480.
Paris, Musée du Louvre, Département des Arts Graphiques, inv. R.F. 31039.

an illuminator who interprets Jean Hey's models combined with Italian motifs (of the same kind as in the Raleigh triptych) with the utmost fluidity, and whose hand appears again in the *Passion Altarpiece* of Moulins (Musée Municipal). We can also mention a collection of various poems and drawings (Paris, Bibliothèque Nationale, MS Fr. 24461), in which a very fine artist appears in contact with Moulin milieau [fig. 10].

pl. 47

Evidently influenced by Jean Hey, the mural depicting the *Liberal Arts* in the room formerly used as the library of the chapter in Le Puy Cathedral, reveals a more complex artistic background. Fragmentary, it features female personifications of the four of the Liberal Arts, enthroned in front of a panoramic landscape: *Grammar* beside Priscian and two children; *Logic* flanked by Aristotele; *Rhetoric* in Cicero's presence; and *Music* with Tubal-cain. Commissioned by Canon Odin, the mural may date to around 1500. Composite in style, with Hispanic tones that are explained by connections with Languedoc, the paintings can be compared to works like the *St Veronica* formerly in the Durrieu collection, and are close to several Languedoc sculptures, such as the famous Albi *Judith*. The work skilfully

Fig. 10. Painter active in the Bourbonnais, *Collected poems and drawings*, ca. 1500. Paris, Bibliothèque Nationale, MS Fr. 24461, folio 38.

combines the Netherlandish models of Jean Hey's generation with Italian motifs that reached the area through various channels, in particular via Gilbert de Bourbon-Montpensier's diplomatic network. The latter, whose court was based in Aigueperse in the Auvergne, displayed a precocious taste for Italian painting perhaps due to the family ties of his wife, Chiara Gonzaga. Thus, perhaps on the occasion of his wedding in 1481, Gilbert received as a gift Andrea Mantegna's *St Sebastian* (Paris, Musée du Louvre), and about ten years later he commissioned a sumptuous *Nativity* (Aigueperse, church) from Benedetto Ghirlandaio, Domenico's brother, who worked in France toward 1490.

The incoming inventions of the Italian Renaissance were also diffused by the artists present in Lyon, whose pictorial production was dominated by Jean Perréal. Born in

Lyon and also called Jean de Paris he was one of the celebrities mentioned by Jean Lemaire de Belges. Active from 1483 to 1530 as painter, poet, engineer and diplomat, in 1496 he became the king's official painter, first of Charles VIII, then of Louis XII whom he accompanied to Milan in the campaigns of 1499, 1502 and 1509. He was appreciated in Milanese circles as well for his portraits *aux crayons* (with various chalk colours) and his "modo di colorare a secco" (use of pigments *a secco*) that Leonardo recommended to his pupils. He equally provided the designs for the Italianate tomb Anne of Brittany commissioned for her parents in the Carmes of Nantes and was charged with supervising its execution by Michel Colombe (1497–1507). Among his extant works we should mention the frontispiece illustrating one of his own poems, *La Lamentation de Nature à l'alchimiste errant* (Nature chastising the Errant Alchemist), a miniature that allowed to identify the painter (Paris, Musée Marmottan, Collection Wildenstein, MS 147). But it is especially the small portraits, illuminated or painted on wood, that insured Jean Perréal great fame and gave him a leading role in the development of the genre in France. The *Portrait of a Man* recently acquired by the Louvre or the *Portrait of the Poet Pierre Sala* (London, British Library, Stowe 955, fol. 17) are very characteristic of the manner the painter achieved: confined space, neutral but coloured background, insistence on the structure of the face stressing the large fixed eyes and systematic fleshy mouth.

pl. 48

Aside from Jean Perréal a number of painters worked in Lyon but nothing has survived. Among the rare vestiges, several fragments of stained-glass windows with heads of angels come from the Bourbon chapel in the cathedral. Executed after 1500 and traditionally attributed to Pierre de Paix (documented from 1479 to 1503), they suggest a composite background with Rhenan influences comparable to what can be found in the duchy of Savoy. In the Musée des Beaux-Arts of Lyon there is also an interesting panel that represents St Catherine between two angels in the main section and her martyrdom attended by five canons in the predella. It is believed to come from Beaujeu, fief of the dukes of Bourbon, and so may have been commissioned by Anne of France. Its composition is comparable to the *Dukes' Stained-Glass Window* in Moulins Cathedral. Dated 1507 it is attributed, without actual evidence, to Claude Guinet, who died around 1512/13 and was among the signatories of the *Statutes of Painters* in 1496. His style that blends Dutch plasticity with an Italian setting is a fair illustration of the situation in Lyon, a true cultural junction on the "Burgundian" artery between north and south.

pl. 49

This artery continued to be travelled in both directions even after the collapse of the duchy of Burgundy, in particular by Georges Troubert. Born in Troyes, in 1467 Trubert entered the service of King René as *valet de chambre* after the court settled permanently in Provence in 1471, thereby succeeding Barthélemy d'Eyck and

performing a diplomatic journey to Rome for the king in 1476. Upon the death of his patron (1480), Trubert stayed on in Avignon, then between 1491 and 1499 in Nancy he became the official illuminator of René II of Lorraine for whom he illuminated magnificent manuscripts. In a *Diurnal* produced toward 1492–93 he presented inside a rich border *David and four prophets* whose clear outline and bright colours reveal the painter's "Burgundian" background and that can be compared to the Louvre *Three Prophets*. This fragmentary panel, painted toward 1490 in Provence, features sharp outlines and mighty volumes recalling Sluter's manner. It is by the same painter as the *St Peter* in a private American collection, a painter plausibly identified as Jean Changenet, known as "le Bourguignon".

pl. 50

pl. 51

Born in Dijon, Jean Changenet was probably the brother of Pierre who worked in Dijon from 1477 to 1503, and has plausibly been identified with the so-called Master of the Burgundian Prelates, notably responsible for the murals of the Ferry de Clugny Chapelle Dorée in Autun Cathedral, together with several manuscripts. Active in Avignon from 1485 to 1494, Jean Changenet gave his daughter Michelle's hand in marriage to a painter to whom he appears to have passed on several of his workshop models: Josse Lieferinxe. The latter, born in Hainaut (perhaps in Enghien), is documented from 1493 to 1505 in Provence, where he attended the workshop of Philippon Mauroux from 1493 to 1497, and briefly associated with the Piedmontese artist Bernardino Simondi. In 1497/98, he and Simondi (who died in the meanwhile) were commissioned to paint an altarpiece for the Luminaire de Saint Sébastien confraternity in the church of Notre-Dame des Accoules in Marseille.

pl. 52

The seven surviving scenes are devoted to the life of St Sebastian (Philadelphia, Museum of Art; Baltimore, Walters Art Gallery; Rome, Galleria Nazionale d'Arte Antica; St Petersburg, Hermitage). During the same years he painted *Abraham's Encounter with Three Angels* (Denver, Art Museum), derived in all likelihood from a drawing left by Antonello during his presumed stay in Provence toward 1460. Between 1500 and 1505 he executed a Marian altarpiece (Avignon, Musée du Petit-Palais; Brussels, Musées Royaux des Beaux-Arts; Paris, Musée du Louvre), a *Calvary* (Paris, Musée du Louvre) indebted to a Burgundian model conveyed by the Changenet workshop, a *Pietà* held in Antwerp and an *Ecce Homo* (Milan, Pinacoteca Ambrosiana). His style, midway between the Dutch models of Geertgen tot Sint Jans and the Piedmontese one of Giovanni Martino Spanzotti (probably mediated through the said Simondi), adjusted to the quiet equilibrium of Provençal tradition, gradually developing greater expressivity. His light effects recall the comparable instance of the mysterious *Nativity* of the Musée Calvet in Avignon, recently tentatively attributed to Aine Bru, a Brabantine painter active in Catalonia from 1500 to 1507, who apparently died in Albi shortly before 1510.

pl. 53

The similarities between these fine works should not conceal the real situation of the Mediterranean area which, after having given rise to an authentic *koiné* toward the middle of the fifteenth century (its golden age), gradually slid into a decline. Of course, artists continued to move around Europe, and exchanges were maintained. But a kind of "regionalisation" of pictorial production took place, resulting in more fragmented, unconnected traditions. In this context, painting production in Provence was impoverished, as attested by the various followers of Josse Lieferinxe, first of all his cousin and heir Hans Clemer (documented from 1498 to 1513).

In Lieferinxe's circle we should also mention two painters who illustrate the circulation of artists and works along the "Burgundian" artery. The first, Jean Boachon, residing in Avignon, in 1515 painted an altarpiece for the Franciscans of Bourg-en-Bresse, of which a severely damaged wing survives (now in the museum of Brou), featuring an almost naive interpretation of Provençal models. The second, Nicolas Dipre (documented in Avignon from 1495 to 1531), completed an altarpiece for the Conception de la Vierge confraternity in the church of Saint-Siffrein in Carpentras in 1499–1500. This work, of which some fragments are extant (Carpentras, Musée Municipal; Paris, Musée du Louvre; Denver, Art Museum; Detroit, Institute of Arts; San Francisco, De Young Memorial Museum), shows a slight indebtedness to Enguerrand Quarton, with a dry draughtsmanship. Having a northern background, Nicolas Dipre was the son of the renowned Colin d'Amiens, and was presumably trained by him in Paris, the other great cultural crossroads of the period.

pl. 54

The Paris crossroads

At the end of the fifteenth century Paris enjoyed an economic upturn owing to its two arteries—on the one hand, its traditional links with Tournai and Picardy; and on the other, the Seine with Rouen serving as outer harbour. Paris became once again a cosmopolitan capital where merchants and financiers converged and princes acquired precious items. Drawn by the university, printers began to settle and set up shop there in the 1470s, greatly increasing the integration of the Germanic *nation* (that is, the German community of Paris). Their presence had a profound effect on the production of painted manuscripts, which became a speciality of the city and continued in the activity of illuminators, such as Maître François and his follower, the Master of Jacques of Besançon.

Active in the 1480s and 1490s, the Master of Jacques of Besançon remained faithful to his master's repertory, which he tirelessly repeated with a painstaking technique.

In 1492 he began to collaborate with the bookseller Antoine Vérard, whose printed books he illuminated with miniatures. His great competitor, the Master of the Très Petites Heures d'Anne de Bretagne, went further, providing models directly to the etcher [fig. 11]. Far more versatile, he not only illustrated manuscripts, including several for Queen Anne of Brittany, but designed cartoons for stained-glass windows, notably the rose window of Sainte-Chapelle with the arms of Charles VIII, and tapestries as well, such as the famous hangings of the New York *Unicorn Hunt* and the *Lady and the Unicorn* (Paris, Musée National du Moyen-Age). These hangings, whose design derived from the models of Charles VII's period (witness the Rouen *Winged Deer*), expressed an allegorical and essentially anti-naturalistic world, rejecting spatial conventions and abounding in refined details. French

Fig. 11. Master of the Très Petites Heures d'Anne de Bretagne, *Annunciation*, 1498. Book of Hours for Rome Use. Paris, Bibliothèque Nationale, Rés. Vélins 2912, folio b8.

pl. 55

specialities, they reveal a continued attachment to a "national" tradition, which they served to advertise abroad. Our painter was so faithful to Colin d'Amiens' repertory that he may actually have been his son. He has also been identified with the brother of Nicolas Dipre, Jean d'Ypres, master-juror of the painters' craft in Paris in 1504, who died four years later.

Along with these trends connected with local tradition, outside elements reached Paris through economic channels. Thus, conditioned by the florid printers' activity, in the early sixteenth century a current from Cologne appeared. It is reflected by the importation of the *Deposition* (Paris, Musée du Louvre), a sophisticated, expressive interpretation of Rogier van der Weyden's model (Madrid, Prado). Painted around 1501/02 by an outstanding personality of Cologne, the Master of Saint Bartholomew, the altarpiece was in all likelihood made for a community of Antonites that had settled in Paris. It was doubtless removed by the master's collaborators, one of whom was the Master of the Saint-Germain-des-Prés Pietà. Conserved in the Louvre, the *Pietà* is the central section of a triptych commissioned probably toward 1503 by Guillaume Briçonnet, commendatory abbot of Saint-Germain-des-Prés (1503–07).

pl. 56

Its left wing depicts *Christ carrying the Cross* (Lyon, Musée des Beaux-Arts) and the right wing a *Resurrection* (present location unknown). It has a horizontal format and a subject popular toward 1500, as noted in the Autry-Issards altarpiece. It depicts the protagonists of the *Lamentation* (with a likely portrait of Guillaume as Nicodemus) in front of a landscape, where we recognise a very accurate view of Paris, and in particular the abbey of Saint-Germain-des-Prés. Its affected style and bright palette soften the Master of Saint Bartholomew's vehemence by apparently adjusting to the taste of the patron, who was close to the court and a good friend of the rhetorician Lefèbvre d'Etaples.

Among the Master of Saint Bartholomew's collaborators hailing from Cologne at that time, a far more modest painter appears to have settled in France under Louis XII. He painted notably two triptychs inspired by the one by the Master of Saint-Germain-des-Prés Pietà. The first (present location unknown) dated from 1512 was commissioned by Foulque de Bouthéon for the Saint-Romain-le-Puy Benedictine abbey in Forez, certainly connected with that of Saint-Germain-des-Prés. The second, dated from 1515, might be linked to an outbreak of the plague, in view of the presence of the saints Sebastian and Roch. We only know two of its panels: the *Lamentation over the Dead Christ* in the Museum of Fine Arts in Springfield pl. 57 which is the central section and the *Entombment* in a private collection which is the left wing. The background of the painter we might call the Bouthéon Master is defined by a petrification of the Cologne models that reflects a rather brutal adjustment to French culture.

While the Cologne presence was periodical, it was quite a different story for the "Picard" channel which, as noted in the previous period, insured a constant circulation of artists and art works, especially tapestries—the great speciality of Tournai. To be sure, Picardy declined during the last third of the fifteenth century and its pictorial production tended to become "regionalised". There were two contrasting trends. The first, that resisted the Netherlandish innovations, pursued the manner of Nicolas Froment in a dry, graphic register, as we see in the author of the Châteauroux *Portrait of a Man* (ca. 1470) or the Master of Thuizon (ca. 1480) whose inventions seem to have been followed up until the early sixteenth century, in particular in four panels of the *Life of Christ* (with the monogram "A.H.") in the Musée des Beaux-Arts of Lyon. The second, more refined, interprets the Netherlandish models in a softer style, as evidenced among others by the "Puy d'Amiens" of 1501 (Paris, Musée National du Moyen-Age) or an interesting *Martyrdom Scene* (Amiens, Musée de la Picardie) whose smooth rendering recalls Colin d'Amiens, and the scenographic layout, Fouquet's manner. It probably derives from the Tournai production that we regrettably know so little about.

During the 1490s in Tournai Cathedral, Henri de Campes (recorded as of 1473 in the guild of St Luke) made several stained-glass windows after cartoons by Arnoult of Nijmegen. Six of them illustrate in a different style the feudal privileges granted the bishopric. It is assumed they are by Henri's son, Gauthier de Campes, born in 1458 and in part trained by his father. He appears aware of late examples of Hugo van der Goes, and admits to several contacts with circles in Bruges, where he is documented in 1480 and 1490. In 1500 he settled in Paris, where he designed the project for the new Notre-Dame bridge, and passed away some time between 1530 and 1534. He provided several cartoons, notably in 1503 for a hanging portraying the *Life of St Stephen* in Sens Cathedral, and in 1515 for a stained-glass window at Saint-Étienne la Grande Église in Rouen. On the basis of the Tournai windows, a recent hypothesis attributes to him a whole set of stained-glass windows (in the nave of Saint-Merry in Paris) and tapestries (the *Life of St Stephen of Auxerre*), along with the nineteen panels traditionally assigned to the Master of Saint Giles.

Should this be the case, during his Tournai period Gauthier de Campes would have executed the altarpiece of which a piece of the left wing is held in Brussels (Musées Royaux des Beaux-Arts) with on one side the *The Taking of Christ*, on the other the *Archangel Gabriel* in grisaille. The fragment apparently belongs to the "Picard" trend, recalling with greater restraint the brutality of a Nicolas Dipre. As soon as he settled in Paris, the painter developed a softer manner, integrating some of the Netherlandish innovations. Toward 1501 he painted the portrait of Philippe le Beau (Winterthur, Fondation Reinhart) on his way through Paris. Shortly afterward, he created his masterpiece, an altarpiece, which was probably commissioned for the Parisian church of Saint-Leu-Saint-Gilles, of which four two-sided wings have survived (Washington, National Gallery; London, National Gallery), which illustrate various episodes in recognisable settings: the christening of Clovis is set in the Sainte-Chapelle; the miracles of St Leu before the porch of Notre-Dame; the mass of St Giles at Saint-Denis; the episode of St Giles protecting a hind, showing a king and an ecclesiastic probably in the semblance of Louis XII and the donor, are set in a landscape that resembles Pontoise. Featuring clear outlines, full volumes, dazzling colour and an almost transparent texture, the panels are evidence of the painter's activity as a large-scale cartoonist, but also suggest contact with Cologne painters such as the Master of Saint-Germain-des-Prés Pietà. In that case they might date to around 1505.

pl. 59

pl. 58

Gauthier de Campes' recorded activity at Rouen in 1515 highlights another essential channel of Parisian economy, namely, the Seine. The constant connection between Paris and Rouen is easily confirmed by examining the artistic production. For example, a *Calvary* executed in Parisian circles was probably sent to Rouen toward

1500, when Louis XII transformed the Exchequer into a Parlement (today the Palace of Justice). It is also evidenced by the activity of the illuminator Jean Pichore, active in Paris between 1502 and 1520, who apparently ran a business which, with the help of several collaborators, produced standardised manuscripts in the purest Parisian tradition. Indeed his style pursued Maître François' models in a more elegant register, with chiselled forms and a cold, almost metallic light. In 1502/03 he is documented in Rouen in the employ of Cardinal Georges d'Amboise, for whom he illuminated among others a *De Civitate Dei* (Paris, Bibliothèque Nationale, MS Lat. 2070) and perhaps *Les Remèdes de l'une et l'autre Fortune* (Paris, Bibliothèque Nationale, MS Fr. 225), a manuscript made as a gift to King Louis XII.

Archbishop of Rouen from 1494, in 1501 Cardinal Georges d'Amboise began renovating the archiepiscopal residence of Gaillon, built in the purest French tradition but decorated in an entirely Italianate manner. He set up the Neapolitan library with books that he had purchased in 1501 from Frederick II of Aragon, exiled in Touraine. From this region he summoned several craftsmen, French and Italian, employed in the royal yards, and had them carve reliefs on the porch, inspired in particular by Mantegna's *Triumphs of Caesar*. He also commissioned Michel Colombe for a spectacular *St George and the Dragon* influenced by Lombard sculpture (Paris, Musée du Louvre), and furthermore acquired several Italian paintings for his library. Between 1504 and 1507 he engaged the Lombard painter Andrea Solario, who during his stay in France executed several works, including the Louvre *Lamentation over the dead Christ*. Georges d'Amboise's artistic patronage, wavering between local tradition and Italian innovations introduced by the royal campaigns, highlights the links established between Paris and the court settled in the Loire Valley.

The Loire cultural artery

Consolidated by the policies of Charles VIII and Louis XII, the Loire region created a distinct cultural identity of its own, lying midway between the Netherlandish and the Italian styles. This then began to bear fruit thanks to painters who, like the great rhetoricians of the period, skilfully blended the motifs of the established repertory, while selectively assimilating the innovations that arrived via Paris and Lyon. Eventually, the emphasis went to the Italianate taste that had first appeared in the mid-fifteenth century, and later grew in intensity during the French military campaigns on Italian soil of 1494/95. However, the two principal artistic centres of the Loire reacted to these new developments quite differently: where Tours was quick to assimilate, Bourges remained only slightly affected.

Despite the brevity of Charles of France's patronage, the city of Bourges was by no means on the decline. In addition to its natural links with the Touraine milieu and the court, the city took advantage of its privileged location on the Loire artery, which passed through Lyon on the way to the duchy of Savoy, whose territories extended beyond the Alps and into Italy. After a university opened in 1467, the city's economic boom fostered a lively production of miniatures. During the last third of the fifteenth century two workshops in particular exerted their influence over a broad area, especially in Lyon, Dijon and the Bourbonnais, namely, those of Jean Colombe (documented from 1463 to 1493) and the Montluçons.

pl. 60

In the 1470s Jean Colombe, the sculptor Michel Colombe's brother, enjoyed the patronage of Louis XI's wife, Queen Charlotte of Savoy, who recommended him to her nephew, Duke Charles I of Savoy. Thus between 1485 and 1490 Colombe completed two important manuscripts for the ducal library in Chambéry: the *Très Riches Heures du duc de Berry* and the *Apocalypse* (Madrid, Escorial, MS E. vit. 5) commissioned almost sixty years earlier by Duke Amadeus VIII from Jean Bapteur. He also produced a number of manuscripts for court circles in particular in collaboration with workshops in Tours, either Fouquet's or that of the Master of the Della Rovere Missal. It seems that he trained several associates who would continue his manner. His style is based on models of Jean Fouquet and Jacob de Litemont's generation and features a swifter, more flowing technique, a volumetric simplification expressed by unnatural perspectives and more jagged forms. His work expresses not only a devotion to his predecessors' repertory, but even a certain reluctance toward Italian innovations, of which he accepted only a few architectural motifs.

Born in Montluçon, Jean Raoul worked concurrently with Jean Colombe, and had a similar relationship with Italy. Active in Bourges by 1461 in collaboration with Jacob de Litemont, Raoul is regularly documented for communal works until his death in 1494. His signature can be seen in the so-called *Chappes Hours* (Paris, Bibliothèque de l'Arsenal, MS 438, fol. 74), on the grand-priest's apparel ("Johannes de Montelucio me pinxit"). In this picture the different scenes are represented in half-length behind borders richly adorned with Italianate motifs. His graphism rather emphatically interprets the models of the previous generation, and recalls works like the *Nativity* (formerly in the Boer collection, Amsterdam), a transposition of a prototype by Jean Hey.

Raoul's son Jacquelin de Montluçon achieved greater elegance, styling himself upon Jean Colombe, as we can see in the *Monypenny Hours* (private collection), where he left his signature. Born in 1463, Jacquelin is recorded at Tours in 1483 but resided mostly in Bourges until his death in 1505. Probably between 1496 and 1498 he was

in the duchy of Savoy, and notably at Chambéry, where he altered a *Last Supper* (Chambéry, Musée Savoisien), which was signed in 1482 by a certain Godefroy (doubtless a pupil of Antoine de Lonhy), and he painted an altarpiece for the church of the Antonites. Three two-sided wings of this altarpiece survive, the first with a *Descent to Limbo* and a *Martyrdom of St Catherine* (Chambéry, Musée Savoisien); the second with an *Annunciation* and a *Raising of Lazarus* (Lyon, Musée des Beaux-Arts) bearing the painter's signature; and the third with a *Nativity*, recently acquired by the Lyon museum, separately from the back, which shows a *Feast in the House of Simon* (private collection). Their flowing graphism that reflects an illuminator's hand might be the same as in the *Apparition of the Risen Christ*, which recently entered the collection of the Pont-Saint-Esprit museum. In the wake of the Montluçons' workshop, the so-called Master of Spencer 6, who may plausibly be identified with a certain Laurent Boiron (documented in Bourges from 1480 to 1510), reflects exchanges with cultural circles in Touraine.

pl. 61

Despite the less frequent stays of the court (principally based in Amboise and Blois), the city of Tours continued to develop thanks to the eminent families from which many of the royal officials were recruited. The city's workshops continued to provide luxury crafted items and manuscripts to the court, which adopted the Italianate tastes rather than the Parisian production. This preference is attested by the Master of the Della Rovere Missal, who had been active in Rome toward 1480, and appears to have worked in Touraine about ten years later. He was recently identified with a certain Jacopo Ravaldi, who may have been French (therefore Jacques Ravaud?), and settled in Rome between 1469 and 1478. If this were the case, then it is likely that he had his training in Tours. At any event, he adapted Italian motifs to Fouquet's manner, simplifying them considerably, as can be seen in a Book of Hours of Tours Use [fig. 12]. In the Vienna *Pontifical* (Österreichische Nationalbibliothek, cod. 1819), he executed a miniature for Pierre d'Amboise, bishop of Poitiers from 1481 to 1505. Might he have entered the service of this bishop who, like his younger brother Georges, was clearly fond of Italy? In that case, at a more advanced stage (toward 1500), he might have been the artist behind some of the murals that adorn the chapel of the castle of Dissay, the bishop's property, perhaps executed with collaborators. Created after designs for tapestries, these paintings depict Nebuchadnezzar and Menes on their thrones, King David at prayer matched by Adam in the same attitude, sentenced to work after the original sin and the expulsion from Paradise. They show a Fountain of Life as well with angels, whose figure types with bulging foreheads and heavily lidded eyes recall our painter.

An exact contemporary of the Master of the Della Rovere Missal was Jean Poyer, a painter of great virtuosity whose artistic personality was only very recently brought

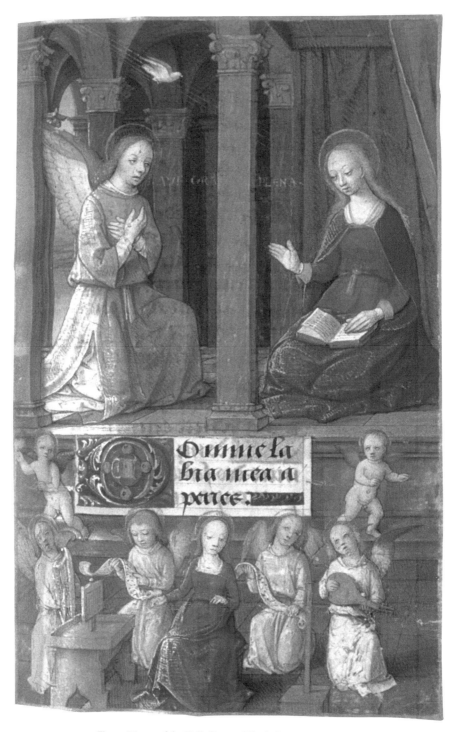

Fig. 12. Master of the Della Rovere Missal, *Annunciation*, ca. 1490.
Paris, Bibliothèque de l'Arsenal, MS 432, folio 34.

into focus. He was one of the most outstanding painters mentioned by Jean Lemaire de Belges and Jean Pèlerin Viator, especially for his mastery of perspective. Recorded in Tours as of 1465 he probably trained in contact with Jean Fouquet, developing his scenographic qualities. We might even say he was to Fouquet what Jean Michel, the author of a *Passion Mystery* performed at Angers in 1486, was to Arnoul Gréban, but with a greater sense of the changing times. Indeed he thoroughly assimilated the Italian innovations and especially Andrea Mantegna's models, which he might even have seen in France, notably at Aigueperse. Yet, considering the variety of his sources, he might have directly travelled toward 1480 in northern Italy (the Veneto), as the Loches altarpiece suggests. Dated 1485, Jean Béraud commissioned it for the charterhouse of Liget. It depicts three episodes of the *Passion*: *Christ carrying the Cross*, the *Crucifixion*, and an *Entombment* attended by the donor. Its highly sculptural manner of carefully arranged volumes in space appears again in a *Book of Hours* (Haarlem, Teylers Museum, MS 78) commissioned almost at the same time, most likely by the then secretary of the royal treasury, Guillaume Briçonnet.

pl. 62

In the following years Jean Poyer appears to have been particularly appreciated at court, especially by King Charles VIII and Queen Anne of Brittany, for whom he respectively illuminated just before 1495 a *Book of Hours* (New York, Pierpont Morgan Library, MS M. 250) and a prayer book (New York, Pierpont Morgan Library, MS M. 50). In 1497 the queen commissioned him for a *Book of Hours*, a leaf of which represents a *Lamentation over the dead Christ* (Philadelphia, Free Library, Rare Book Department, Lewis, MS 11. 15a). A short while later he executed a sumptuous missal for Guillaume Lallemant, canon and archdeacon of Tours, a delicate *Virgin and Child Enthroned* (Paris, Musée du Louvre, Département des Arts Graphiques, R.F. 3890), which is a separate folio of the *Heures of Henri VIII* (New York, Pierpont Morgan Library, MS H. 8), a singular set of five ink drawings (held in four different collections), among which we can mention the *Sacrifice of Isaac* [fig. 13] with its elaborate setting (London, British Museum, Department of Drawings, inv. 1874-6-13-539). In these last works, dated toward 1500, Poyer's style is more fluid, as he re-elaborates Mantegna's repertory (which circulated in France), and reveals his direct experience of Lombard circles.

Like his contemporary Jean Perréal, it seems that Jean Poyer followed Louis XII and his court to Milan in 1499. Here he particularly admired Leonardo's *Last Supper*, which evidently inspired him for a triptych that was only recently rediscovered. Painted between 1500 and 1502, this work was commissioned by Jean IV of Chalon, Anne of Brittany's first cousin, for the Cordeliers' church of Nozeroy in the Jura. It is consecrated to St Mary Magdalene, who was particularly venerated in royal circles. The central section (Lons-le-Saunier, Conseil Général), unfortunately heavily

pl. 63

overpainted on the right side, replicates Leonardo's model for the *Feast in the House of Simon*, in which (according to an early written record), Simon is supposedly a portrait of the donor. Remounted on canvas and conserved in the Censeau church (not far from Nozeroy), the wings depict on one side Christ preaching in the presence of Mary Magdalene inside an edifice with a Renaissance decor, on the other a *Noli me tangere* in a luminous landscape showing the empty tomb in an extraordinary setting with a grand staircase, a balustrade with alternating motifs and an arbour. The triptych is perfectly consistent with Poyer's late work, as we see in comparing the figure of Judas in the central panel with that of St Matthew in a *Commentary* of the Apostolic Credo by Pierre Louis de Valtan (Rotthalmünster, Antiquariat Heribert Tenschert, fol. 21), dated to 1500 and made for Isabella the Catholic.

Jean Poyer probably died around 1503 or shortly before, thereby leaving the field clear for his main competitor, who was less drawn to the Italianate taste, and also more repetitive. Inexplicably overlooked by the historiographers Jean Lemaire de Belges and Jean Pèlerin Viator, Jean Bourdichon (1457–1521) was actually the most prominent court painter of his day. He was probably apprenticed in the workshop of Jean Fouquet, to whom he succeeded in 1481 as Louis XI's royal painter. At any event, Bourdichon collaborated with the so-called Master of the Munich Boccaccio (presumed to be François or Louis Fouquet), in several manuscripts. A *Lamentation* (Gonesse, Saint-Pierre-Saint-Paul) was recently attributed to him and dated toward 1485. It indeed presents similarities with his youthful miniatures, such as the Saint Petersburg *L'Estrif de Fortune et de Vertu*. Yet judging by several details, such as Nicodemus' puffed sleeves, it could not date to before the very late fifteenth century, and has affinities with his fellow artist Poyer's style in both the scenography and the morphology. It may therefore be the work of a third, as yet unnamed figure, whose style lies midway between Poyer and Bourdichon. Whatever may be the case, Jean Bourdichon's manner was more static, suiting the court's refined taste, and recalls the sculptor Michel Colombe's impassive sweetness, while applying the great rhetoricians' precious conventional tone. Bourdichon soon became an intimate of King Charles VIII, who set up a studio for him in the castle of Plessis. Subsequently Bourdichon would be confirmed by Louis XII as royal painter.

pl. 64

During Frederick III of Aragon's exile in Tours (1501–04) Jean Bourdichon collaborated with the Neapolitan illuminator Giovanni Todeschino on various manuscripts, including the deposed king's splendid *Book of Hours* (Paris, Bibliothèque Nationale, MS Lat. 10532). He probably painted at the same time the small triptych of the *Virgin and Child* for one of Frederick's intimates, who seems to have taken it to Naples around 1504, whence it entered the collection of the Museo di Capodimonte. The central section, which was copied by Protasio Crivelli in Naples,

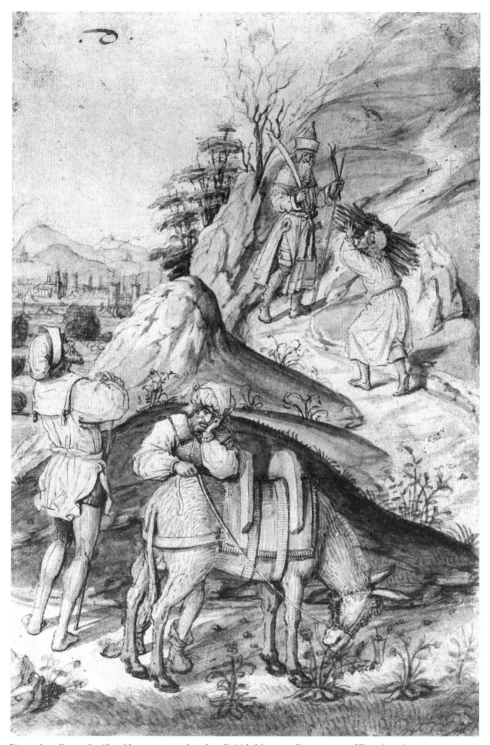

Fig. 13. Jean Poyer, *Sacrifice of Isaac*, ca. 1500. London, British Museum, Department of Drawings, inv. 1874–6–13–539.

depicts the Virgin and Child in a pillared aedicule within an ample landscape that adapts a model often found in Fouquet's illuminations (as in the Wolfenbüttel *Jouvencel*), and in the upper lunette a Calvary in front of a similar landscape. The wings that continue the two superimposed registers depict St John the Baptist and St John the Evangelist below, and St Michael and St George above. The clarity of the composition and refinement of the rendering makes this triptych particularly representative of the "French manner" that Bourdichon perfected between 1503 and 1508, culminating in his masterpiece, the manuscript that provided the key to his identification: the *Grandes Heures d'Anne de Bretagne* (Paris, Bibliothèque Nationale, MS Lat. 9474).

Despite the clear assertion of a cultural identity exemplified by Bourdichon's work, the court became increasingly fond of Italian Renaissance works. We see this in Jean Poyer's stylistic evolution, which highlights the change in taste, first looking to Mantegna for inspiration, and then gradually to Leonardo da Vinci. Mantegna's works, we should recall, met with an early interest in France, particularly at Aigueperse with Gilbert de Bourbon-Montpensier who, through his wife Chiara Gonzaga, owned Mantegna's *St Sebastian* in 1480. They were evidently also appreciated by King Charles VIII who, according to a letter of 12 October 1494, had his portrait made after a drawing. In 1502 Louis II de la Trémoïlle, husband of Gabrielle de Bourbon, received from the marquis Gian Francesco Gonzaga a painting by Andrea Mantegna for his chateau in Thouars. Jacques d'Amboise, bishop of Clermont, was introduced to this style through his younger brother Georges, who since 1499 had been transacting on behalf of Isabella d'Este to obtain a work by the master, and through his nephew Charles who apparently had a *Triumph of the condottiere Castruccio Castracani* in his chateau in Chaumont. Toward 1505 or a short while later, for the cathedral he commissioned Marian tapestries in Mantegna's style, probably created by a Lombard artist. Concurrently Florimond Robertet, secretary of King Louis XII, had also requested a picture by the painter, but the painter however died in 1506. So, by way of compensation he received a *St Veronica* by Lorenzo Costa in 1507/08, sent by the marquis of Mantua with his apologies. A great collector, the king's secretary already owned works by Leonardo da Vinci, including the *Madonna of the Yarnwider*, painted in 1501 and known through Lombard copies.

Indeed, after the French conquest of Milan in 1499, Leonardo da Vinci became greatly sought-after by French collectors. His works enthralled Louis XII, who brought back to France the female portrait known today as *La Belle Ferronnière* (Paris, Musée du Louvre), part of the confiscated collection of Milan's ruler Ludovico il Moro, and the *Virgin of the Rocks* (Paris, Musée du Louvre), which may have been painted for the church of San Gottardo in Milan, and acquired through Charles d'Amboise.

The latter, lieutenant general of the duchy of Milan (1499–1511), was a go-between on several occasions for royal officials such as Florimond Robertet and his uncle Georges, who in his Gaillon castle owned a *Bacchus* by Leonardo. Charles d'Amboise endeavoured to bring Leonardo to the French court, and, failing that, he organised a sojourn in France for one of Leonardo's followers, Andrea Solario, who painted his portrait (Paris, Musée du Louvre). Several other works, including the *Virgin of the Green Cushion* (Paris, Musée du Louvre), are likely to have belonged to the court. Toward 1510 d'Amboise had a set of murals painted in the chapel of Gaglianico, depicting the castle of Gaillon, doubtless after a drawing by Andrea Solario.

It seems that Louis XII was so enraptured by the paintings of Leonardo da Vinci, that he even proposed to break up the wall of the refectory of Santa Maria delle Grazie and have the *Last Supper* mural removed to France. As we have seen, Leonardo's composition was echoed by Jean Poyer in the Nozeroy triptych, and generated more literal copies on wood. In 1503 the king's treasurer, Antonio de Tropinis, commissioned Bramantino for a version that has occasionally been mistakenly associated with the Saint-Germain l'Auxerrois painting in Paris, and with a preparatory drawing at Windsor. In 1506 the dean of the chapter cathedral of Sens, Gabriel Gouffier, engaged Marco d'Oggiono to paint a replica also, which took him three years (now in Écouen). Furthermore, Leonardo's *Last Supper* composition was reproduced in a wall painting executed in the Blois Cordeliers, very damaged. It would probably be repeated in a tapestry (Vatican, Musei Vaticani) commissioned by Louise of Savoy and her son, the future Francis I who, risen to the throne in 1515, would one year later summon Leonardo da Vinci to France, to reside at his chateau in Cloux.

CONCLUSION

During the first part of Francis I's reign (between 1515 and 1530), the geography of the arts scarcely changed. The Italianate taste continued to spread through Lyon and the Loire artery. Yet it did not deeply affect the pictorial production, dominated by Jean Bourdichon (d. 1521) and Jean Perréal (d. 1530), that is, the "French manner" that however was gradually declining and entering an identity crisis. Seeking fresh inspirations, it looked to the north through Paris and the Burgundy cultural artery, rather than to Italy.

The northern trend—traditionally originating in Tournai, passing through Picardy and Paris—began to come from a new European centre: the port of Antwerp. It brought to France the dynamic, light manner of painters like Jan de Beer, artists whom modern historiographers labelled the "Antwerp Gothic Mannerists". The

northern influences can be found in the Master of Amiens, how executed several "Puys" for that city between 1518 and 1525. In Paris, this trend found a significant outlet in the Antwerp painter Noël Bellemare (documented from 1512 to 1546), whose highly versatile personality was very recently rediscovered. Bellemare contributed cartoons for stained-glass windows, illuminated manuscripts, and painted altarpieces, one for the church of Saint-Gervais-Saint-Protais. He might also be responsible for the *Crucifixion* commissioned by the bishop of Paris, François Poncher (private collection).

At court there were other painters with a similar background. Born in the northern Lowlands but apparently trained in contact with Antwerp circles, Godefroy le Batave should probably be identified with a Gaudefroy de la Rye who appeared in 1522 in Louise of France's accounts. Active from 1516 to 1522–24, he illuminated in his tense style a text by François Desmoulins narrating a pilgrimage Francis I accomplished in 1515 to the Sainte-Baume with his wife Claude of France and his mother Louise of Savoy (Paris, Bibliothèque Nationale, MS Fr. 24955). Toward 1519 he illustrated for the king another text by the same author, *Commentaires de la guerre gallique* (London, British Library, MS Harley 6205; Paris, Bibliothèque Nationale, MS Fr. 13429; Chantilly, Musée Condé, MS 764), in which Jean Clouet also worked. The latter (d. 1541), also from the former Lowlands (Antwerp?), from the start proved himself an expert in portraiture. Notably toward 1525–30 he painted the portrait of Francis I (Paris, Musée du Louvre) and that of the provost of merchants and humanist Guillaume Budé (New York, Metropolitan Museum of Art). His incisive graphism recalls that of the Antwerp artist Joos van Cleve who, according to Guicciardini, probably arrived at the court of France toward 1530.

Concurrently with the trend from Antwerp, the Burgundian artery also provided a channel for a more Italianate manner, which was introduced by painters from the northern Low Countries. Despite being hailed in the sixteenth century as an excellent painter, Grégoire Guérard, a relative of Erasmus of Rotterdam, has since been entirely and unfairly forgotten. Probably trained in the Romanising milieu of Utrecht, and attracted toward 1510 by the busy building yard of Brou, which enjoyed the patronage of Margaret of Austria, Guérard is responsible for almost twenty altarpieces executed in southern Burgundy between 1512 and 1530, all works that reflect direct contact with the Italian Renaissance (particularly Filippino Lippi and Leonardo da Vinci), of which the magnificent *Triptych of St Jerome* (Brou, Musée de l'Ain) is an excellent example. Established at Tournus, Guérard ran a small *atelier* in which at one time his compatriot Bartholomeus Pons from Haarlem collaborated. Quite a bit younger, the latter settled at Troyes in the 1520s and was in touch with the Dinteville family for whom he painted in particular in 1537 the famous New York

Allegory and the Frankfurt *Descent to the Pit*. His language, comparable to that of a Jan van Scorel, re-interprets Raphael's models with a personal, northern accent.

Toward 1530, the distinct Raphaelesque manner—either directly imported by Italian painters, or made familiar by Marcantonio Raimondi's etchings—gradually took over France. Indeed the second part of Francis I's reign (1530 to 1547) was characterised by the aspiration to a new cultural identity, whose tone was given by the humanist Guillaume Budé with the creation of the Collège des Lecteurs Royaux, in reaction against the aesthetics of the great rhetoricians with all its conventions. This signalled the demise of the manner that Jean Bourdichon had so long exemplified. The king applied his new artistic policy in the huge Fontainebleau yard, summoning Italian artists of the calibre of Rosso Fiorentino and Primaticcio, who brought the local French artists an entirely new repertory of imagery, which they in turn selectively assimilated and altered so as to create their own language, just as the poets of Joachim du Bellay's generation did. Thus the king launched a new and distinct "French manner", which, after a century of adherence mainly to Netherlandish models, now looked to Italy for its principal source of inspiration.

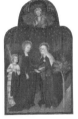

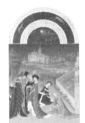

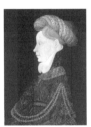

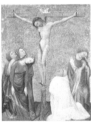

pl. 1. Master of the Small Pietà Roundel, *Small Pietà Roundel* (verso), ca. 1395–1400, tempera on wood, 22.8 cm (diam.), Paris, Musée du Louvre, inv. R. F. 2216. See pl. 2.

pl. 2. Master of the Small Pietà Roundel, *Small Pietà Roundel* (recto), ca. 1395–1400, tempera on wood, 22.8 cm (diam.), Paris, Musée du Louvre, inv. R. F. 2216.
The round panel, the verso of which features the three nails surrounded by the Crown of Thorns, is conceived as a luxury item comparable to a goldwork piece and made for a princely milieu. The painter was probably established in Paris, and possible had contact with the Dijon production, and in particular with Jean de Beaumetz.

pl. 3. Master of the Small Pietà Roundel, *Deposition*, ca. 1400, tempera on wood, 32.8 x 21.3 cm, Paris, Musée du Louvre, inv. M. I. 770.
The panel's exquisite workmanship and delicate texture strongly suggests an attribution to the Master of the Small Pietà Roundel, who also was responsible (ca. 1400–5) for the Brussels *Pietà* and the *Dead Christ held by the Virgin and St John* in Troyes. It attests to the popularity in the princely milieu of themes expressing pathos.

pl. 4. Master of the Coronation of the Virgin, *Coronation of the Virgin*, ca. 1400–5, tempera on wood, 20.5 cm (diam.), Berlin, Gemäldegalerie, 1648.
The panel's style is more flowing, and the forms are taller and more slender than in the works by the Master of the Small Pietà Roundel. We discern the same hand in a *Virgin and Child* formerly in the Vitale Bloch collection (Paris, private collection) and in several miniatures attributed to the Master of the Coronation of the Virgin, named after the frontispiece of a *Golden Legend*.

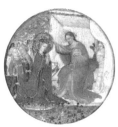

pl. 5. Master of the Mazarine, *Visitation*, ca. 1410–12, vellum, 25 x 17.5 cm, *Book of Hours*, Paris, Bibliothèque Mazarine, MS 469, folio 36.
The manuscript may have belonged to King Charles VI, and has helped identify an important illuminator, who may have been the principal collaborator of the Boucicaut Master (Jacques Coene?), with whom he had been mistakenly identified for a long time; his simpler style distinguishes him, however.

pl. 6. The Limbourg brothers, *The Month of April*, ca. 1413–16, vellum, 29 x 21 cm, *Très Riches Heures du duc de Berry*, Chantilly, Musée Condé, MS 65, folio 4v.
Named after the inventory drawn up after the duc de Berry's death in 1416, the *Très Riches Heures* were incomplete at the time of the death of the painters Pol, Jean, and Herman de Limbourg. Additions were made by Barthélemy d'Eyck in the 1440s, and the work was completed ca. 1485 by Jean Colombe, at the court of Savoy.

pl. 7. Circle of the Limbourg brothers, *Portrait of a woman in profile*, ca. 1410–15, tempera on wood, 52 x 36,6 cm, Washington D.C., National Gallery of Art, inv. 1937.1.23.
Formerly attributed to Pisanello, this panel with bare outlines shows affinities with the work of the Limbourg brothers, and might be evidence of their activity in easel painting, in which case, the sitter might belong to the court of the duc de Berry.

pl. 8. Jean de Beaumetz, *Calvary*, ca. 1389–95, tempera on wood, 60 x 48.5 cm, Paris, Musée du Louvre, inv. R. F. 1967–3.
The panel belongs to a set of twenty-six Calvaries, one for each monk's cell in the Champmol Charterhouse; a second exemplar, of lesser quality, is in the Cleveland Museum of Art. Its flowing *ductus* and soft modelling recall the style of the Master of the Small Pietà Roundel.

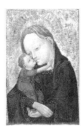

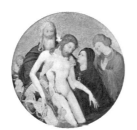

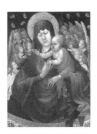

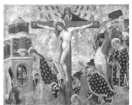

pl. 9. Collaborator of Jean de Beaumetz (Master of the Breviary of Jean Sans Peur?) *Virgin and Child*, ca. 1400, tempera on wood, 21.9 x 14.3 cm, New York, Frick Collection, inv. 27.1.57.
Set in a richly adorned frame, the panel imitates a Sienese model and its manner is comparable to that of Jean de Beaumetz. Its rather dry graphic style and the plant motifs in the background link it to the Cleveland *Calvary*. It might be by one of Beaumetz' associates, such as the Master of the Breviary of Jean Sans Peur, an illuminator expressing the same sense of pathos.

pl. 10. Jean Malouel, *Large Pietà Roundel*, ca. 1400–4, tempera on wood, 64.5 cm (diam.), Paris, Musée du Louvre, inv. M. I. 692.
The panel's reverse bears the coat of arms of the duke Philippe le Hardi (d. 1404) and was made for the Champmol Charterhouse, as confirmed by its subject, the Trinity. Midway between Jean de Beaumetz' sense of pathos and the Limbourgs' bareness, it can be attributed to Jean Malouel.

pl. 11. Jean Malouel, *Virgin and Child with Butterflies*, ca. 1410–15, tempera on canvas, 107 x 81 cm, Berlin, Gemäldegalerie, on loan.
Perhaps made for Duke Jean Sans Peur, the canvas shows the Virgin and Child in half-length behind a curtain, according to a model commonly adopted in Gueldre and Westphalia (cf. Meister Francke). It is a derivation of the *Beistegui Virgin and Child* and the *Large Pietà Roundel*, from which it differs slightly in terms of the arrangement of volumes.

pl. 12. Henri Bellechose, *Trinity with the Communion and Martyrdom of St Denis*, 1416, tempera on wood remounted on canvas, 162 x 211 cm, Paris, Musée du Louvre, inv. M. I. 674.
Painted for the Champmol Charterhouse, according to a document of 1416, the panel was "perfected", by Henri Bellechose, Malouel's successor. Long held to be a work in which the two painters collaborated, its uniform execution justifies the attribution to Henri Bellechose alone, albeit deeply influenced by his predecessor's last works.

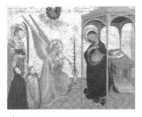

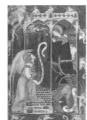

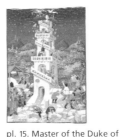

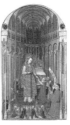

pl. 13. Jacques Iverny, *Annunciation*, ca. 1430, tempera on wood, 151 x 193 cm, Dublin, National Gallery of Ireland, inv. 1780.
The altarpiece may originally have hung in a church in Avignon. With its rectangular, unified composition it adopts a Provençal tradition contemporary to the Florentine revival. It was probably painted a few years before the Turin triptych, in which we find the same figure types derived from Sienese models.

pl. 14. Rohan Master, *Annunciation*, ca. 1430, vellum, 29 x 21 cm, *Grands Heures de Rohan*, Paris, Bibliothèque Nationale, MS Lat. 9471, folio 45.
According to the coat of arms, the manuscript once belonged to a member of the Rohan family, an involved the contribution of several illuminators, among whom the principal one is characterised by a singular style, emblematic of the "mannerist" period of International Gothic, namely, the denial of spatial conventions, and an expressive, tense execution.

pl. 15. Master of the Duke of Bedford, *Construction of the Tower of Babel*, ca. 1423–30, vellum, 26.3 x 18.5 cm, *Heures du duc de Bedford*, London, British Library, Add. 18850, folio 17v.
The miniaturist takes his name from three manuscripts illuminated for John of Lancaster, duke of Bedford and regent of France from 1422 to 1435. Less eccentric than the Rohan Master, the artist nonetheless shares the latter's "mannerist" conception of International Gothic, with small nervous figures and a two-dimensional rendering of space.

pl. 16. Master of the Collins Hours, *The Ministry of the Virgin*, 1438, tempera on wood, 99 x 57 cm, Paris, Musée du Louvre, R. F. 1938-63.
The panel was commissioned in 1438 by Jean du Bos, master of the Puy Notre-Dame confraternity at Amiens, who is depicted with the inscription "Digne vesture au prestre souverain". Belonging to the stiff, simplified late phase of International Gothic, it has recently been attributed to the Master of the Collins Hours, an important illuminator active in Amiens in the 1440s.

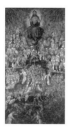

pl. 17. Dunois Master (Conrad de Vulcop?), *Last Judgement*, ca. 1435–40, tempera on wood remounted on canvas, 110 x 65 cm, Paris, Musée des Arts Décoratifs, inv. Pe. 1.
The panel features a composition that appears almost identical in the Windsor Castle *Sobieski Hours* (folio 109). Formerly attributed to a Dutch painter, the painting is by the Master de Dunois who, with his northern background and his clientele recruited in royal circles, might be tentatively identified with Charles VII's first painter, Conrad de Vulcop.

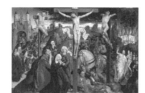

pl. 18. André d'Ypres, *Passion Scenes*, ca. 1445–50, oil on wood, 48 x 71.5 cm, Los Angeles, J. Paul Getty Museum, inv. 79.PB.177.
The panel forms the central section of a triptych commissioned by Dreux Brudé, councillor of Charles VII; the wings depict the *The Betrayal* (Bremen, Bischoff collection) and the *Resurrection* (Montpellier, Musée Fabre). The triptych is probably by André d'Ypres who, after his apprenticeship at Tournai, was active at Amiens and introduced the *Ars Nova* to Paris just before the middle of the century.

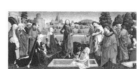

pl. 19. Colin d'Amiens, *Raising of Lazarus*, ca. 1455–60, oil on wood, 78.5 x 141 cm, Paris, Musée du Louvre, inv. R. F. 2501.
The panel was recently matched with a small piece of the right section (78.5 x 35 cm), indicating that it shows on each side the donors, still not identified. Its blurred design interprets the Netherlandish models in the manner of the Picard, Simon Marmion, and it can be assigned to André d'Ypres' son, Colin d'Amiens.

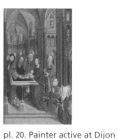

pl. 20. Painter active at Dijon (Jean de Maisoncelles?), *Presentation in the Temple*, ca. 1440–45, tempera on wood, 88 x 53 cm, Dijon, Musée des Beaux-Arts, inv. 3765.
In the lower right corner the panel depicts the donors in prayer, yet to be identified. Its composition is almost identical to one in a mural (unfortunately very damaged), in the church of Notre-Dame in Dijon. With its Tournai-style background, it might be by Jean de Maisoncelles, who was born in Artois and active at Dijon.

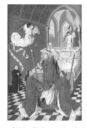

pl. 21. Painter active at Dijon (Pierre Spicre?), *Mass of St Gregory*, ca. 1460, tempera on wood, 60 x 39.7 cm, Paris, Musée du Louvre, inv. R. F. 1941–8.
According to an indication on the back, the panel comes from the Champmol Charterhouse. Its composition derives from a Tournai model adopted by Dijon illuminators. Long held to be a Picard work, the piece has recently been attributed to Pierre Spicre, active at Dijon, on the evidence of the documented hangings of the Beaune collegiate church (1474).

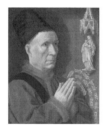

pl. 22. Painter active in Burgundy (Guillaume Spicre?), *Portrait of a Man at Prayer*, ca. 1470, oil on wood, 60 x 49 cm, Dijon, Musée des Beaux-Arts, inv. D 1986 I. P.
See pl. 23.

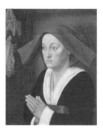

pl. 23. Painter active in Burgundy (Guillaume Spicre?), *Portrait of a Woman at Prayer*, ca. 1470, oil on wood, 60 x 49 cm, Dijon, Musée des Beaux-Arts, inv. D 1986 I. P.
The diptych that comes from the chateau of Epiry (near Beaune) depicts a couple formerly identified with the lords of Rabutin, and evinces a very synthetic style that is also found in the wall paintings of the Saint-Maire chateau in Lausanne (unfortunately in very poor condition), commissioned toward 1476–77 by Bishop Benoît de Montferrand, perhaps from Guillaume Spicre.

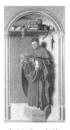

pl. 24. Barthélemy d'Eyck, *The Prophet Jeremiah*, ca. 1443–44, oil on wood, 152 x 86 cm, Brussels, Musées Royaux des Beaux-Arts, inv. 4494.
The panel has a *Noli me tangere* Christ on the back, and is the right wing of a triptych whose central section depicts the *Annunciation* (Aix-en-Provence, Sainte-Marie-Madeleine) and the left wing the prophet Isaiah (divided between Rotterdam and Amsterdam). It was commissioned by the draper-merchant Pierre Corpici for the cathedral of Saint-Sauveur in Aix-en-Provence.

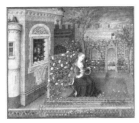

pl. 25. Barthélemy d'Eyck,
Emily in the Garden, ca. 1460,
vellum, 26.6 x 20 cm,
Giovanni Boccaccio, *Teseida*,
Vienna, Österreichische
Nationalbibliothek,
Cod. 2617, folio 53.
The Vienna *Teseida*, like the *Cœur
d'amour épris*, the *Livre des
Tournois* and the lost original
of the *Mortifiement de vaine
plaisance*, belongs to the maturity
of Barthélemy d'Eyck who, in
adopting a clear layout, adjusted
to the refined taste of his patron
René d'Anjou.

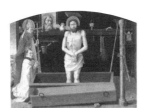

pl. 26. Painter active in
Provence, *Boulbon altarpiece*,
toward 1450–60, oil on wood
remounted on canvas,
172 x 227.8 cm, Paris, Musée
du Louvre, inv. R. F. 1536.
The altarpiece that comes from
the church of Saint-Marcellin in
Boulbon was probably created for
Saint-Agricol in Avignon. Its style
lies midway between Barthélemy
d'Eyck and Enguerrand Quarton.

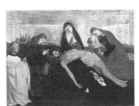

pl. 27. Enguerrand Quarton
(or Charanton), *Avignon Pietà*,
ca. 1455, oil on wood,
163 x 218.5 cm, Paris,
Musée du Louvre, inv. R. F. 1569.
The panel comes from the
Charterhouse of Villeneuve-lès-
Avignon. It depicts a *Pietà* with a
kneeling donor that may plausibly
be identified with Jean de
Montagnac, who commissioned
the *Coronation of the Virgin* from
Enguerrand Quarton for the same
building. It appears to have given
rise to several imitations, such as
the *Tarascon Pietà* (Paris, Musée
National du Moyen-Age).

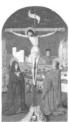

pl. 28. Enguerrand Quarton
(or Charanton), *Calvary*, ca.
1465–66, vellum, 36.6 x 27.6 cm,
Missal of Jean des Martins,
Paris, Bibliothèque Nationale,
MS N. a. Lat. 2661, folio 292.
This important missal, whose date
and commissioner (Jean des
Martins, chancellor of Provence)
are known to us by the colophon,
provides a valuable reference for
the painter's late activity, making
it possible to date works such as
the Carpentras *Coronation of the
Virgin* or the Altenburg-Vatican
diptych to the 1460s.

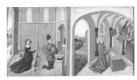

pl. 29. Provençal painter (Pierre
Villate?), *St Bernardino of Siena
and two Donors*, ca. 1460, oil on
wood, 37 x 68 cm, Marseille,
Musée Grobet-Labadié.
Divided into two compartments,
the panel from a collection in
Aix-en-Provence is doubtless part
of a predella. It shows the hand
of a Provençal painter steeped
in Enguerrand Quarton's example,
whom we might identify with the
latter's collaborator Pierre Villate
on the grounds of similarities with
a set of miniatures.

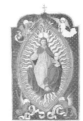

pl. 30. Antoine de Lonhy,
Majestas Domini, ca. 1460,
vellum, 34.5 x 25 cm,
Los Angeles, J. Paul Getty
Museum, MS 69.
The page is from a missal,
of which a *Crucifixion* miniature
is kept in the Narodni Gallery of
Prague. Copied in a missal of
Toulouse Use (preserved *in situ*,
Bibliothèque Municipale, MS 95),
it testifies the painter's stay in
Languedoc between the beginning
of the early 1450s and the early
1460s.

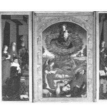

pl. 31. Nicolas Froment,
Moses and the Burning Bush,
ca. 1475–76, oil on wood,
225 x 192 cm (folded shut),
Aix-en-Provence, Saint-Sauveur
Cathedral.
The triptych was created for the
King René's chapel in the church of
Grands-Carmes in Aix-en-Provence.
The back carries an *Annunciation*
derived from a Jan van Eyck model.
The front shows the donors in
prayer before the *Burning Bush*,
a symbol of Mary's virginity.

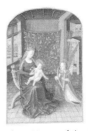

pl. 32. Master of the Geneva
Boccaccio (Coppin Delf?), *Virgin
and Child*, ca. 1455–60, vellum,
19 x 12.5 cm, *Book of Hours*,
Paris, Bibliothèque Nationale,
MS Rothschild 2530, folio 165.
This sheet reveals Barthélemy
d'Eyck's deep influence on the
Master of the Geneva Boccaccio,
who was active in Anjou,
and worked for King René.
We might tentatively identify
him with Coppin Delf, celebrated
by historiography as an
outstanding painter.

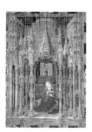

pl. 33. Master of Charles of France (Jean de Laval?), *Virgin of the Annunciation*, 1465, vellum, 17 x 12.5 cm, page from a *Book of Hours*, New York, Metropolitan Museum of Art, Cloisters, inv. 58.71b.
Dated 1465, the page comes from a *Book of Hours* illuminated for Charles of France, Louis XI's younger brother (Paris, Bibliothèque Mazarine, MS 473). The work is generally ascribed to Jean de Laval, who was in the service of Charles at Bourges in the 1460s.

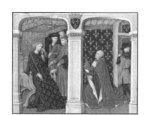

pl. 34. Master of Bartholomaeus Anglicus, *Scene of presentation of the book*, ca. 1445–50, vellum, 31.8 x 24.2 cm, *Livre des Propriétés des Choses*, Paris, Bibliothèque Nationale, MS Fr. 135, p. 26.
This impressive page depicts the author, Jean Corbichon, offering his French translation of the *Livre des Propriétés des Choses* by Bartholomaeus Anglicus to King Charles V of France. It is from a manuscript split into two volumes, whose recipient is still unknown, but which bring to light a prominent painter whose style is close to that of the presumed Jacob de Litemont.

pl. 35. Jacob de Litemont, *Stained-glass window of the Annunciation*, ca. 1450, Bourges, Saint-Étienne.
Installed in the Jacques Cœur chapel, the window displays direct knowledge of Jan van Eyck's models, and is apparently by the same artist as the *Vault of Angels*, unfortunately heavily overpainted, in the Bourges' financier's mansion. It might be the work of Jacob de Litemont, who became Charles VII's official painter in 1451. According to a recent hypothesis, Jean Fouquet, just back from Italy, might also have collaborated in it (*St Catherine*).

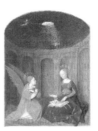

pl 36. Jouvenel Master (Henri de Vulcop?), *Annunciation*, ca. 1450, vellum, 20.5 x 14.4 cm, Book of Hours, Paris, Bibliothèque Nationale, MS N. a. Lat. 3211, p. 35.
The *Annunciation* is from an Angevine *Book of Hours* on which young Fouquet collaborated. The Jouvenel Master was a painter of the preceding generation, and may have been important in Fouquet's training. Associated with the innovations from the north, he might be tentatively identified with Henri de Vulcop, a Dutch painter in the service of Marie of Anjou.

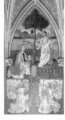

pl. 37. Painter active at Bourges, *Noli me tangere*, ca. 1470, wall painting, Bourges, Saint-Étienne.
The mural belongs to the decoration executed in the chapel of the Breuil family. In the foreground it depicts the canons Jean and Martin du Brueil. Its figure types and ivory-white flesh tints recall the art of the Jouvenel Master, who would have assimilated several Italianate features in the meantime. However its very poor state of conservation makes attribution difficult.

pl. 38. Jean Fouquet, *Étienne Chevalier presented by St Stephen*, ca. 1452, oil on wood, 93 x 85 cm, Berlin, Gemäldegalerie, inv. 1617.
The panel is the left wing of a diptych of which the right wing with a *Virgin and Child* is in Antwerp, and it comes from the church of Notre-Dame in Melun. It depicts Étienne Chevalier, assessor of receipts in 1444 and treasurer of France after 1452, in the company of his patron saint. It displays very vivid reminders of Italy in the carefully rendered coloured marble and Renaissance architecture.

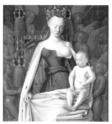

pl. 39. Jean Fouquet, *Virgin and Child*, ca. 1452, oil on wood, 94.5 x 85.5 cm, Antwerp, Koninklijk Museum voor Schone Kunsten, inv. 132.
A pendant of the preceding item, the panel belongs to the Melun diptych, whose frame also contained two enamelled medallions: the Louvre *Self-portrait* and an episode from the *Life of St Stephen* (formerly in Berlin). It equally draws on Italian art, using a sculptural manner and recalling the glazed terra-cotta *Madonna and Child* reliefs from the della Robbia workshop.

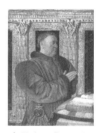

pl. 40. Jean Fouquet, *Portrait of Guillaume Jouvenel des Ursins*, ca. 1460–65, oil on wood, 96 x 73.2 cm, Paris, Musée du Louvre, inv. 9619.
The panel, of which a preparatory drawing has survived, shows the portrait of Guillaume Jouvenel des Ursins, chancellor of France, in prayer in a setting in which Italian motifs are adapted to suit the going taste for excess. The piece may be the left wing of a diptych, its counterpart (now lost) perhaps featuring a *Madonna and Child*.

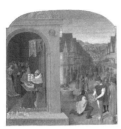

pl. 41. Master of the Munich Boccaccio (François or Louis Fouquet?), *Boccaccio at work*, ca .1459–60, vellum, 39.8 x 29.5 cm, *Des cas des nobles hommes et femmes de Boccace*, Munich, Bayerische Staatsbibliothek, Cod. Gall. 6 (formerly Gall. 369), folio 10. The manuscript containing a full page by Jean Fouquet (the *Lit de Justice de Vendôme*) is mainly illuminated by a younger artist, recently assigned the name Master of the Munich Boccaccio, who might be one of the Tours painter's sons.

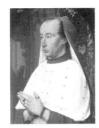

pl. 42. Jean Hey, *Portrait of Charles de Bourbon*, ca. 1476–80, oil on wood, 34 x 25.7 cm, Munich, Alte Pinakothek, inv. WAF 648. Usually referred to the 1480s, the panel might date a little earlier, at the end of the 1470s, given that its stiff draughtsmanship shows Hey still under the influence of Hugo van der Goes before his style became more flowing.

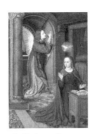

pl. 43. Jean Hey, *Annunciation*, ca. 1490, oil on wood, 72 x 50 cm, Chicago, Art Institute, inv. 1933.1062. The *Annunciation* forms part of an altarpiece to which the London *Meeting at the Golden Gate* also belongs. Based on a typically Netherlandish composition, it integrates Italianate architectural elements probably encountered in France, at Lyon or Moulins. It appears to be mid-way between the stiffness of the *Portrait of Charles de Bourbon* and the softer manner of the Brussels *Man of Sorrows*.

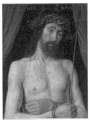

pl. 44. Jean Hey, *Man of Sorrows*, 1494, oil on wood, 39 x 30 cm, Brussels, Musées Royaux des Beaux-Arts de Belgique, inv. 4497. Created by Jean Fouquet in a manner similar to the *Portrait of Charles VII* the panel depicts an *Ecce Homo* between two curtains. The inscriptions indicate it was painted in 1494 for Jean Cueillette, treasurer of the Bourbons, by "magister Johannes Hey teutonicus". Thus it provides us with the key for the identification of the painter who used to be known as the Master of Moulins in reference to the *Moulins Triptych*.

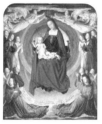

pl. 45. Jean Hey, *Moulins Triptych*, ca. 1500, oil on wood, 159 x 133 cm (centre), Moulins, Notre-Dame. Commissioned by Pierre II de Bourbon and Anne de Beaujeu, the triptych shows the donors at prayer in front of the *Virgin and Child in Glory*, and on the reverse a grisaille *Annunciation*. It was probably made for the chapel of the castle of Moulins, where construction was under way in the late 1490s. According to the probable age of little Suzanne (born in 1491), it could not date to before 1500/1 which would make it Jean Hey's last work.

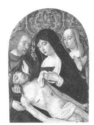

pl. 46. Dreuille Master, *Pietà with St John and St Mary Magdalene*, ca. 1500, oil on wood, 34 x 25 cm, Paris, Musée du Louvre, R.F. 536. The panel is the work of a minor painter, who was active in the Bourbonnais in the late 15th century concurrently with Jean Hey, whose models he imitated in simplified form. We can attribute to him the Autry-Issards *Pietà*, commissioned by the Dreuille family, the Otterlo *Madonna and Child*, the *Virgin and Child with an angel* sold in Paris in 1985, and more tentatively the cartoons for the *Petitdé* stained-glass window in Moulins Cathedral.

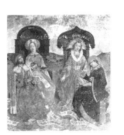

pl. 47. Painter active in the Languedoc, *The Liberal Arts* (detail), ca. 1500, wall painting, Le-Puy-en-Velay Cathedral. The mural that decorates the former library planned by Canon Odin shows fragments of four personifications of the *Liberal Arts*. It suggests a Hispanic manner midway between Flanders and Italy that can be seen in several Languedoc sculptures.

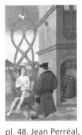

pl. 48. Jean Perréal, *Nature chastising the Errant Alchemist*, 1516, vellum, Paris, Musée Marmottan, Wildenstein Collection, MS 147. This illumination that resurfaced in 1963 depicts an alchemical allegory. Originally it illustrated a poem signed by Perréal himself in the form of an acrostic. It is thus the key work for reconstructing the work of the painter, especially renowned as a portraitist. It reflects a hybrid background, associating Burgundy and the Loire.

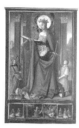

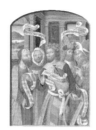

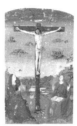

pl. 49. Attributed to Claude Guinet, *St Catherine*, 1507, oil on wood, 158 x 100 cm, Lyon, Musée des Beaux-Arts, inv. B 564.

Dated to 1507, the panel might come from Beaujeu, Anne of France's fiefdom. It borrows an Italian structure with a predella showing the *Martyrdom of St Catherine* accompanied by kneeling canons. It might be by one Claude Guinet, active in Lyon from 1493 to 1512/13. His manner is reminiscent of Josse Lieferinxe.

pl. 50. Georges Trubert, *David and Four Prophets*, ca. 1492–93, vellum, 24.7 x 16.5 cm, *Diurnal of René II of Lorraine*, Paris, Bibliothèque Nationale, MS Lat. 10491, folio 7.

According to ducal accounts, the diurnal (day breviary for the use of laymen) of the duke René II of Lorraine was written at Nancy in 1492–93 by François Elzine, summoned from Provence to perform this task. It was concurrently illuminated by the duke's miniaturist, Georges Trubert. His personality is a recent discovery and he appears to have specialised in miniatures.

pl. 51. Painter active in Provence (Jean Changenet?), *Three Prophets*, ca. 1490, oil on wood, 61 x 94.5 cm, Paris, Musée du Louvre, inv. 1992.

The fragmentary panel depicts the prophets Isaiah, Jeremiah and Ezechiel. It may have completed an *Annunciation*. Reflecting influences of Sluter's sculpture and Quarton's use of light, it is probably by a Burgundian painter active in Provence, a painter plausibly identified with Jean Changenet. Its composition is comparable to the preceding entry.

pl. 52. Master of the Burgundian Prelates (Pierre Changenet?), *Calvary*, ca. 1490, vellum, 39.2 x 27.6 cm, *Missal of Richard Chambellan*, Paris, Bibliothèque Nationale, MS Lat. 879, folio 105v.

The *Calvary* belongs to a missal illuminated for Richard Chambellan, abbot of Saint-Étienne in Dijon between 1477 and 1495, and is by a painter known as the Master of the Burgundian Prelates, who might be one and the same as Pierre Changenet, in Dijon between 1478 and 1503 and the brother of Jean (active in Provence). As a matter of fact its composition can be found in Provençal circles, as the following entry suggests.

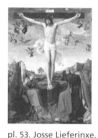

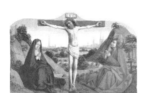

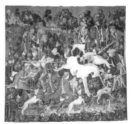

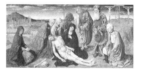

pl. 53. Josse Lieferinxe, *Calvary*, ca. 1500, oil on wood, 170 x 126 cm, Paris, Musée du Louvre, inv. R. F. 1962-1.

The panel is probably the central section of an altarpiece, the other parts of which have so far not been traced. Its composition, apparently of Burgundian derivation, may have been passed down to Josse Lieferinxe by the Changenet workshop. Indeed he was clearly in contact with Jean Changenet since he married one of his daughters in 1503. His style, rooted in his northern apprenticeship, assimilated several Piedmontese elements and Provençal light.

pl. 54. Nicolas Dipre, *Calvary*, ca. 1500, oil on wood, 29.2 x 44.3 cm, Detroit, Detroit Institute of Arts, inv. 50.57.

The panel, coming from the Durazzo collection in Genoa, is part of an altarpiece painted for the church of Saint-Siffrein in Carpentras in 1499–1500, other pieces of which are known. Its strident manner is comparable to that of the hangings of the *Unicorn Hunt*, probably created by Nicolas Dipre's brother.

pl. 55. Master of the Très Petites Heures d'Anne de Bretagne, *The Unicorn at Bay*, ca. 1500, tapestry, New York, The Metropolitan Museum of Art, inv. 37.80.4.

The set of hangings this composition belongs to is devoted to the *Unicorn Hunt*, a theme developed during the 14th century featuring erotic connotations and very popular toward 1500. It may have been created, like the series of *The Lady with the Unicorn* (Paris, Musée National du Moyen-Age), by the Master of the Très Petites Heures d'Anne de Bretagne, a versatile painter plausibly identified with Jean d'Ypres.

pl. 56. Master of the Saint-Germain-des-Prés Pietà, *Saint-Germain-des-Prés Pietà*, ca. 1503, oil on wood, 97.3 x 198.5 cm, Paris, Musée du Louvre, inv. 8561.

The panel, of which there is a partial copy (private collection), is the central section of a triptych. Its wings show a *Christ Carrying the Cross* (Lyon, Musée des Beaux-Arts) and a *Resurrection* (present location unknown) by a Cologne painter active in Paris. It was probably commissioned toward 1503 by Guillaume Briçonnet for the abbey of Saint-Germain-des-Prés.

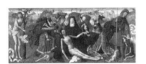

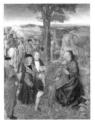

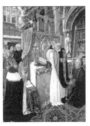

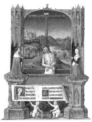

pl. 57. Bouthéon Master, *Lamentation over the Dead Christ*, 1515, oil on wood, Springfield (Mass.), Museum of Fine Arts, inv. 60.05.
The panel is the central panel of a triptych of which the left wing, an *Entombment* (private collection) bears the monogram "M.M." crowned by a tilde and the date 1515. It is by the same hand as a very similar triptych (present location unknown) commissioned three years earlier by Foulque de Bouthéon for the abbey of Saint-Romain-le-Puy in the Forez.

pl. 58. Master of Saint Giles, *St Giles and the Hind*, ca. 1505, oil on wood, 61.6 x 46.4 cm, London, The National Gallery, inv. NG 1419.
The panel, the reverse of which depicts a bishop saint in grisaille, might represent disguised portraits: in particular those of Louis XII and the donor. It is part of an altarpiece that may come from the church of Saint-Gilles-Saint-Leu in Paris, and to which two Washington panels and another London panel belong (see following entry).

pl. 59. Master of Saint Giles, *The Mass of St Giles*, ca. 1505, oil on wood, 61.6 x 45.7 cm, London, The National Gallery, inv. NG 4681.
The panel depicts the St Giles holding Mass in front of the wrought main altar of Saint-Denis, and hence is a valuable document on the church itself. On the back it carries a grisaille *St Peter* in a niche featuring the painter's monogram, probably Gauthier de Campes, active as painter-glassmaker in Tournai Cathedral (where there is a similar monogram), and later in Paris after 1500.

pl. 60. Jean Colombe, *Imago Pietatis*, ca. 1485, vellum, 29 x 21 cm, *Très Riches Heures du duc de Berry*, Chantilly, Musée Condé, MS 65, folio 75.
The folio shows the Man of Sorrows in front of whom Duke Charles I of Savoy and his wife Blanche de Montferrat are in prayer. It belongs to the *Très Riches Heures du duc de Berry*, begun by the Limbourg brothers ca. 1413–16, continued by Barthélemy d'Eyck in the 1440s, and completed by Jean Colombe in Chambéry toward 1485.

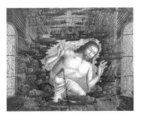

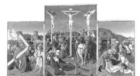

pl. 61. Jacquelin de Montluçon (?), *Apparition of the Risen Christ in a Church*, ca. 1500, oil on wood, 60 x 80 cm, Pont-Saint-Esprit, Musée d'Art Sacré du Gard, inv. CD. 96-12-1.
In all likelihood the panel is a fragment of a *Mass of St Gregory* probably divided into two distinct panels within a larger altarpiece. Its technique is that of an illuminator close to Jean Colombe. It might be attributed to Jacquelin de Montluçon, the author of the altarpiece of the Chambéry Antonites (split between Chambéry, Lyon and a private collection).

pl. 62. Jean Poyer, *Passion Altarpiece*, 1485, oil on wood, 143 x 283 cm, Loches, Musée du Château.
The altarpiece, coming from the Liget Charterhouse, depicts three successive episodes of the Passion: *Christ carrying the Cross*, the *Crucifixion*, and the *Entombment* attended by the donor Jean Béraud. Its complex scenography relates it to Fouquet's tradition. But it also admits a direct contact with northern Italy, and more precisely with Mantegna's milieu, as concurrently attested by the Haarlem *Briçonnet Hours*.

pl. 63. Jean Poyer, *The Feast at Simon's House* (detail), ca. 1500–2, oil on wood, 122 x 207 cm, Lons-le-Saunier, Conseil Général (on loan from the bishopric).
Coarsely overpainted in the right section, the panel came down to us in a poor state of conservation. It is the central part of a triptych devoted to St Mary Magdalene and commissioned around 1500–2 by Jean IV de Chalon for the Cordeliers' church at Nozeroy (Jura). Two wings of this triptych have been preserved, remounted on canvas (church of Censeau).

pl. 64. Jean Bourdichon, *Triptych of the Virgin and Child*, ca. 1501–04, oil on wood, 114 x 74 cm, Naples, Museo di Capodimonte, inv. Q.25.
The triptych was probably commissioned by Frederick of Aragon who, in exile at Tours from 1501 to 1504, also commissioned Bourdichon for a sumptuous Book of Hours (Paris, Bibliothèque Nationale). It probably was taken to Naples by 1504, where it was placed at an unknown date in the charterhouse of San Martino, and copied by Protasio Crivelli.

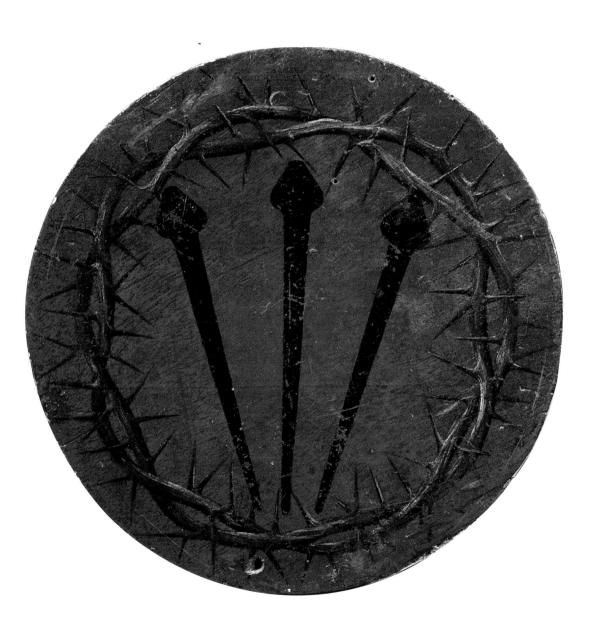

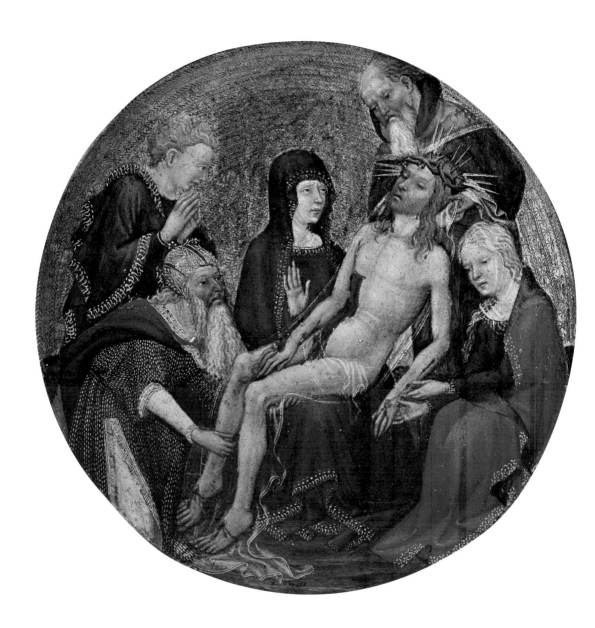

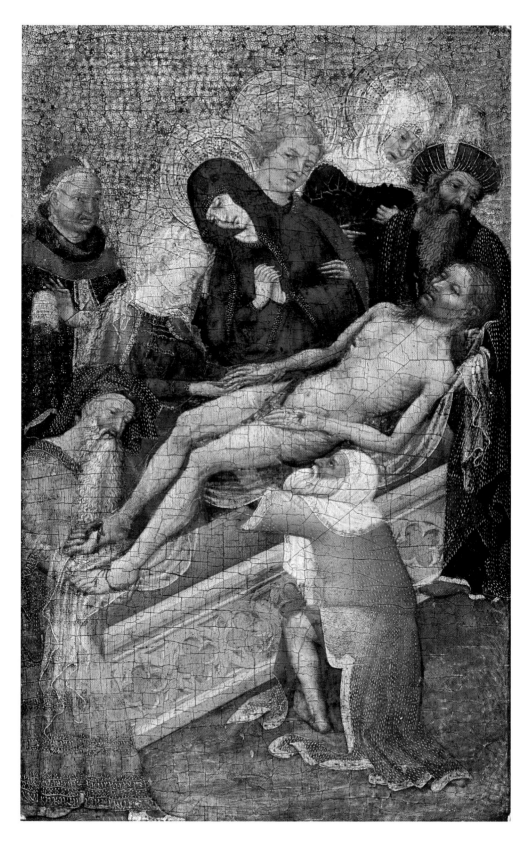

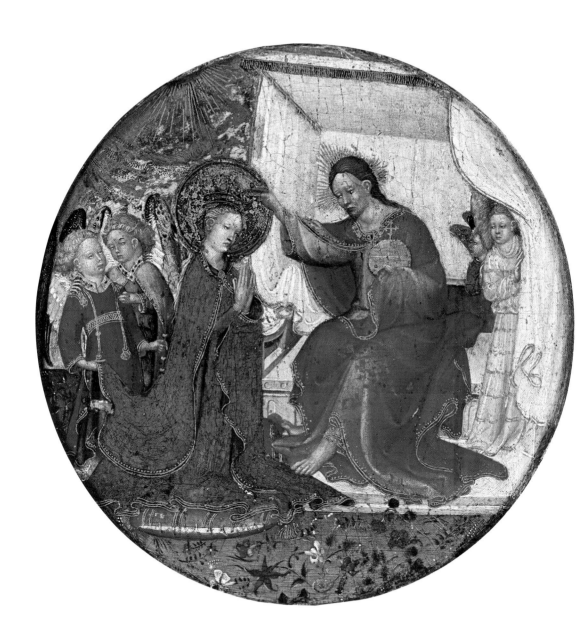

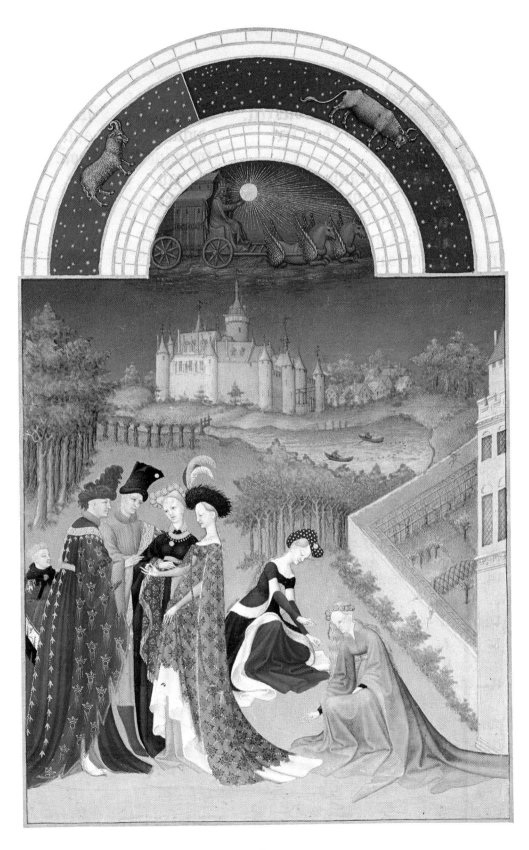

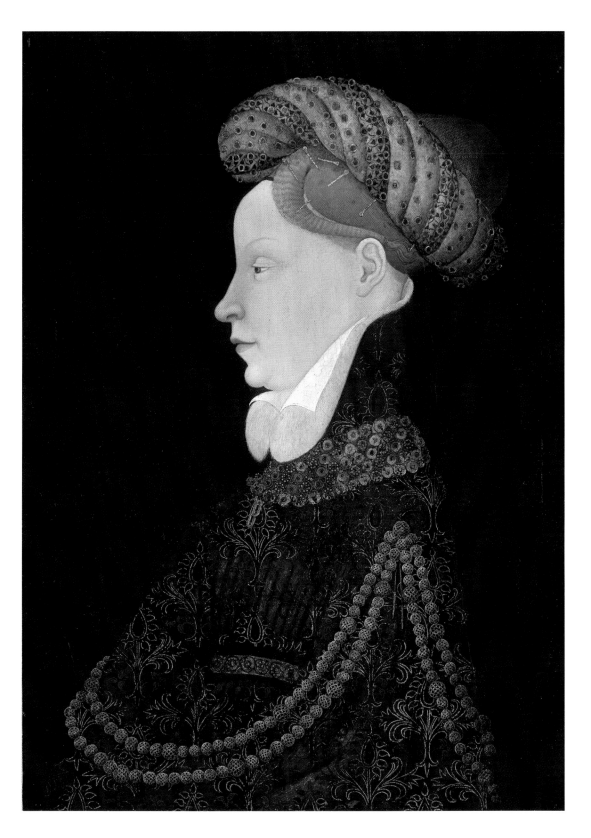

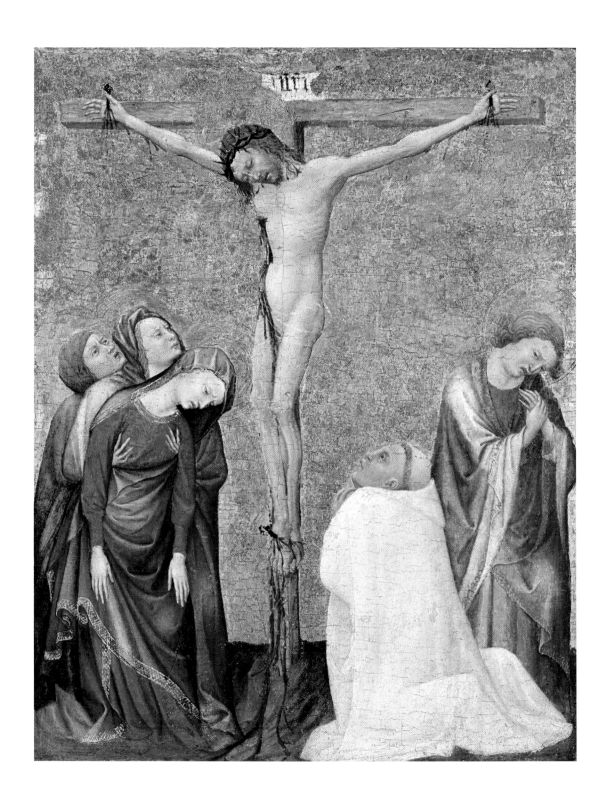

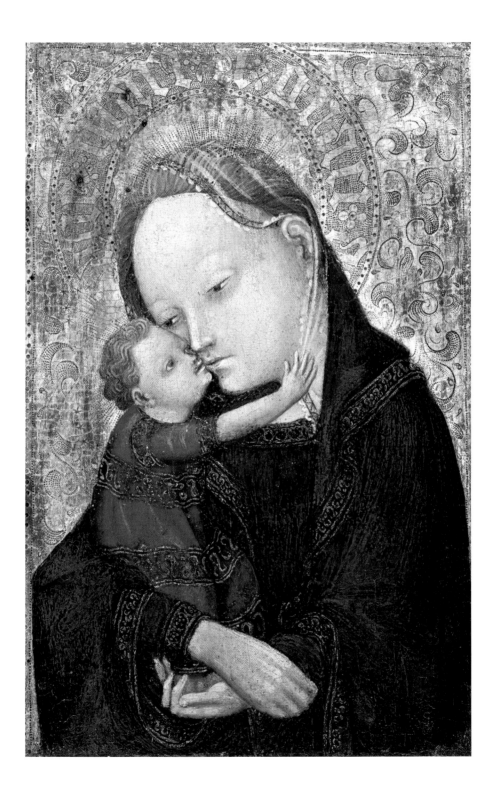

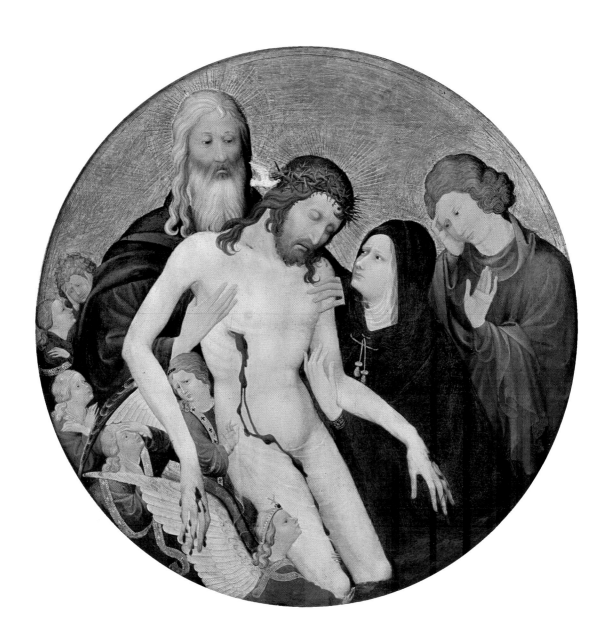

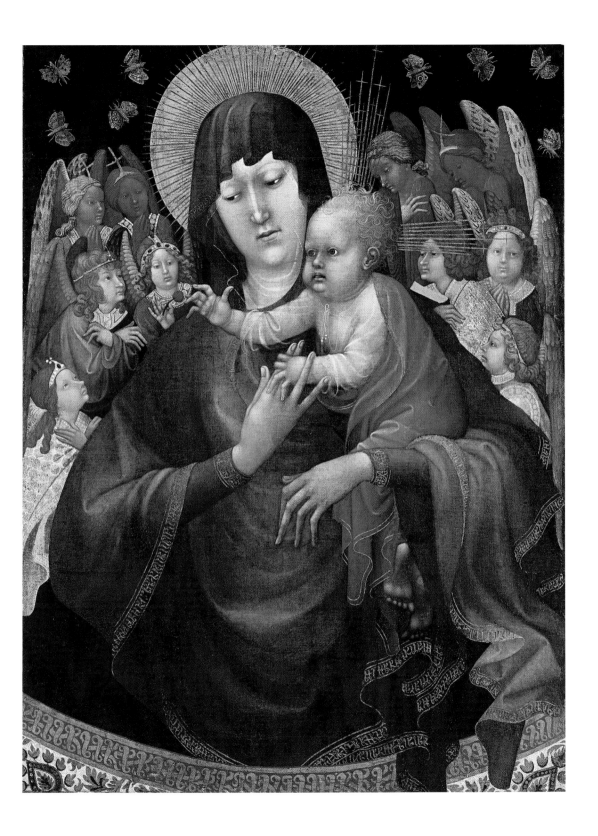

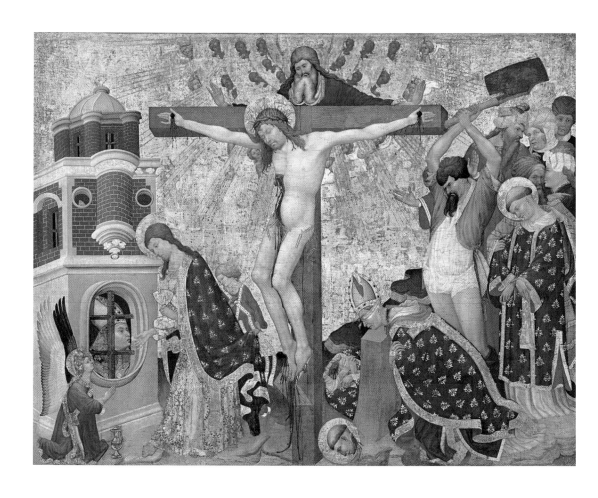

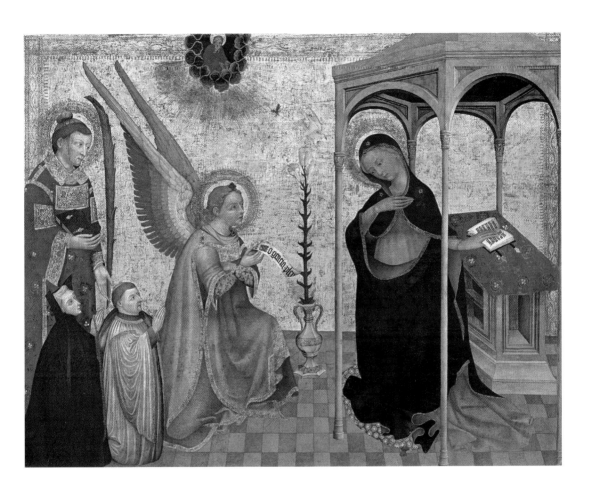

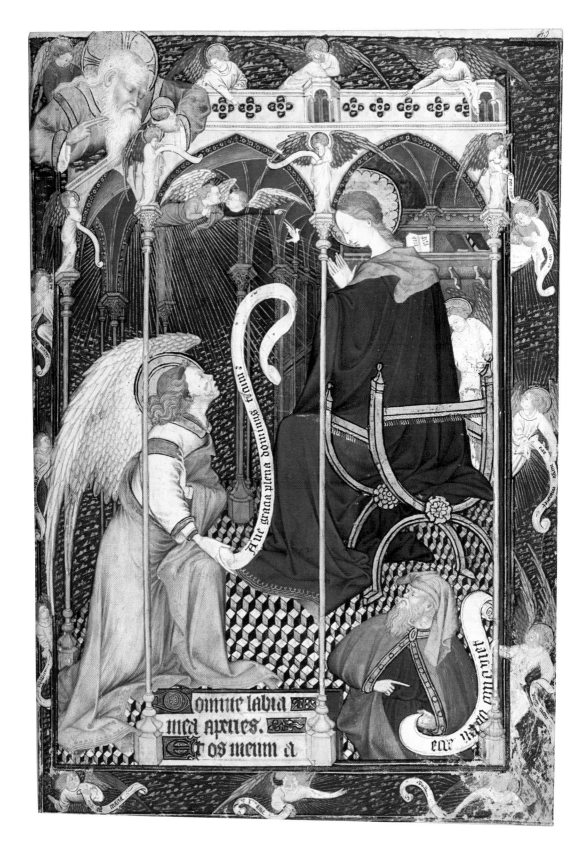

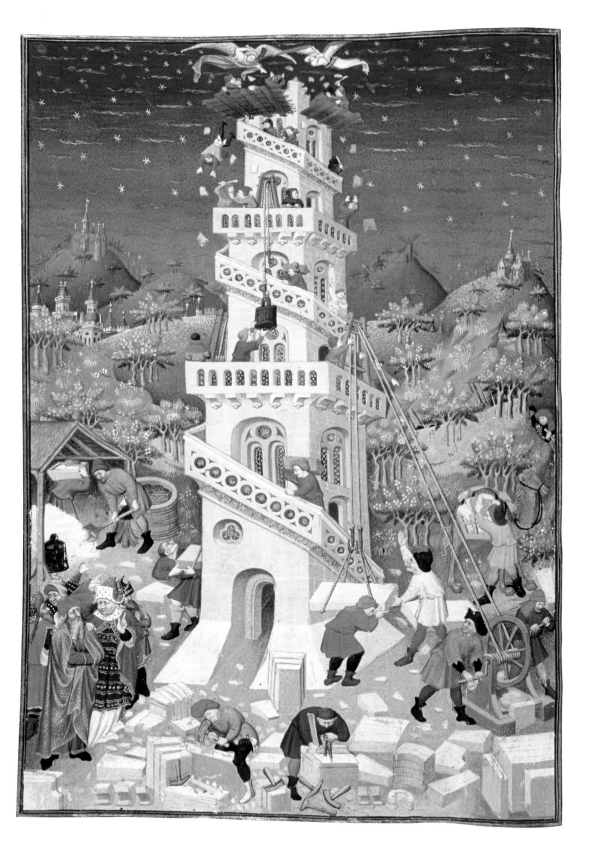

16

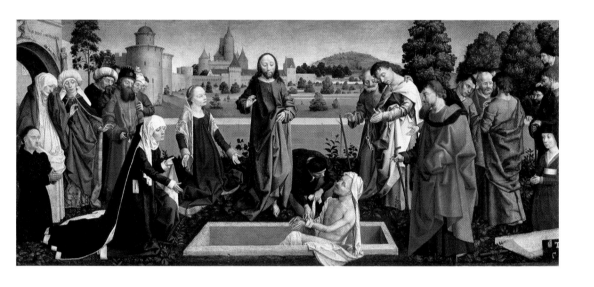

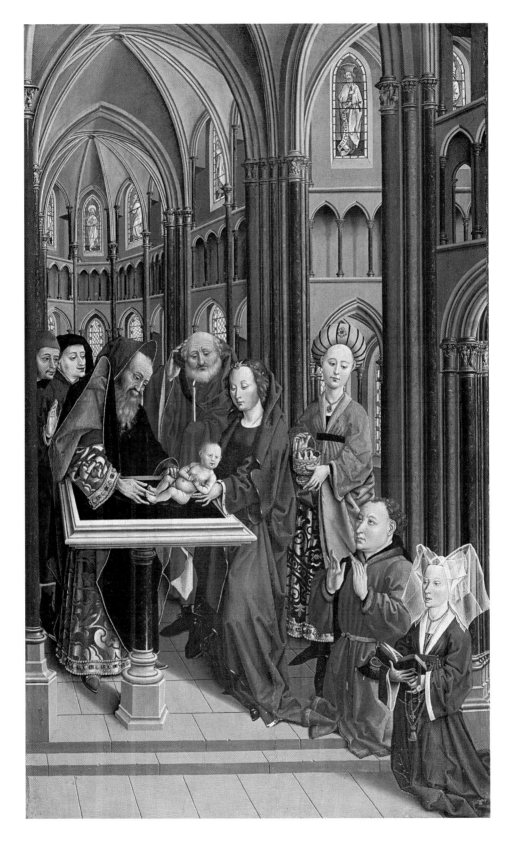

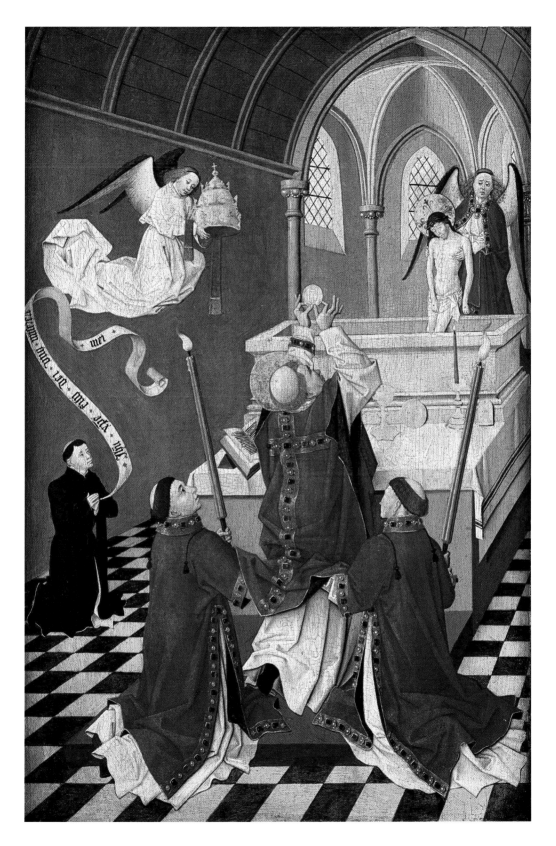

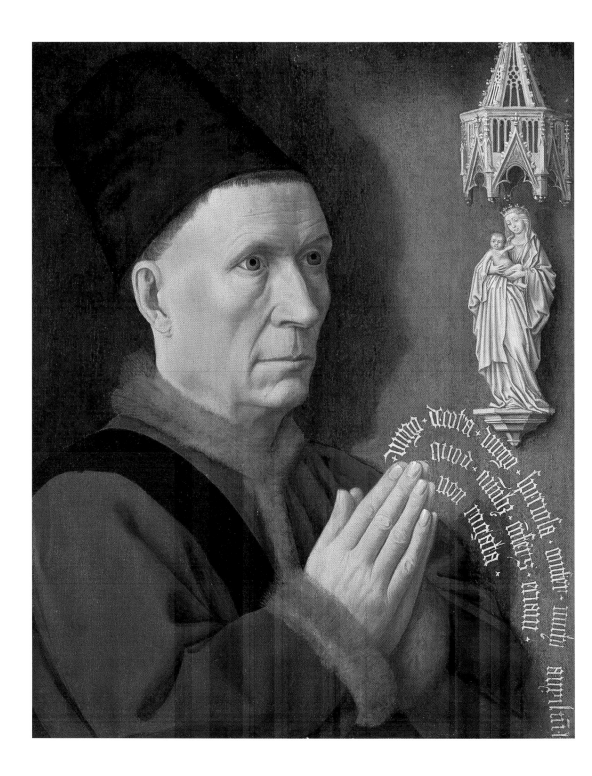

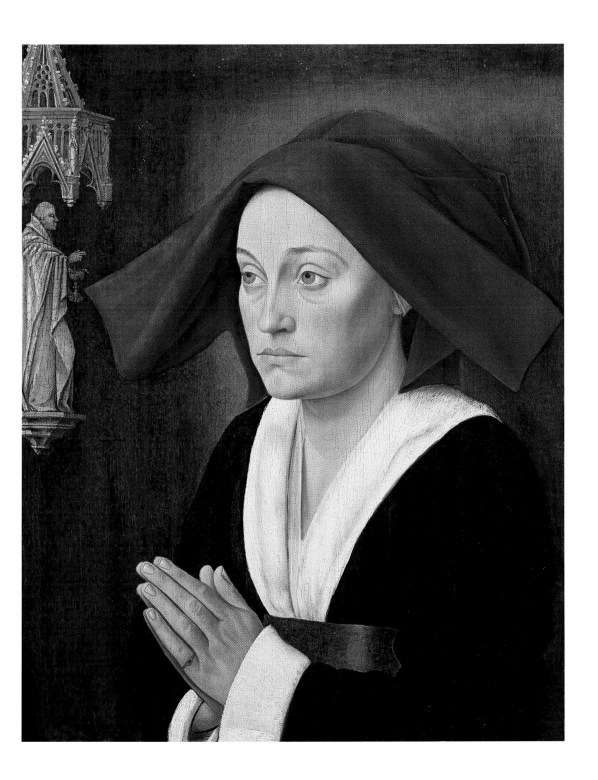

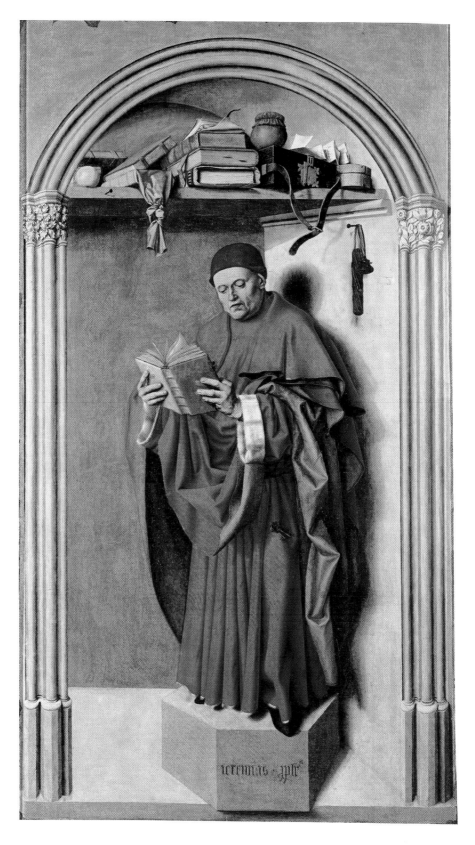

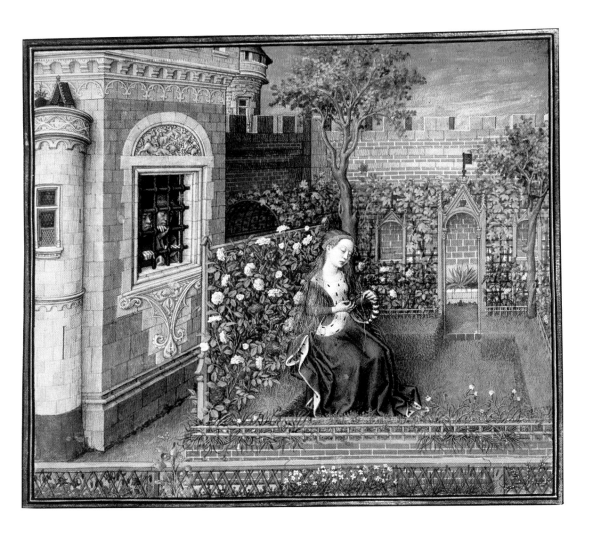

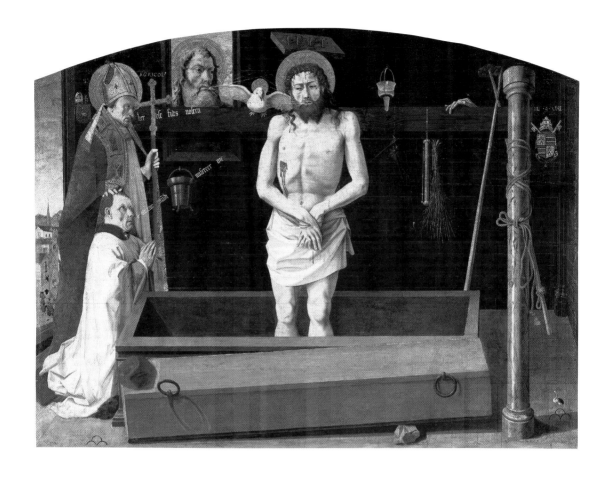

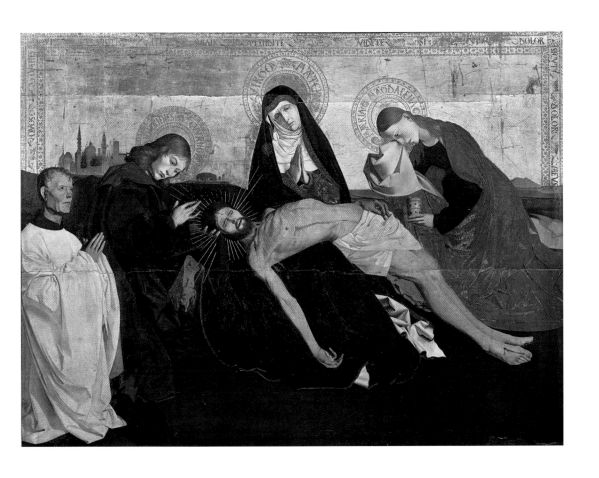

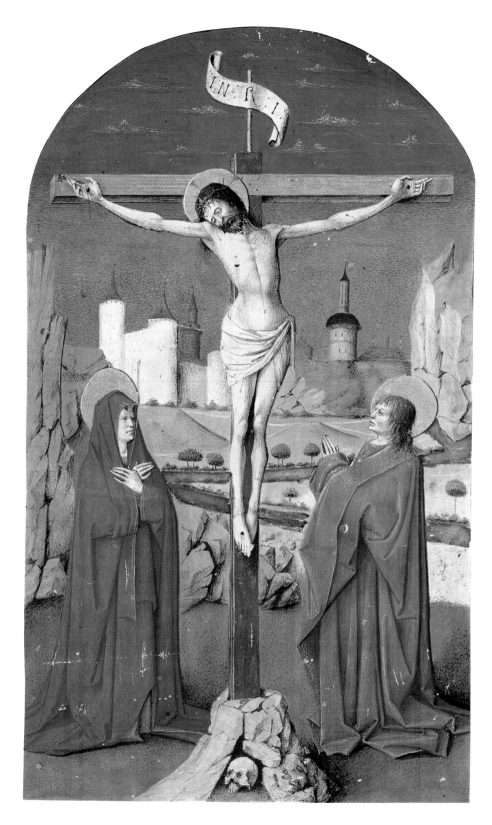

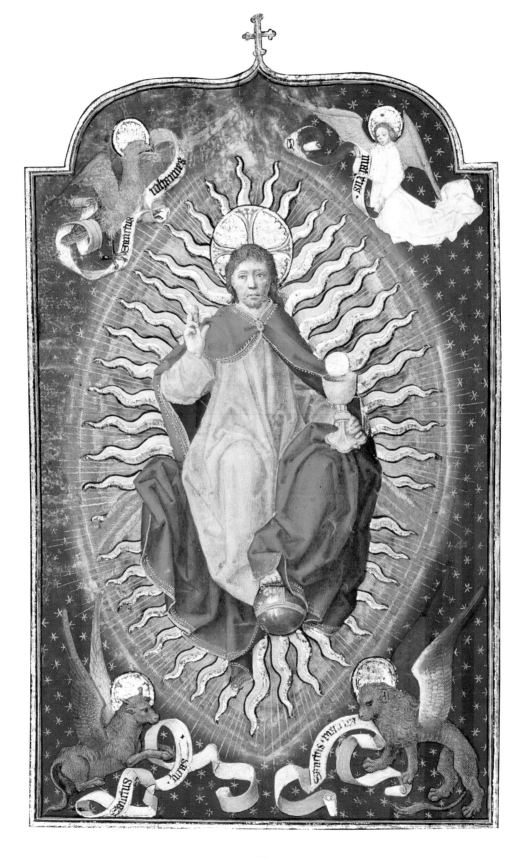

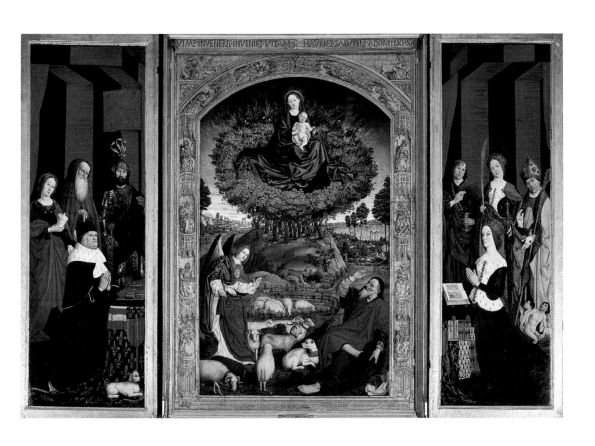

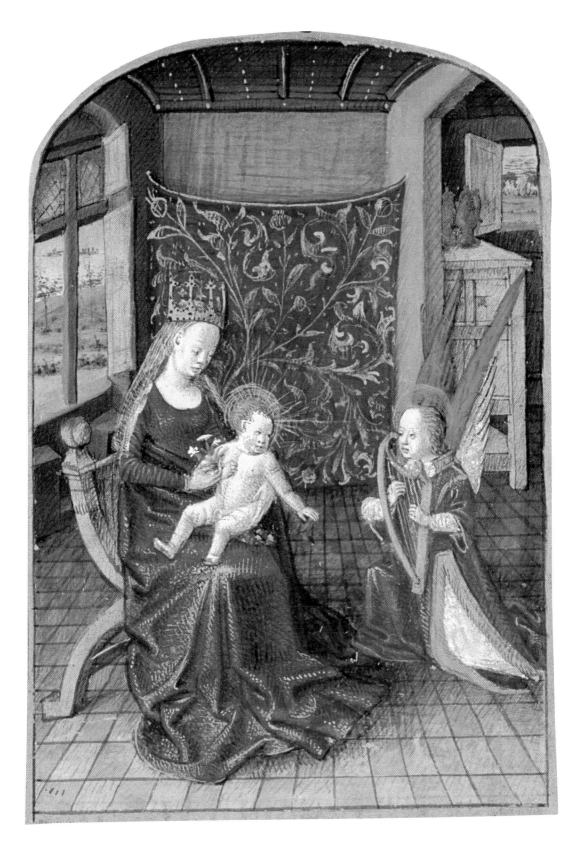

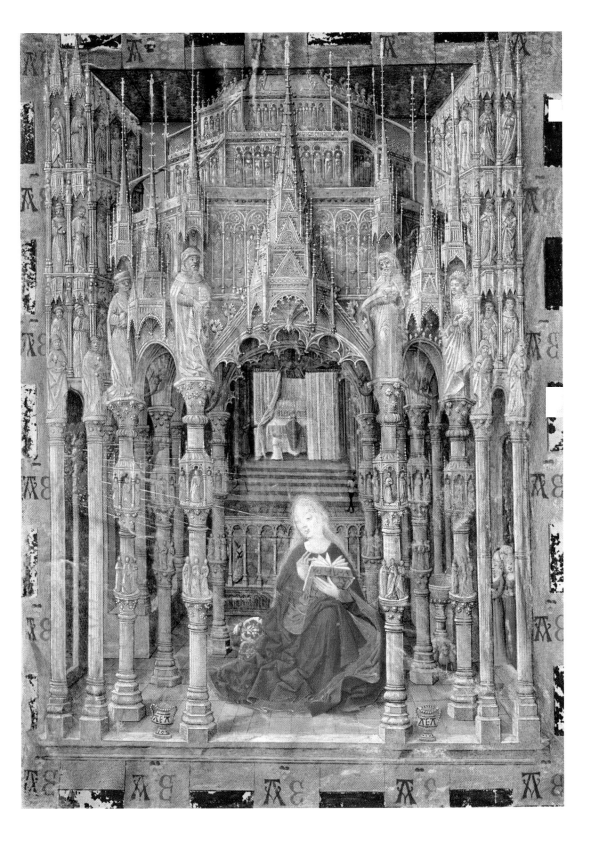

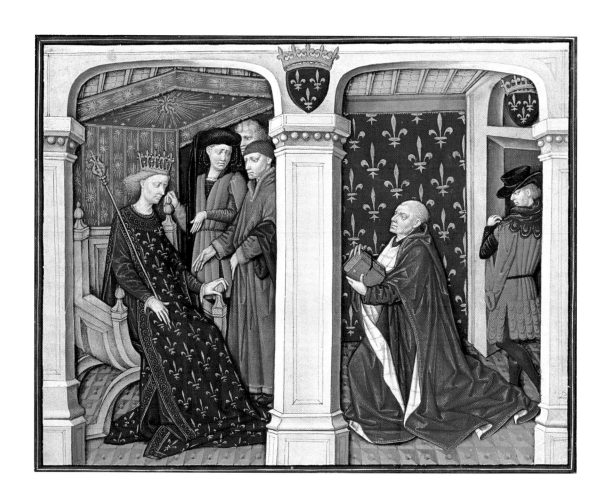

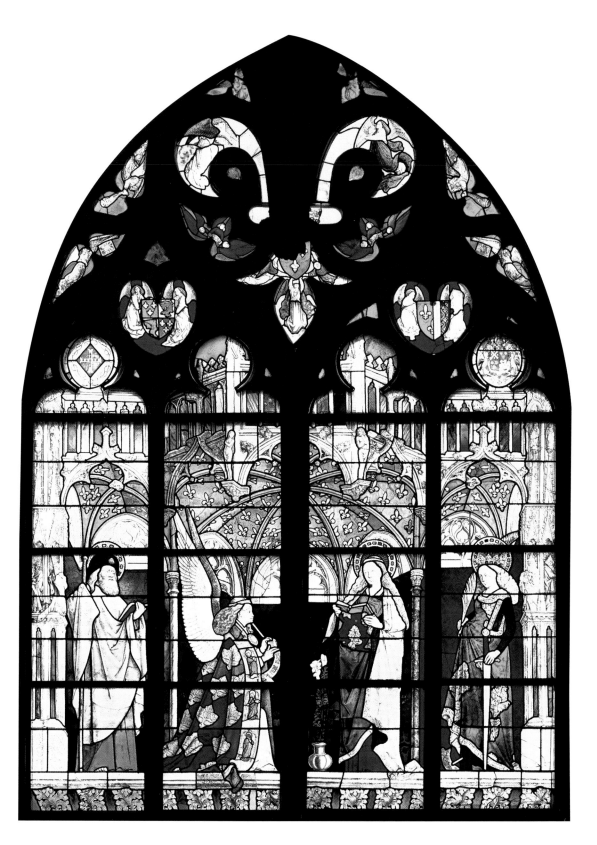

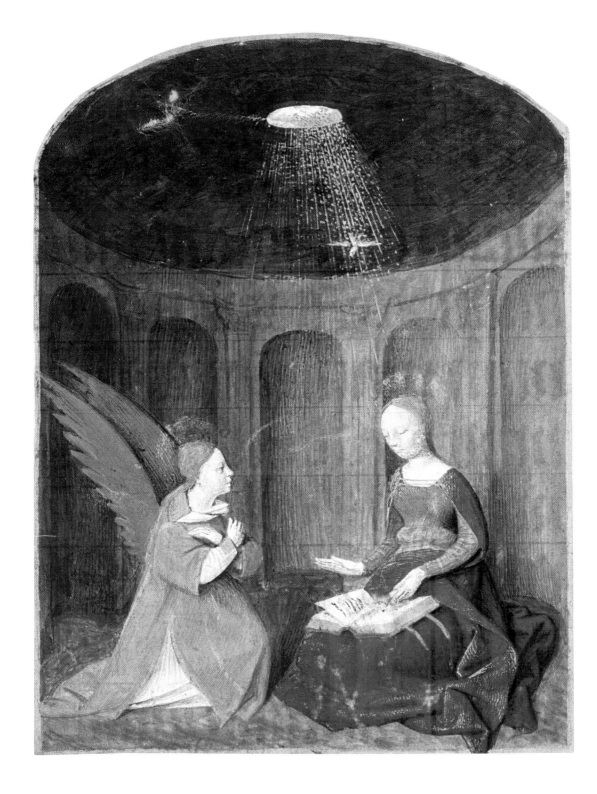

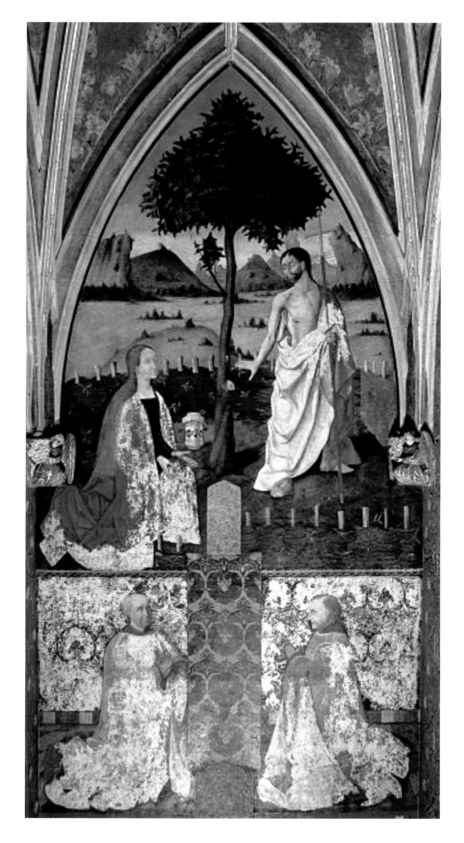

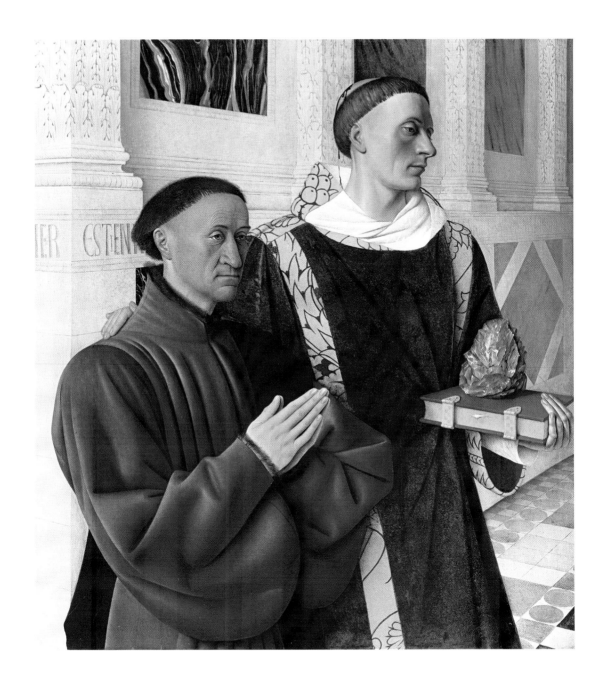

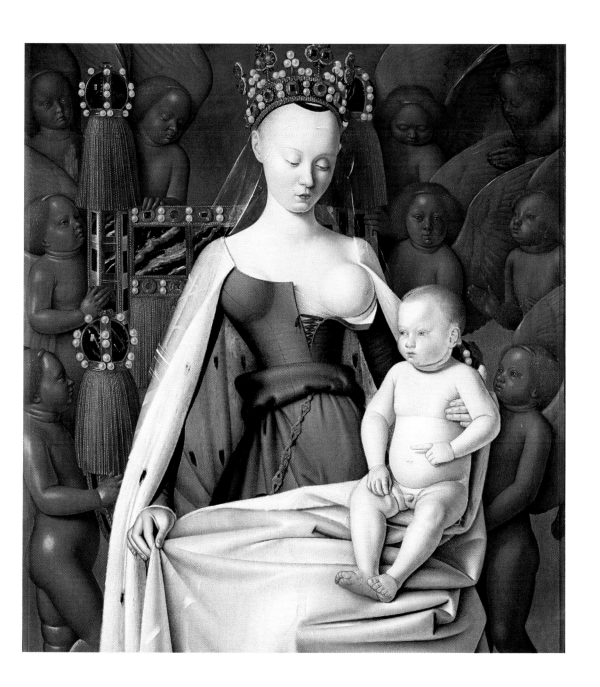

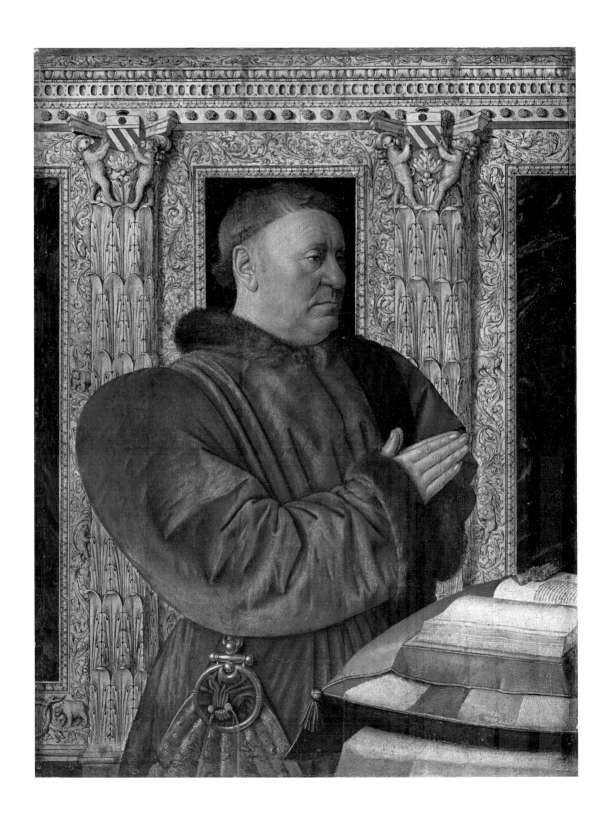

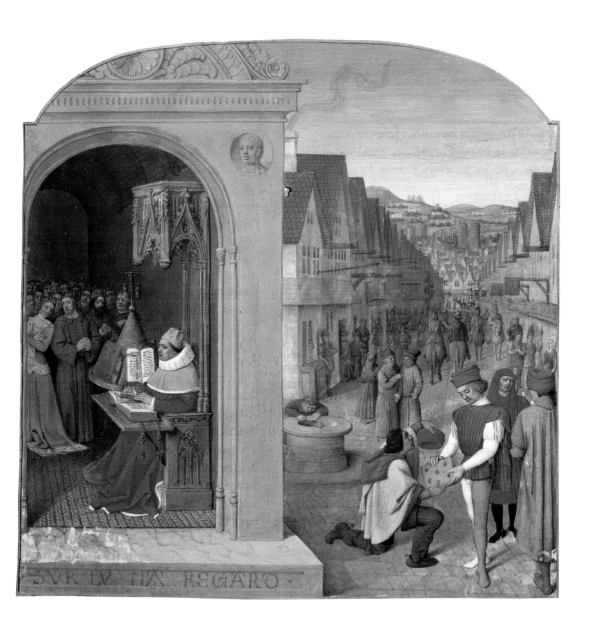

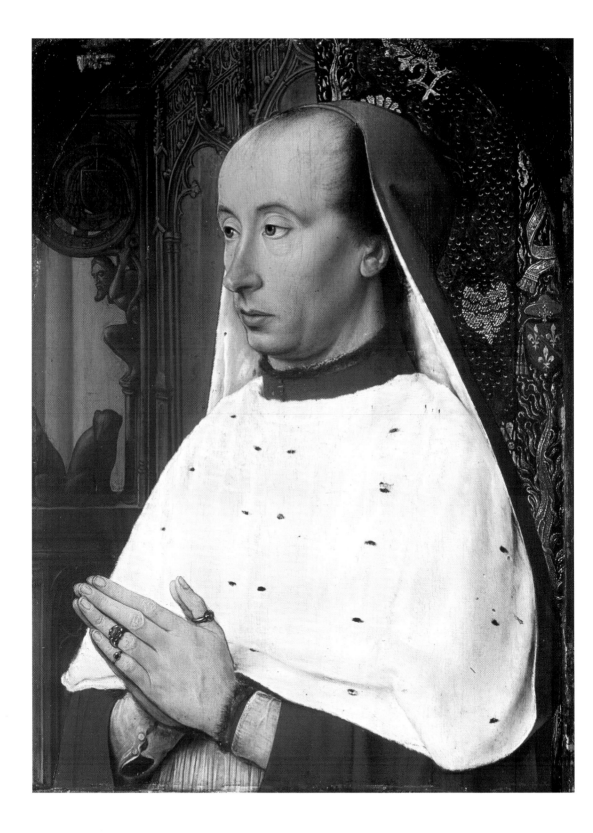

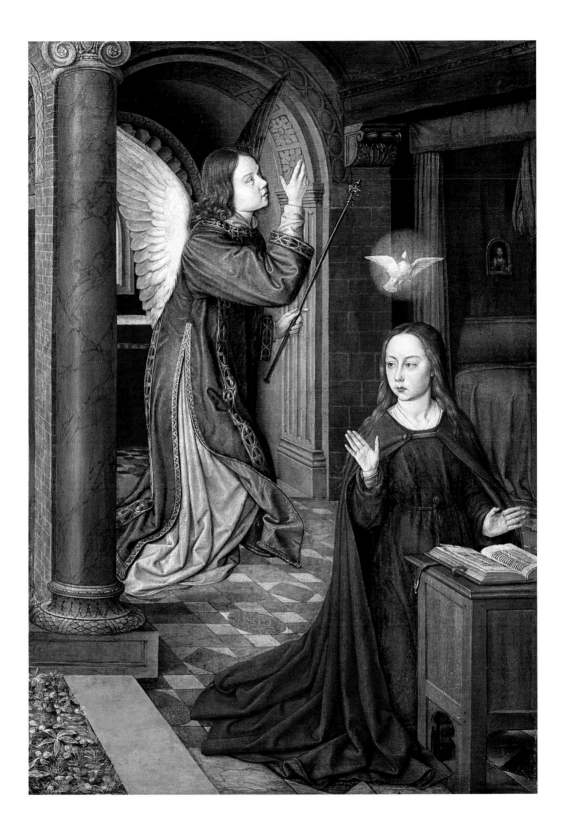

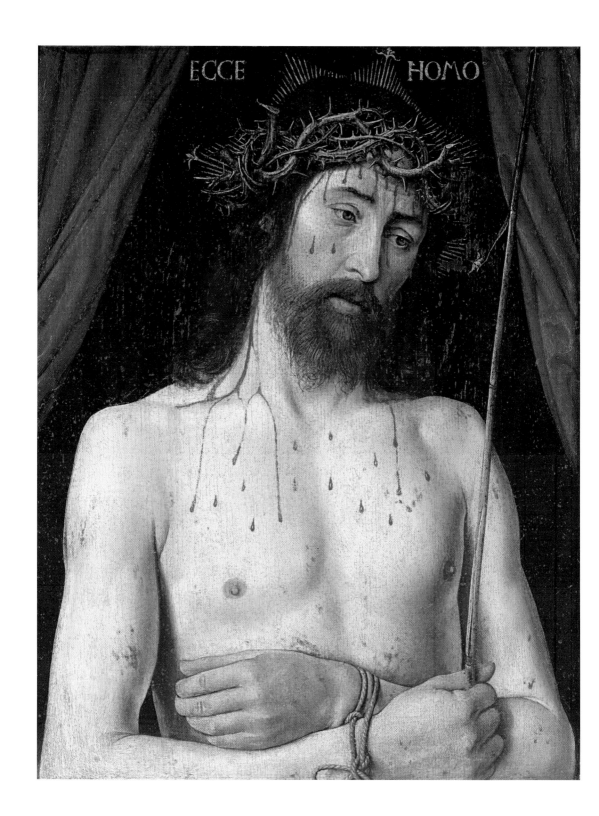

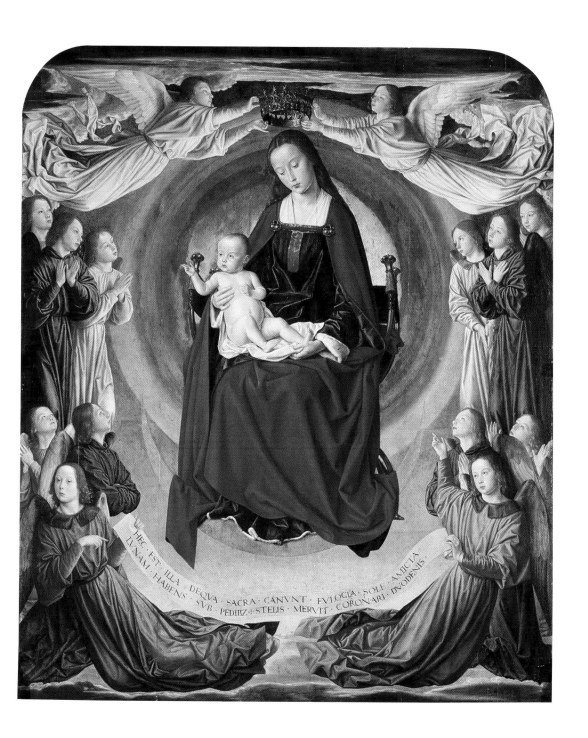

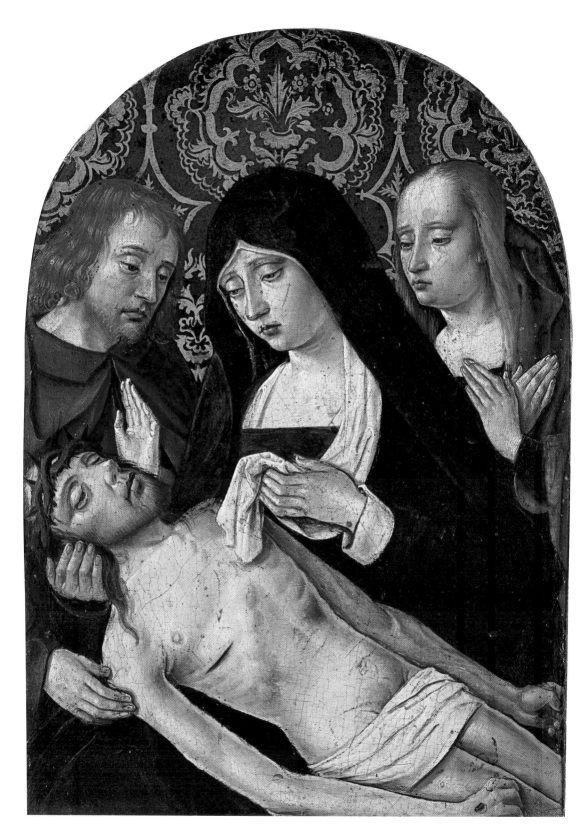

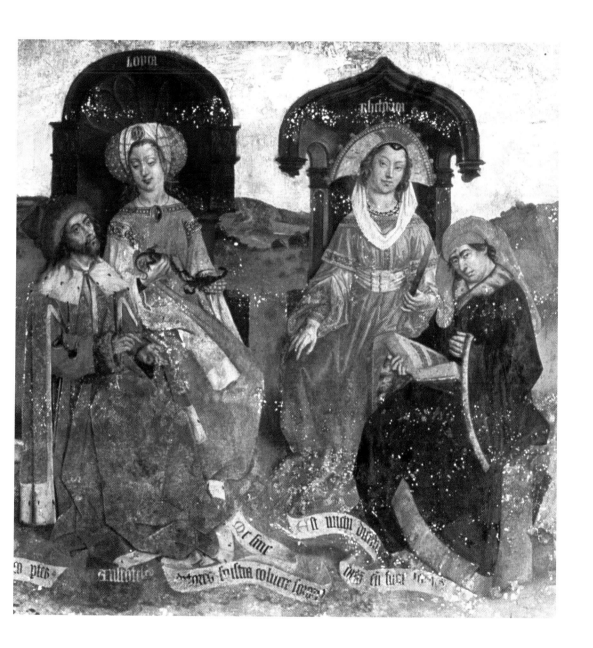

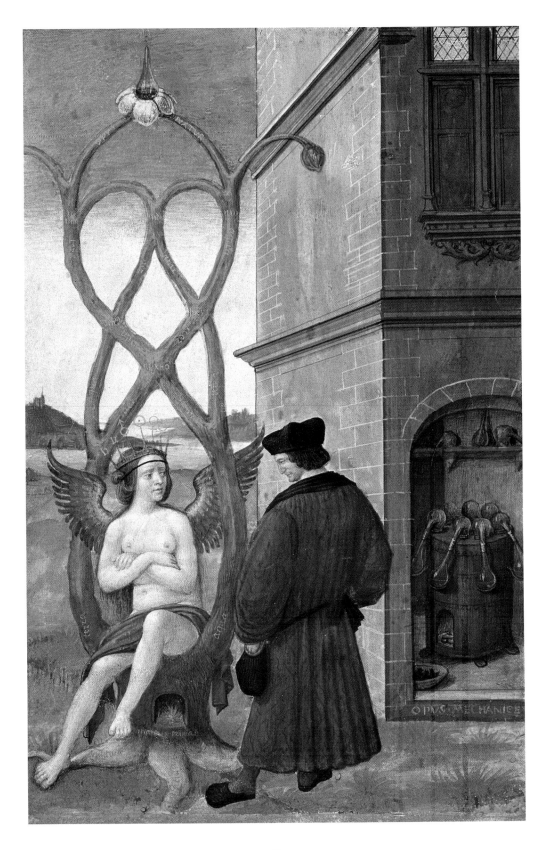

48

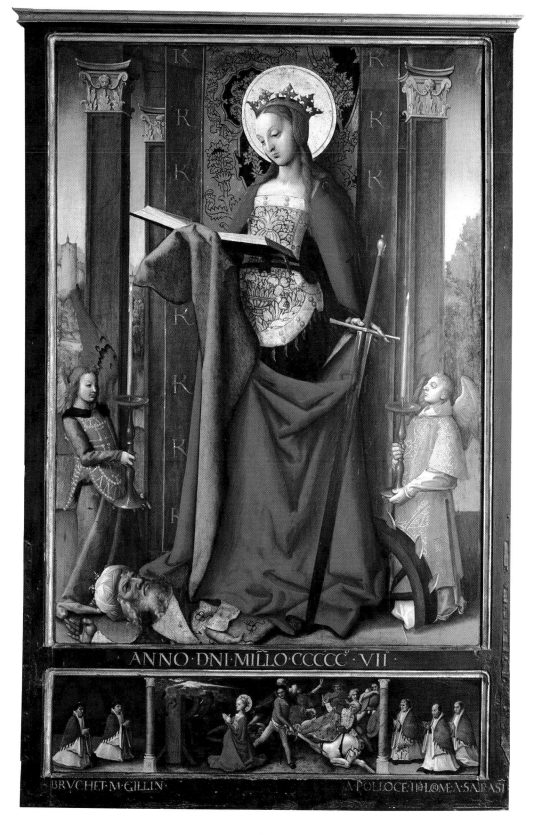

ANNO · DNI · MILLO · CCCC° · VII

BRVCHET · M · GILLIN A · POLLOCE IIIⒾ ☉ · LOMEA · SALPASI

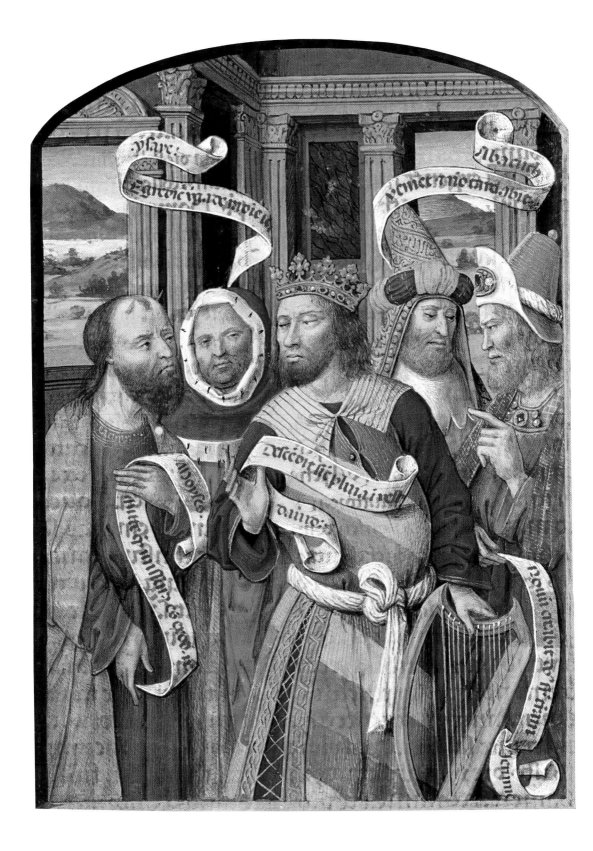

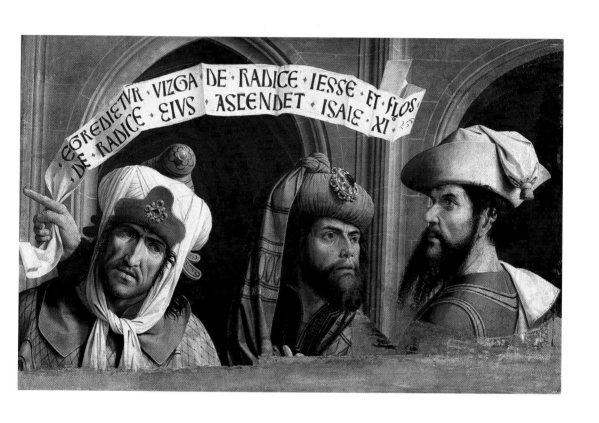

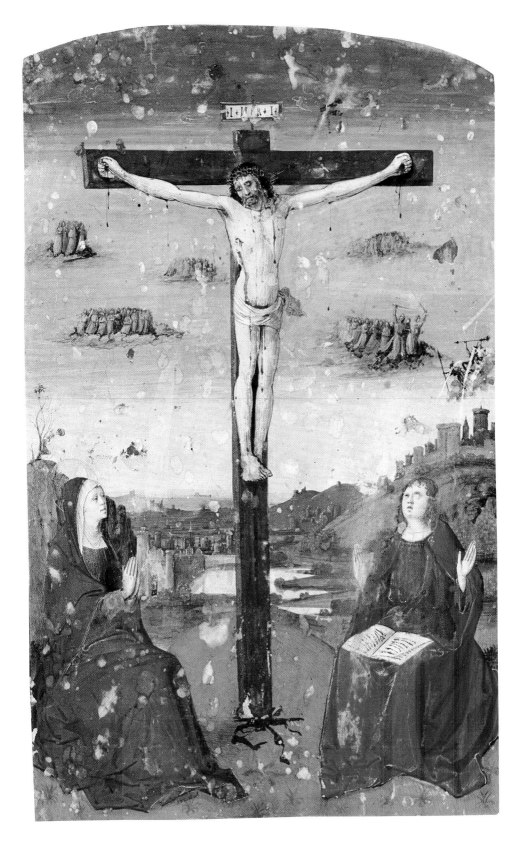

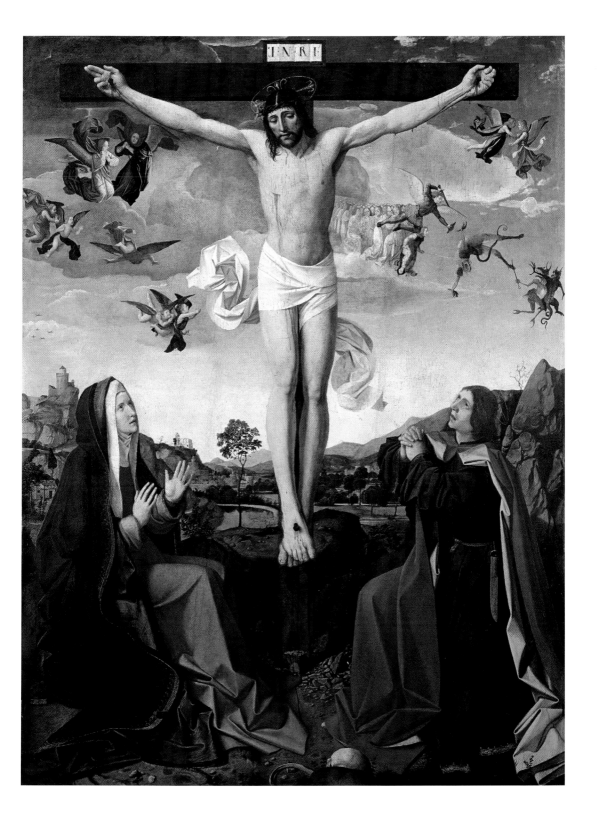

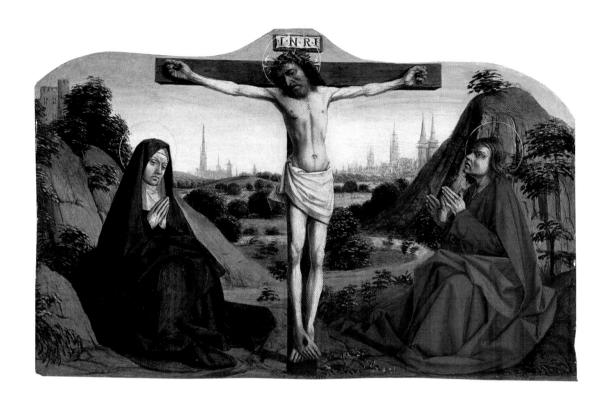

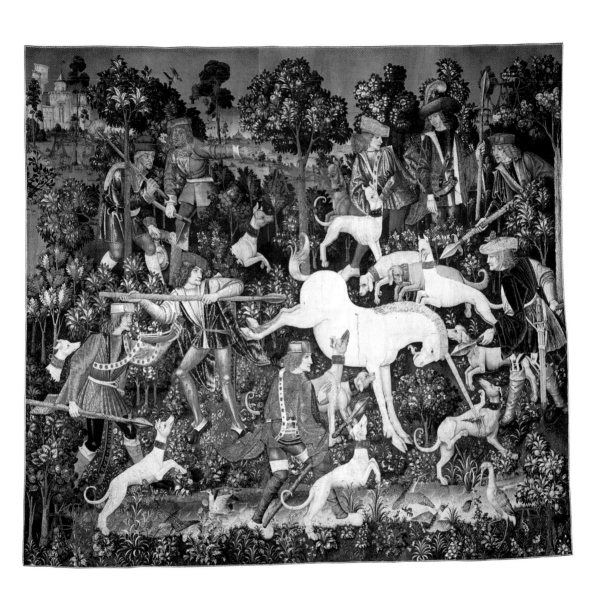

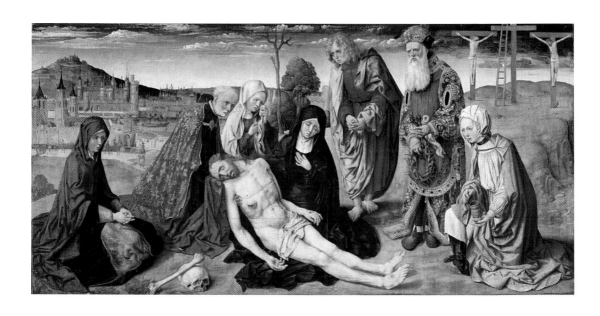

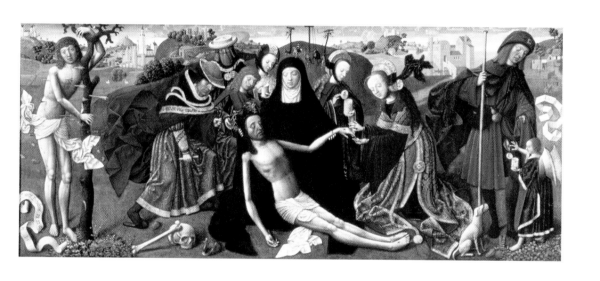

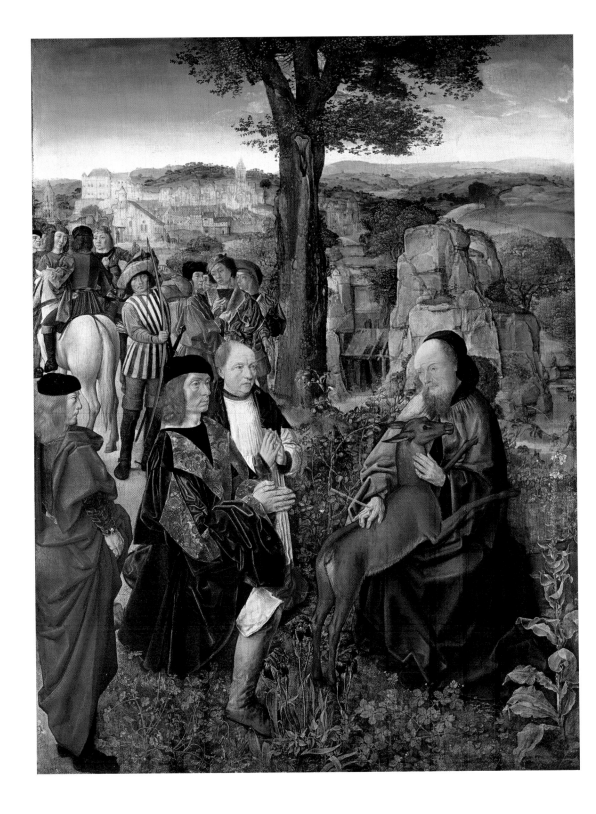

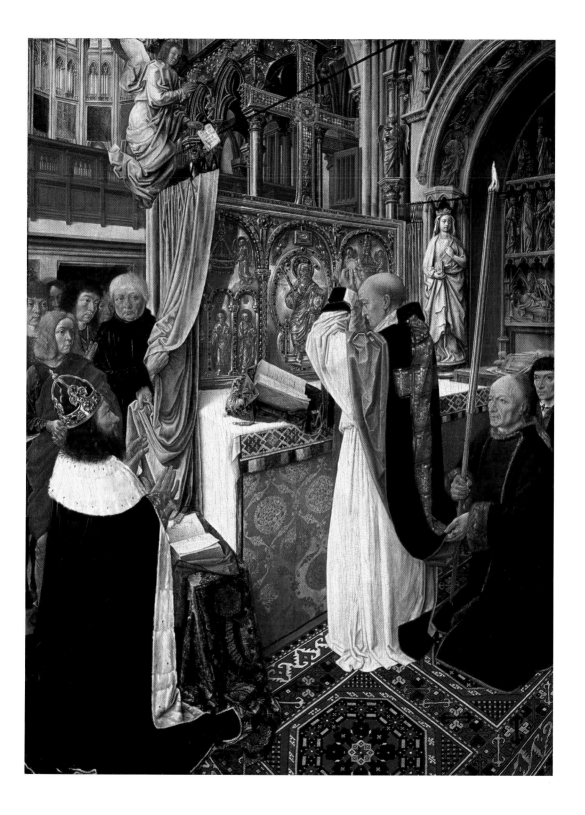

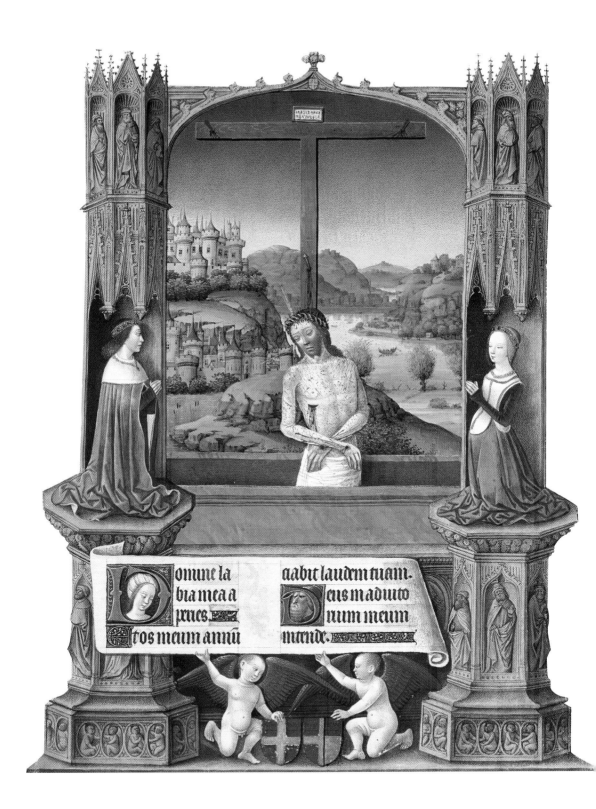

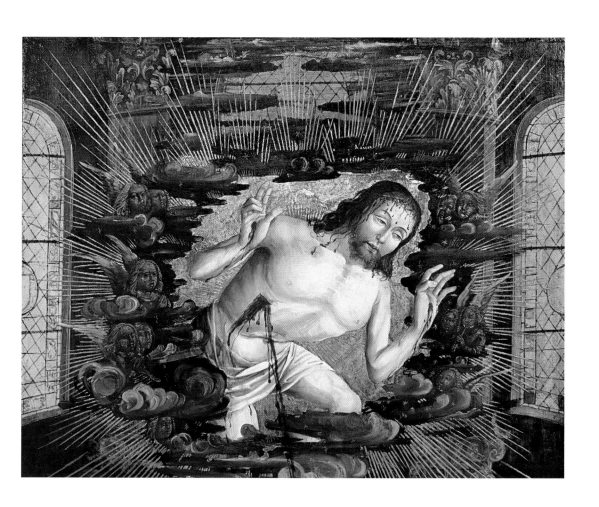

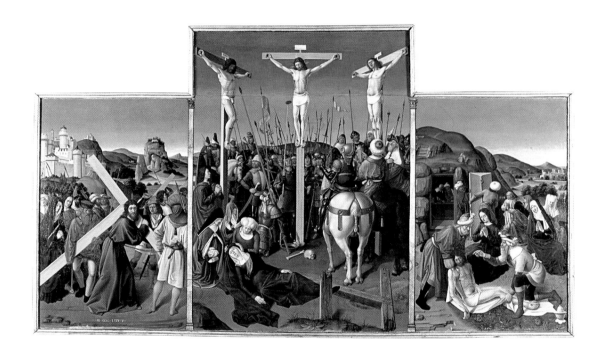

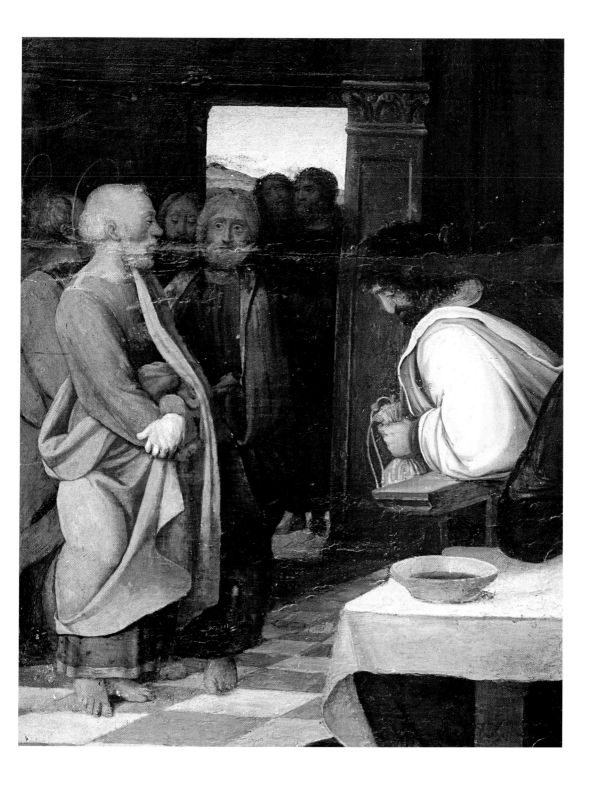

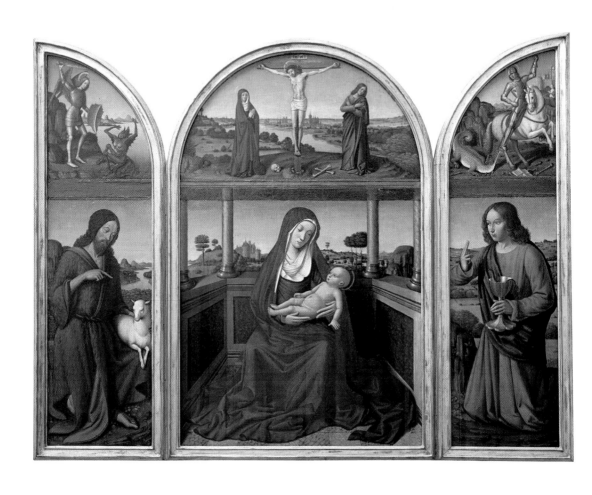

APPENDICES

CHRONOLOGY

1380

Accession to the throne of Charles VI,
who succeeds his father Charles V as king
of France; regency of his uncles Louis d'Anjou,
Jean de Berry and Philippe le Hardi, duke of
Burgundy.

1389

Charles VI convenes his father's past councillors;
the government rallies after a period of crisis.

1392

First signs of Charles VI's insanity; return of his
uncles to the government; start of the regency
of his brother Louis d'Orléans, who maintains
a prominent literary court at Blois.

1404

Accession to the throne of Jean Sans Peur,
who succeeds his father Philippe le Hardi as
duke of Burgundy.

1407

Assassination of Louis d'Orléans by supporters of
Jean Sans Peur; France is torn between the party
of the Armagnacs (favourable to the Orléans)
and the Burgundians.

1415

Victory of the English at Agincourt;
the Hundred Years' War continues, and King
Henry V of England occupies a large part of
the country.

1416

The plague carries off Jean de Berry, the greatest
collector of his times.

1419

Assassination of Jean Sans Peur on the bridge of
Montereau by the men of the dauphin, the future
Charles VII.

1420

Treaty of Troyes: the new duke of Burgundy,
Philippe le Bon, forms an alliance with the king
of England Henry V; meanwhile Charles VI of
France, through his wife Isabeau of Bavaria, is
forced to disinherit his own son and wed his
daughter Catherine to Henry VI of England,
then declared heir to the crown of France.

1422

Death of Charles VI and Henry V; accession to
the throne of Henry VI; Charles VII, recognised
only by the party of the Armagnacs, establishes
himself at Bourges.

1423

Paris is occupied by the English troops; regency
of John of Lancaster, duke of Bedford.

1429

Liberation of Orléans by Joan of Arc; coronation
of Charles VII at Reims.

1435

Treaty of Arras: Charles VII forms an alliance with
the duke of Burgundy, Philippe le Bon.

1436

Liberation of Paris; beginning of the reconquest
by Charles VII.

1438

Pragmatic sanction of Bourges: rights of the
monarchy over the clergy.

1442

René d'Anjou, forced by Alfonso of Aragon
to flee Naples, loses his claim to the kingdom
of Naples, and establishes a brilliant court in
Anjou and Provence.

1444

Truce of Tours: the English retreat; the king
symbolically establishes himself in the Loire Valley.

1451

Jacques Cœur, treasurer of the king, is arrested,
replaced the following year by Étienne Chevalier.

1453
End of the Hundred Years' War: the English only retain Calais.

1461
Accession to the throne of Louis XI, who succeeds his father Charles VII as king of France; revocation of the pragmatic sanction of Bourges.

1465
League of the Public Weal: coalition against Louis XI, accused of having diplomatic relations with the king of England.

1467
Accession to the throne of Charles le Téméraire who succeeds his father Philippe le Bon as duke of Burgundy; Treaty of Péronne: Louis XI has to yield territories to Charles le Téméraire.

1470
Annulment of the Treaty of Péronne.

1475
Louis XI forms an alliance with the duke of Lorraine, the Rhenish cities and the Swiss cantons triumph over Charles le Téméraire, who dies two years later in the battle of Nancy.

1480
Death of René d'Anjou; transfer the following year of Anjou and Provence to the kingdom of France.

1482
Pact of Arras: Louis XI keeps Picardy and the duchy of Burgundy, but must yield Franche-Comté and Artois to Maximilian of Habsburg, heir of Charles le Téméraire.

1483
Accession to the throne of Charles VIII who succeeds his father Louis XI as king of France; regency of his sister Anne de Beaujeu, wife of Pierre de Bourbon, at Moulins.

1491
Personal reign of Charles VIII who marries Anne, heir to the duchy of Brittany.

1493
Treaty of Senlis: Charles VIII must permanently transfer France-Comté and Artois to the Habsburgs.

1494
Swift take-over of Naples by Charles VIII, against whom a coalition (Milan, Venice, Pope Alexander VI) is formed, backed by the Habsburgs.

1495
Victory of Fornovo; end of the Neapolitan campaign that plays an essential role in the introduction of the Italian Renaissance in France.

1498
Death of Charles VIII; accession to the throne of his cousin Louis XII d'Orléans who marries the widow, Anne of Brittany, the following year.

1499-1500
Grandson of Valentine Visconti, Louis XII asserts his claims to the duchy of Milan that he places under the regency of Charles d'Amboise until 1511. Conquest of Genoa.

1501
Conquest of Naples.

1504
Treaty of Lyon: retreat of the French who nonetheless keep the duchy of Milan.

1509
Victory of Louis XII and the League of Cambrai over Venice at Agnadello; anti-French coalition forces led by Pope Julius II.

1512
Victory of the French (with Gaston de Foix) against the Spanish at Ravenna.

1513
The French defeated by the Swiss cantons at Novara.

1515
Death of Louis XII; accession to the throne of his cousin François d'Angoulême: a new chapter in French history begins.

THE ARTS IN FRANCE

1385
Death of Bishop Gontier de Baigneux, who shortly before had commissioned the wall paintings for the Le Mans cathedral choir.

1386
André Beauneveu enters the service of duc Jean de Berry.

1391
Colart de Laon, *valet de chambre* of King Charles VI and his brother Louis d'Orléans; drafting of the statutes of painters in Paris.

1393
The decor of the chateau of Mehun-sur-Yèvre, residence of the duc de Berry, is appraised by two artists in the service of the duke of Burgundy: the painter Jean de Beaumetz and the sculptor Claus Sluter.

1399
Jacques Coene (the Boucicaut Master?) is recorded among those working on the building site of Milan Cathedral.

1406
Colart de Laon paints an altarpiece (lost) for the Parlement of Paris.

1415
Death of Jean Malouel. He is replaced by Henri Bellechose in the service of Jean Sans Peur, duke of Burgundy.

1416
Death of the Limbourg brothers, carried away by the plague at the same time as their patron, duc Jean de Berry.

1423
Arrival in Paris of the regent John of Lancaster who commissions the illustration of several manuscripts to an illuminator, known as the Master of the Duke of Bedford.

1426
Robin Favier at Grenoble and Saint-Antoine-en-Viennois.

1433
René d'Anjou perhaps recruits, in Jan van Eyck's workshop, Barthélemy d'Eyck, who is one of the first to introduce the *Ars Nova* into France, in particular with the Le Puy *Holy Family* (ca. 1435).

1435
The Treaty of Arras, in which Jan van Eyck takes part, also contributes to the penetration of the *Ars Nova* in France.

1443
Barthélemy d'Eyck begins the triptych of the Aix-en-Provence *Annunciation* for the draper-merchant Pierre Corpici.

1444
Barthélemy d'Eyck collaborates with Enguerrand Quarton (Charonton) at Aix-en-Provence.

1445
Conrad de Vulcop enters the service of Charles VII; approximately at this time, Jean Fouquet is sent to Italy, where he certainly meets Fra Angelico.

1446
Antoine de Lonhy in the service of Nicolas Rolin.

1450
Death of André d'Ypres, a painter trained at
Tournai concurrently with Rogier van der
Weyden and presumed author of the altarpiece
for the Parlement of Paris; Jean Fouquet, back
from Italy and settled at Tours, is appreciated
as portraitist at the court of France.

1451
Jacob de Litemont in the service of Charles VII.

1452
Enguerrand Quarton collaborates with Pierre
Villate on the *Virgin of Mercy*.

1454
Enguerrand Quarton executes the *Coronation of
the Virgin* of Villeneuve-lès-Avignon, the contract
of which is the most detailed to our knowledge.

1455
Simon Marmion begins the altarpiece of the
abbey of Saint-Bertin at Saint-Omer.

1461
Jean Fouquet and Colin d'Amiens participate in
the preparations for the obsequies of Charles VII.

1462
Antoine de Lonhy, in a Barcelona document, is
called "resident of Avigliana" (Piedmont) in the
duchy of Savoy.

1474
Pierre Spicre is given the commission for the
hangings in the Notre-Dame collegiate church
of Beaune.

1475
Jean Fouquet appointed official painter of king
Louis XI; Nicolas Froment begins the altarpiece
of the *Burning Bush* in Aix-en-Provence.

1476
Diplomatic journey to Rome of Georges
Trubert, painter of King René.

1481
Arrival of Mantegna's *St Sebastian* at Aigueperse;
Jean Bourdichon, official painter of King
Louis XI.

1482
Probably trained by Hugo van der Goes,
Jean Hey is in the service of Cardinal Charles
de Bourbon.

1485
Jean Poyer paints the Liget triptych (Loches,
Musée du Château); Jean Colombe completes
the *Très Riches Heures du duc de Berry* at
Chambéry.

1488
Jean Hey enters the service of Pierre de
Bourbon at Moulins.

1496
Jean Perréal appointed official painter to
King Charles VIII.

1498
Josse Lieferinxe paints the *Altarpiece
of St Sebastian* for the church of
Notre-Dame-des-Accoules in Marseille.

1500
Arrival of Gauthier de Campes (the Master
of Saint Giles?) in Paris.

1507
Claude Guinet paints his *St Catherine*.

1515
Arrival of Noël Bellemare, a painter from
Antwerp, in Paris: thus ends a tradition
represented by Jean Bourdichon's rhetorical
style and begins a new chapter of the painting
produced in France.

ANNOTATED BIBLIOGRAPHY

GREAT EXHIBITIONS AND GENERAL SURVEYS

In the late nineteenth century the painting produced in France during the fifteenth century was studied in several erudite articles and a small number of surveys: see for instance P. Mantz, *La Peinture française du IX^e siècle à la fin du XVI^e siècle* (Paris, 1897).

However, the 'Exposition des Primitifs français' Henri Bouchot organised in 1904 is the true beginning of the historiography. It gave rise to a number of articles appearing in the *Gazette des Beaux-Arts* and the *Revue de l'Art ancien et moderne* as well as several surveys. See in particular G. Hulin de Loo, "L'Exposition des Primitifs français du point de vue de l'influence des frères van Eyck sur la peinture française et provençale", *Bulletin de la Société d'histoire et d'archéologie de Gand*, 1904; P. Durrieu, "La Peinture en France depuis l'avènement de Charles VII jusqu'à la fin des Valois (1422–1589)", in A. Michel, *Histoire de l'art depuis les premiers temps chrétiens jusqu'à nos jours, IV, La Renaissance* (Paris, 1911), pp. 701–71; P.-A. Lemoisne, *La Peinture française à l'époque gothique, XIV^e et XV^e siècles* (Leipzig, 1931).

The 'Exhibition of French Art' (London, 1932) and the 'Exposition des Chefs-d'œuvre de l'art français' (Paris, 1937) gave these studies new momentum. See J. Dupont, *Les Primitifs français* (Paris, 1937); L. Réau, *La Peinture française du XIV^e au XV^e siècle* (Paris, 1939). In that environment, Charles Sterling stands out as the greatest connoisseur of the "French Primitives", devoting two fundamental surveys to the subject: *La Peinture française. Les primitifs*, Paris, 1938; *La Peinture française. Les peintres du Moyen Âge*, Paris, 1941 (under the pseudonym Charles Jacques), a second edition appearing the following year under his real name. Furthermore, Charles Sterling was to bring back to life a number of regional personalities and productions in his articles, published in particular in *L'Œil*.

Charles Sterling's studies are widely referred to in several surveys published in the third quarter of the twentieth century that accept their conclusions to varying degrees: see in particular G. Ring, *A Century of French painting 1400–1500* (London, 1949); A. Châtelet and J. Thuillier, *La Peinture française. De Fouquet à Poussin* (Geneva, 1963); M. Laclotte, *Primitifs français* (Paris, 1966). The revival of studies is owed to miniatures: J. Porcher, *Les manuscrits à peintures en France du XIII^e au XVI^e siècle* (Paris, 1955); J. Plummer and G. Clark, *The Last Flowering. French Painting in Manuscripts 1420–1530* (New York, 1982).

Arising from this dual tradition, the exhibition 'Les manuscrits à peintures en France 1440–1520' (Paris, 1993) marks a new historiographical turning point. Written by François Avril and Nicole Reynaud, the book published on the occasion of the exhibition assembles the overall conclusions and opens several new directions for research. It thus provides a new foundation on which the most recent studies are based. The very latest, by Fabienne Joubert and Dominique Thiébaut, is exemplary: see respectively "La pittura gotica" and "Dal 1435 al 1500: il primato artistico dei pittori", in *La pittura in Europa. La pittura francese* (Milan, 1999, pp. 59–101 and 105–65). It features an extensive bibliography, updated for the French edition (Paris, 2001). Therefore we shall be content to recall the classical references, merely adding the latest contributions on the principal personalities.

THE BOUCICAUT MASTER

The Boucicaut Master was reconstituted by Paul Durrieu who suggested identifying him with Jacques Coene. He was studied in particular by Millard Meiss in *French Painting in the time of Jean de Berry* and Charles Sterling in *La Peinture médiévale à Paris 1300–1500*. Recently in the illuminator's catalogue, Gabriele Bartz and François Avril pointed out the figure of a disciple: the Master of the Mazarine. See the

entries by Brigitte Roux in the exhibition
'El Renacimiento Mediterráneo', mounted in
Madrid in 2001 by Mauro Natale. See also
B. Guineau and I.Villela-Petit, "Couleurs et
technique picturale du Maître de Boucicaut",
Revue de l'Art, 135, 2002, pp. 23–42; and
I.Villela-Petit, "Le Maître de Boucicaut revisité.
Palette et technique d'un enlumineur parisien
au début du XVe siècle", *L'art de l'enluminure*,
6, 2003, pp. 3–33. By the same author, see the
hypothesis relative to Colart de Laon in
"L'ange au chanoine. Fragment d'un retable
laonnois du XVe siècle", *Monuments et mémoires
de la Fondation Eugène Piot*, 82, 2003,
pp. 173–212.

JEAN DE BEAUMETZ AND JEAN MALOUEL

Jean de Beaumetz and Jean Malouel were
studied in particular by Charles Sterling,
and more recently by Patrick de Winter, who
devoted a book to the background of Philippe
le Hardi, extending it to the Parisian milieu
(in particular to the Master of the Coronation
of the Virgin). Also see S. Cassagnes-Brouquet,
"La peinture en province et les sources
médiévales. L'exemple de la Bourgogne des XIVe
et XVe siècles", in *La peinture en province de la fin
du Moyen Age au début du XXe siècle* (Rennes,
2002), pp. 19–29.

ANDRÉ D'YPRES AND COLIN D'AMIENS

The Dreux Budé Master and the Coëtivy
Master were respectively and most convincingly
identified with André d'Ypres and his son
Colin d'Amiens by Nicole Reynaud. On the
former, see Philippe Lorentz's discussion,
*Corpus de la peinture des anciens Pays-Bas
méridionaux et de la principauté de Liège au
quinzième siècle. Le Musée du Louvre, III*
(Brussels, 2001), pp. 81–132. See also by the same
author, "La France, terre d'accueil des peintres
flamands", in *Le siècle de Van Eyck: le monde
méditerranéen et les primitifs flamands* (Bruges,
2002), pp. 65–71.

BARTHÉLEMY D'EYCK

Barthélemy d'Eyck, formerly called the Master
of the Aix Annunciation, or the Master of the
Cœur d'Amour Épris, was identified by Georges
Hulin de Loo at the time of the 1904 Exhibition.
Since then, the identification was accepted and
developed by Nicole Reynaud and Eberhard
König, who wrote a book on him. Dominique
Thiébaut added further information about him
in the exhibition catalogue *El Renacimiento
Mediterráneo* (Madrid, 2001).

ENGUERRAND QUARTON

Enguerrand Quarton was studied in particular
by Michel Laclotte and Dominique Thiébaut
who also wrote entries on him in the exhibition
El Renacimiento Mediterráneo (Madrid, 2001). Also
see F. Avril and D.Vanwijnsberghe, "Enguerrand
Quarton, PierreVillate et l'enluminure provençale.
A propos d'un livre d'heures inédit conservé au
Grand Séminaire de Namur (Belgique)", *Revue
de l'Art*, 135, 2002, pp. 77–92. The article goes
back to a former assumption of François Avril
regarding the identification of PierreVillate,
Enguerrand Quarton's collaborator.

ANTOINE DE LONHY

Following up clues provided by Charles Sterling,
Antoine de Lonhy was rediscovered by Giovanni
Romano and François Avril, and his work was
shown in the exhibitions' El Renacimiento
Mediterráneo' (Madrid, 2001) and 'Bartolomeo
Bermejo' (Barcelona, 2003).

JEAN FOUQUET

Jean Fouquet is without discussion the fifteenth-
century French painter whose historiography is
the most plentiful. He was studied in particular
by Klaus Perls, Paul Wescher, Nicole Reynaud
and Claude Schaefer. An important exhibition
was devoted to him at the Bibliothèque
Nationale in 2003 by François Avril: 'Jean
Fouquet. Peintre et enlumineur du XVe siècle'.

In the exhibition catalogue, François Avril convincingly demonstrated the existence of a follower, the Master of the Munich Boccaccio, perhaps one of Jean Fouquet's sons.

JEAN HEY

Jean Hey, formerly known as the Master of Moulins, was identifed by Charles Sterling, an identification backed in particular by Henri Zerner, Nicole Reynaud and Philippe Lorentz, but challenged by Albert Châtelet who, in spite of the evidence, prefers that of the Lyonese painter Jean Prévost: see *Jean Prévost. Le Maître de Moulins* (Paris, 2001). Recently, Étienne Hamon found a document dated to 1472 (but that should be interpreted as 1482) that attests the presence of Jean Hey in the service of Cardinal Charles de Bourbon (Pierre-Gilles Girault et Étienne Hamon, "Nouveaux documents sur le peintre Jean Hey et ses clients Charles de Bourbon et Jean Cueillette", *Bulletin monumental*, 161, 2, 2003, pp. 117–25).

THE MASTER OF DI SAINT GILES

The Master of Saint Giles was reconstituted by Max J. Friedländer and Charles Sterling, and identified with one Wouter de Crane, active in Lyon, by Albert Châtelet in his book on the Master of Moulins. But he was more convincingly identified with Gauthier de Campes, active in Paris, by Guy-Michel Leproux: see *La peinture à Paris sous le règne de François I*^{er} (Paris, 2001), pp. 39–108. See also Pierre-Gilles Girault, "De Bruges à Blois, Gauthier de Campes et le Maître de saint Gilles", in *Les amis du château et des musées de Blois*, 33, 2002, pp. 15–23.

JEAN POYER

Jean Poyer was essentially rediscovered by François Avril, and subsequently studied by John Plummer and Roger S. Wieck, who devoted an important exhibition to him at the Pierpont Morgan Library of New York

in 2001. See also F. Elsig, "Un triptyque de Jean Poyet", in *Revue de l'Art*, 135, 2002, pp. 107–14; M. Hofmann, "L'héritage de Jean Fouquet dans l'œuvre de Jean Poyer", in *Dossier de l'art*, 94, 2003, pp. 58–71. Mara Hofmann, who reinstated the spelling "Poyer" (instead of "Poyet"), wrote her doctoral thesis on the painter (forthcoming).

[1]
Frédéric Elsig
*Painting in France
in the 15th Century*

[2]
Fabrizio D'Amico
Morandi

[3]
Antonio Pinelli
David

[4]
Vincenzo Farinella
Raphael

[5]
Alessandro Angelini
*Baroque Sculpture
in Rome*

[6]
Aldo Galli
The Pollaiuolo

[1] Frédéric Elsig teaches the history of medieval art at the University of Geneva. A specialist in fifteenth- and sixtennth-century European painting, he participated in particular in the exhibitions 'El Renacimento Mediterráneo' (Madrid, 2001) and 'Hieronymous Bosch' (Rotterdam, 2001). He co-directed the exhibition 'La Renaissance en Savoie' (Geneva, 2002) and is presently preparing the catalogue of the Flemish and Dutch paintings (before 1620) held in the Musée d'Art et d'Histoire of Geneva.